Stubbs

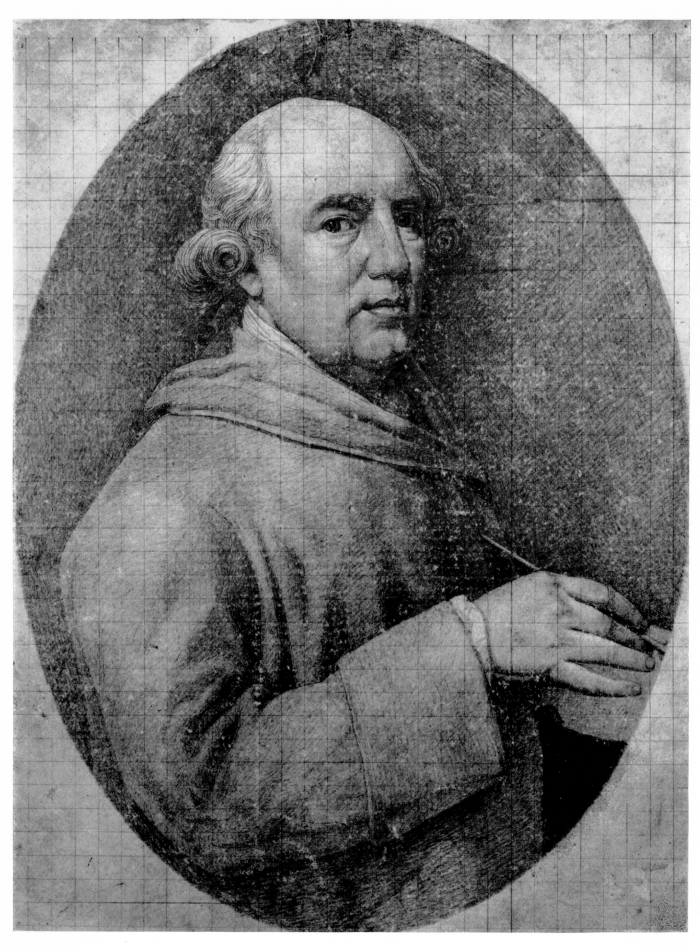

PORTRAIT OF THE ARTIST. 1780–1. 12 × 9 in. Pencil on paper. Mr and Mrs Paul Mellon

BASIL TAYLOR

Stubbs

ICON EDITIONS

HARPER & ROW Publishers

NEW YORK EVANSTON SAN FRANCISCO LONDON

FIRST U.S. EDITION
LIBRARY OF CONGRESS CATALOG CARD NUMBER: 76-162567
SBN: 06-438613-9

CONTENTS

For Michael

THE PRESENT ESSAY is not a substitute for the larger study of Stubbs which has occupied me during many years and which may ultimately be published. The growing interest in the artist in the past decade did, however, encourage me to accept the Phaidon Press's invitation to publish a critical essay which might also offer a summary of my findings, especially as it could be attached to a group of plates which would for the first time adequately show the range and quality of the painter's art. The black and white illustrations have been arranged, if not strictly in a chronological sequence, at least approximately so with the intention of presenting not only the development of Stubbs's work but his historical relationship to English painting as a whole.

The scarcity of biographical sources, as well as the nature of the documents which do exist, creates numerous and substantial problems. In this book I have not attempted to analyse the material critically or even to justify the omission of certain reports and anecdotes, for my present text only incorporates that which I believe to be either sufficiently verifiable or at least acceptable enough to repeat with confidence without adding the critical commentary or detailed reservations necessary in a larger historical study. I have also not treated here questions of attribution, dating and provenance, which belong to a *catalogue raisonné*, and, for that reason, the notes to the plates are primarily intended to explain the pictures' content.

Anyone who has pursued his subject for twenty-five years must be indebted to numerous kind people who have helpfully contributed to the research in large and small ways. I hope to have an opportunity of acknowledging their assistance in time, but three friends must be named here and now. I owe to the late Tom Staveley of Tonbridge School, teacher extraordinary, not only a first encouragement to ask historical questions but also the equally important encouragement to regard one's answers, however conscientiously achieved, with a proper humility and reserve. Geoffrey Grigson, who published in 1938 the most perceptive account of the artist yet to appear, unselfishly supported my enthusiasm and most generously gave me the material he had gathered in connection with that seminal essay. With the late Gerhart Frankl, whose knowledge of the art of painting was profounder than any other I have met in print or in speech, I had many hours of enlightening talk about an artist whose gifts he so deeply understood and enjoyed.

The Phaidon Press and I are most grateful to those owners of works by the artist who have not only allowed them to be reproduced but have, in various ways, helped to make this possible, often at considerable inconvenience to

themselves. We are indebted to Her Majesty the Queen for gracious permission to reproduce pictures in the Royal Collection. We have been enabled to reproduce the portrait of Whistlejacket through the cooperation of Granada Television, who kindly lent a colour transparency in their possession. The following members of the art trade have given invaluable assistance: Arthur Ackermann and Son Ltd, Thomas Agnew and Sons Ltd, Gooden and Fox Ltd, Leggatt Bros.

I am especially grateful to three members of the staff of the Phaidon Press: Keith Roberts, who persuaded me to do this book and supervised the preparation of the text with a nice blend of encouragement and criticism; Ann Barrington, who supervised the gathering of the illustrative material; Simon Haviland, who has so sympathetically seen it through the press.

AFTER STUBBS came south from Lincolnshire about 1759, at the age of 35, he took residence eventually at 24 Somerset Street, in a district on the very edge of town which then had not, like Covent Garden or Piccadilly, a clear social definition. It was an area neither lowly nor fashionable. Within half a mile to the north and west the city streets became country roads. Forty-six years later, in 1806, he died there without much notice being taken of the event and was consigned to a grave now unidentifiable. For two generations his art passed into such obscurity that he might not have existed. The address on the city's margin could be used as a symbol of the painter's career, for he did not fit neatly or centrally into the artistic world of his time, nor have historians found it easy to place him in the reconstructions of the period which they have presented since.

Stubbs has had slowly to be rediscovered, and, even now, almost every-one's response to him must be formed from little more than an experience of the few pictures permanently on view in public collections, and which are by no means sufficiently representative of his genius. Whereas the art of Hogarth, Gainsborough or Constable is easily studied, and has in each case come down to us along an unbroken path of knowledge and interpretation, supported by a large biographical dossier, there are few aids to the appreciation of Stubbs. Taste or critical standards limited by the ruling aesthetic values of the eighteenth century will find his work historically no more significant than his contemporaries did. It is noticeable that Roger Fry, who edited Reynolds's *Discourses* as well as admiring Cézanne, overlooked him, as Ruskin had done.[1] The nineteenth century, when Stubbs was disregarded by critics of art, formed or revived some of those criteria by which his mastery can be judged, and there were times and places before the eighteenth century and outside England wherein his talents would certainly have been more sympathetically treated.

Although his contemporary reputation irked him, Stubbs did not seek to acquire a greater prestige by any permanent or radical adjustment of his art to the most influential taste and opinion; but he cannot be presented as a rebel or a romantic outsider. Simply, his identity as a painter and his intellectual purposes were too strong to be adapted or disguised. Although so little evidence of his character has survived, he appears to have been a very straightforward man, with a resolute will to match his physical strength, and not at all one with that type of divided or spiritually wounded personality to which modern artistic heroes have commonly belonged. He was not a visionary of the Blakean kind that the English have honoured in retrospect

as having been elusively inspired. He did not enjoy a few blazing years of inspiration and fecundity, followed by a bathetic decline. His personality and physique, his art and what is known of his behaviour, seem to have been all of a piece, possessing an impressive resilience and integrity. The explicit iconography of his painting was for the most part unremarkable and, although sometimes its simplicity is misleading, never elaborate or allusive enough to create problems for sophisticated understanding; his particular transformation of the objective world is what has to be understood, and, if his originality is to be recognized, this can require close historical study and meticulous attention to the visual qualities involved. He certainly stands in that company of artists—Dürer being one of its noblest representatives—who, from the centre of their nature, have enjoyed a wide-ranging and un-assailable capability and whose works have the characteristic named by Sir Henry Wotton in his definition of good architecture, 'firmness', a principle implying the most comprehensive definition of craftsmanship and requiring mental discipline as well as skill of hand. Unlike Hogarth, who said that he had to get things wrong before he got them right, Stubbs possessed a natural virtuosity, which he never forfeited or lost but which was always unpreten-tious in its effect.

He attracted no contemporary biographer and, seemingly, no articulate defender with any social or artistic influence. Ozias Humphry admitted that the biographical notes he compiled from the painter's talk were neither sub-stantial nor consecutive enough to deserve publishing, although they now form the chief literary source for our limited knowledge of his life.[2] Because he was not a social creature, there are few useful references in the informal records of the time. J. T. Smith, who lived, as Nollekens's aide, only a few hundred yards from Stubbs's studio, did not bring him into his published gossip. Farington, in his diary, recorded nothing of much importance. Only in Josiah Wedgwood's correspondence with his partner Bentley does a person emerge with any clarity.[3] There is no reason to suppose that future research or some chance discovery will produce any significant revelations or sur-prises. One version of the Humphry document is, in fact, a transcript by that artist's natural son, William Upcott, who was in touch with the family and probably wrote the brief obituary for *The Gentleman's Magazine*.[4] Upcott was an obsessive gleaner of artistic documents, and the absence from his collections of anything else can be taken as some assurance that few tracks were left in the snow. Thus any portrait of the man must be a speculative sketch as we know for certain almost nothing about his response to events or to the course

of his career. The surviving work, if difficult to see, does, however, provide a large body of evidence. Only the portraiture of his youth, several history pieces and the majority of those numerous drawings catalogued in his posthumous sale[5] constitute missing material which might affect the appreciation of his work, if any of it were to reappear.

A large part of the Humphry text describes Stubbs's childhood and youth. The recollections set down, probably in the 1790s, long after the events recounted, lack both detail and precision in the matters of fact, while the occasional remembrance of earlier opinions was probably coloured by the disappointments of his later life. The date 'February 1, 1797', appearing towards the end of the manuscript, suggests that most of it would have been written not long before. Humphry's account of the significant happenings in the first thirty-five years can be stated quite briefly.

George Stubbs was born in Liverpool in 1724, the son of a well-established currier. He came therefore from the same social stratum as Constable. At the age of 15 he was apprenticed by his father to an undistinguished artist, Hamlet Winstanley, then employed at Knowsley Hall as a copyist; as the boy remained with him for only a few weeks, we must assume that he was essentially self-taught. Stubbs practised first as a portrait painter from various centres in the north, and by the age of 26 had come to York, where an interest in anatomy, reputedly formed when very young, led him to give private teaching in the subject to medical students. This, no doubt, encouraged John Burton (the model for Laurence Sterne's Dr Slop, the man-midwife) to commission him to illustrate his *Essay towards a Complete New System of Midwifery* (1751), a task which required Stubbs to learn the rudiments of etching (Plates 1, 2).

In 1754, perhaps through the patronage of Lady Nelthorpe of Scawby, Lincolnshire, he travelled to Rome; Richard Wilson was one of the British artists then working in the city, Reynolds had been there two years earlier, and by an odd, if not very significant, coincidence, living in the same apartment house in the Piazza di Spagna[6] was a French nobleman, le Comte de Lauraguais who, a dozen years later, was to acquire from Lord Bolingbroke the racehorse, Gimcrack, just after Stubbs had painted the animal in one his most beautiful pictures (Plate 32). Having returned to England and spent a further period in Liverpool, he began, about 1758, the studies which were to result in *The Anatomy of the Horse* (Plates 4–6, Fig. 2).

The preliminary work for this book, the dissection and the drawing, was done in the isolated village of Horkstow, near the south shore of the Humber,

presumably in order to escape the hostile attention this undertaking might have attracted in a more populous place, for in York Stubbs had, according to a contemporary, won a 'vile renown',[7] on account of his anatomical researches. He devised a tackle for hoisting horses into life-like postures and then, without skilled assistance, anatomized a number of carcasses. By their fastidious clarity of structure and detail, the drawings prove that he had mastered those techniques which enabled parts such as veins, arteries and ligaments to be kept for investigation in a natural state and position, techniques developed in the seventeenth century by Jan Swammerdam and other workers. The preliminaries completed, he came to London about 1759, if for no other reason than to find a reproductive engraver willing to translate his studies into the plates for the book. In that purpose he failed, but by his immediate success in establishing an artistic practice, at this date he enters the history of English painting, as richly charged with talent and creative energy as any London immigrant of that calling has ever been.

He was already living with Mary Spencer, the woman who was to be a loyal companion until his death and, supposedly, his common-law wife and the mother of his son, George Townley Stubbs. (I reject the discreet nineteenth-century suggestion that she was a niece.) In an age of wives and/or mistresses, the form of relationship they maintained for so long was unconventional and remains something of an enigma. Was it in fact like the partnership of Rembrandt and Hendrickje Stoffels, an implicit declaration of his independent outlook, and did it in any degree contribute to a social loneliness which is detectable in his career? In that connection the influence of his chief scientific interest must always be remembered. To conduct anatomical research involving dissection was then to invite criticism and distrust. Although the Academy appointed a Professor of Anatomy, William Hunter, and although Hunter's private lectures at his own house in Windmill Street attracted such men as Gibbon and Burke, it is difficult to think of any other artist of the time who would have shared Stubbs's unequivocal view of the pursuit. The prevailing dilemma was clearly put in a letter from Burke to his protégé, James Barry: 'Notwithstanding your natural repugnance to the handling of carcasses, you ought to make the knife go with the pencil and study anatomy in real, and if you can, in frequent dissection. You know that a man who despises, as you do, the minutiae of art is bound to be quite perfect in the noblest parts of all; or he is nothing.'[8] Stubbs's anatomizing, however, did not apparently spoil his début in the south, although there is no account of the establishment of his studio in London nor

any explanation of how he came to enter so successfully upon the next phase of his career. At this point the biographical sources become even slighter and more discontinuous, and we have to rely mainly upon the pictures and fragments of indirect or circumstantial evidence, if any sense of his work's development is to be had.

Stubbs could not have arrived in the capital at a moment more advantageous for a painter with his inclinations and ability. The development of hunting and racing had reached a point when an artist fitted to serve a sporting and country-loving patronage could expect abundant opportunities. Racing, in particular, was already well advanced into a new term of expansion. It had yet to become, by later standards, either well administered or a public spectacle, but the creation of the Jockey Club about 1750 had promoted an active partnership of socially powerful enthusiasts who were gradually to create the modern conditions of the Turf. Most significantly for a painter, here was a group of young, aristocratic devotees more influential than any previous company of sportsmen, many of them linked by political as well as sporting interests; Rockingham, Grosvenor, Richmond, Bolingbroke, Grafton, Torrington, Portland were prominent among them. Almost all of these men had been born, within a few years of each other, in the 1730s, and they were therefore conveniently related to Stubbs in age; he was their senior contemporary and as ardent in his expectations as the *aficionados* who were to make or at least further his reputation. Within this circle he was to proceed from one encouraging act of patronage to another throughout the decade, and other prominent figures, the Duke of Ancaster, Sir Henry Bridgeman and Denis O'Kelly, have to be added to the list of employers already mentioned. We may be sure that they were impressed not only by a painter gifted with such a mastery of representation, but by one who offered a new style, showed a modern sensibility and could treat the subjects they proposed with a sophistication quite beyond the scope of his predecessors. The earlier group of sporting artists, active in the first half of the century—Tillemans, Wootton, Seymour, Spencer, for example—were dead or in decline, and their pictures not only belonged to a different age but in the second half of the century were considered to be artistically inadequate. They had been the primitives of a short, but firmly established, tradition, and if that was to survive effectively, it had to attract a man of exceptional gifts, for the general performance of English painting as a whole was to be enriched most strikingly in this decade, and larger ambitions were to emerge. Several of Stubbs's early patrons, or their forbears, for example the Duke of

Richmond and the Marquis of Rockingham, had earlier employed Wootton, and at Goodwood House the pictures by the two artists hanging side by side help to recover the sense of novelty which the appearance of such a striking new talent must have occasioned (Fig. 9). Henry Angelo claimed that his father Domenico, a famous riding-master, introduced the artist to some of his early patrons, but I cannot treat this report with any certainty.[9] Reynolds seems early to have recognized the painter's talent, but probably had little positive influence upon his career, and indeed the patronage which the two attracted hardly overlapped.[10]

The same individuals who would have welcomed Stubbs's gifts as an animal painter were likely to be the source of a more extensive patronage, for not only field-sports but the more informal conditions and pleasures of rural society had become so important in the life-style of the landed classes that the opportunity had emerged for the development of a distinctive iconography. At no other period in English history were the economic and social advantages of land possession and the creative satisfactions to be derived from it so intimately and constructively connected. The great era of country-house building was reaching its climax, and many foreign visitors to England in the eighteenth century were impressed by the attachment to country life they discovered here among moneyed and sophisticated people. In the sixteenth and seventeenth centuries the portrait had uniquely served the interests of family, rank and ambition. A different form of art with a wider range of subject could confer a similar honour upon the whole scope of material property and the social returns it provided; English painting in the first half of the century provides abundant evidence of its outgrowth. In the 1760s Stubbs was to be the most talented, responsive and versatile interpreter of such an iconography of rural life; his work should be seen in this context and not regarded—as it has been formerly—as one unusually refined and distinguished manifestation of sporting art.

At this date also a movement of wider historical significance was coming to fulfilment. Since the beginning of the century, the desire to create the practical conditions for a national school of painting, especially permanent facilities for study and exhibition, had been constantly voiced. In the 1760s organized annual shows were begun, first those sponsored by the Society of Artists and the Free Society, and then, from 1769, those at the new Royal Academy. A painter could, through these exhibitions, advertise his skill, learn more readily from his contemporaries and, in due course, like a writer through publishing, gain some critical attention. Stubbs was to benefit

immediately from this, for his distinctive and, at that moment, particularly useful talent was instantly publicized. As it happened, few animal painters were emerging just then to compete with him in that activity. Only Sawrey Gilpin, born in 1733, could claim to offer a rival competence and, in spite of finding his own patronage, he had yet to prove himself more than merely a promising follower of the man in command of the market. An older painter of equestrian pictures, David Morier, was not only approaching the end of his life, but continued in his later years to work in a style which was beginning to look archaic in comparison with Stubbs's art.

Like Robert Adam, another immigrant from the north with a similar energy and resource, indeed, like many of his fellow painters, Stubbs was due to benefit from the surge of economic prosperity which was affecting the country and which largely accounts for the elaborate, expensive works commissioned from that architect during the next decade by men with money to spend and cultural aspirations to be satisfied. It was also the beginning of a new reign and there were optimistic expectations of royal interest and patronage, so that, all in all, this was a moment of hope, ambition and impending artistic expansion. After the gradual and obscure beginnings in the provinces, he was, by 1760, an essentially mature, if professionally untried, painter, ready with an abundance of pictorial ideas which were soon to be so richly exploited; in scope and productiveness this was the most fecund time of his life. There were apparently few of those occasions in the decade when his talent was wasted upon uninspiring commissions of a kind he had so often to accept afterwards, but which he always executed so conscientiously. As he seldom dated pictures in the 1760s and because the sequence of his work has not until now been shown, the range and originality of his achievement in those years has gone unrecognized; the undeniable fact established by the pictorial evidence that he was the most versatile and exploratory painter of the time has yet to be registered in historical accounts of English art. Plates 7–60 offer a representative sample from his remarkable output, but these pictures alone cannot convey how productively he was engaged between 1760 and 1770. He made the intricate plates for *The Anatomy of the Horse* (Fig. 2), which was published in 1766, and saw the book through the press as his own personal enterprise: he worked in oil colours on every scale from canvases twelve feet by ten feet to little cabinet pictures and applied his inventiveness to a great range of subjects, greater indeed than can be illustrated here; he made his first pictures in enamel colours having learned that craft at the end of this period; he was concerned in the affairs of the Society

of Artists, of which he was later to be Treasurer and Director; he must have journeyed frequently and far, out of London, in the service of his patrons; and there is no evidence, nor reason to suppose, that he had any assistance in executing all these tasks.

By subject the paintings of the time fall into two quite distinguishable classes. There were the pictures which continued a prevailing tradition of English animal painting and so re-created the pictorial types or models which during the century had already become characteristic of it. These were what Stubbs's leading patrons primarily expected and commissioned: portraits of horses and dogs, for example, and hunting or racing scenes that were in the same general form which their predecessors had obtained from a Wootton or Seymour. What they received from Stubbs, however, was as different in quality and imagination from the earlier products as the new portraiture of Reynolds from that of, say, a Jervas or a Hudson. Stubbs also made his distinctive contribution to those other forms characteristic of the school, the conversation piece and the informal portrait. There were to be few pure landscapes, but, in composing the scenes occupied by his figures and animals, he tried every current mode of landscape painting from the topographical to the Sublime. In the other class of subjects were those for which no precedent existed, at any rate in English art: the compositions of brood mares, or mares and foals, wild animal paintings of several different types, the first of what may be called animal history pictures, as well as a miscellany of other themes, including the series devoted to shooting.

By 1770, therefore, Stubbs had exhibited and tested all his resources, although he had by no means revealed the deepest levels of his formal and imaginative powers which were, indeed, only to be sounded when his circumstances were less prosperous. If certain impulses within himself as well as influences quite beyond his personal control had not started to affect his career about this date, the practice which he had established in the 1760s might have continued as favourably at least for another fifteen or twenty years. As it was, his affairs were never again to proceed with the same security and coherence; increasingly he had to face the particular challenges of that unhelpful social ambience within which so many English painters have vainly sought security and self-fulfilment, so many found crippling disappointment

Like other artists, whether members of the Academy or not, Stubbs was influenced by the very existence of a buoyant institution which in 1768 divided the leading painters of the country into two companies. He was

affected by its claims to artistic authority and, in so far as these ideas influenced taste and patronage, by the aesthetic canons proposed then and in the next generation by its most articulate and forceful members under Reynolds's purposeful leadership. Having been cast as an animal painter, and as a result of the plain, undemonstrative style that was natural to him, he could not hope to achieve the status which less gifted but more biddable artists were to enjoy. At a time when the honours were being conferred and aesthetic values being more comprehensively defined than in any earlier phase of English painting, his predicament must have been similar to that which Constable was to face fifty years later, when he found—and felt—himself to be an underprivileged person, having to listen to Lawrence's condescending suggestion that a painter of his modest kind was fortunate indeed to be elected to the Academy. We can deduce that in the 1770s, when he became Director of the Society of Artists, by then an insignificant body, the tenor of Stubbs's life changed fundamentally. It is known, for Josiah Wedgwood records his opinion, that by 1780—and probably earlier than that—he was seeking to alter his practice, hoping, according to Humphry, to be 'considered as an history & portrait painter'.

Here is probably one reason—and another will be suggested later—why the number of his sporting patrons seems to have been diminishing and why there was a severance from those generous early employers, many of whom remained until the end of the century active sportsmen and, as such, kept an interest in pictures of the kind he had formerly supplied. If this was one reason for the derangement of Stubbs's career, another can be more precisely identified and explained. During the 1770s the chief extension of his work resulted from his continuing the experiments with enamel colours which had started by 1769 and were to be maintained at least until 1795.[11] His commitment to the technique seems to have been as resolute as his devotion to anatomical study. According to Humphry, Richard Cosway originally suggested that Stubbs should use the material, but he never applied it to either of those purposes for which it was normally employed in the eighteenth century, miniature painting and the decoration of *objets de vertu*. For Stubbs it became an alternative means of normal picture-making, although his consistent use of that oval shape not found in the oil paintings does indicate that he thought of these works as having a separate identity. His desire to establish the technique and to gain recognition for his use of it may indeed have become an obsession, as well as being a symptom of his independence.

When the established method of applying the enamel pigments to a metal support proved impracticable beyond a size too small to satisfy his ambitions, Stubbs looked for a provider of ceramic tablets which would neither buckle nor crack in the heat of the kiln. The quest for this alternative brought him into contact with Wedgwood; the potter not only made searching experiments to give Stubbs just what he wanted—becoming, as the former wrote, his 'canvas maker'—but proved to be a sympathetic collaborator and, in a small way, a patron. With his help Stubbs was able to create enamels more than three feet long, but not many of them were to be sold, and they failed to please those commenting upon the Academy exhibitions in which some were shown. Counting the examples made on copper with the ones on Wedgwood tablets, about thirty-six can be identified, of which twenty-two are presently known. Apart from horse portraits and conversation pieces, all his characteristic subjects are found in this medium: portraits (himself, Mr and Mrs Wedgwood and Warren Hastings being among the sitters), four of his farming scenes, wild animals, including the horse and lion theme, and a history piece, *Phaeton with the Chariot of the Sun*. Twenty-six of these works were still in the studio at his death and of the remainder perhaps only six were commissioned or purchased according to the normal conditions of his practice. Like *The Anatomy of the Horse*, this was entirely a personal enterprise, for Wedgwood's role in it was only to supply a material, not to form the artistic partnership such as he shared with Flaxman, for instance. So completely did Stubbs master the chemistry of his pigments and the method of applying them, that in terms of drawing, colour and tonal control he needed to modify very little, although inevitably they lack those more subtle qualities of atmosphere and touch which belong to the oil paintings of these years and which have so often been weakened by cleaning or restoration. If, however, one considers what were, in the 1780s and 1790s, those features of a painting technique and of pictorial form most admired, a dramatic tonality, a richness of *matière* and the pigment applied with an explicit, vigorous touch, it is understandable why the bland, unemotive surface of these unique pictures was then out of taste.

In other respects the enamels raise questions which cannot be satisfactorily answered. From whom, if not Cosway indeed, did Stubbs get his first instruction in the craft, for the earliest dated examples show a full control of it? If we may assume that the paintings made around 1780 were completed in Wedgwood's kilns, where did he fire the fine examples of the 1790s? The most important and suggestive question, however, is, *why* did he persevere so

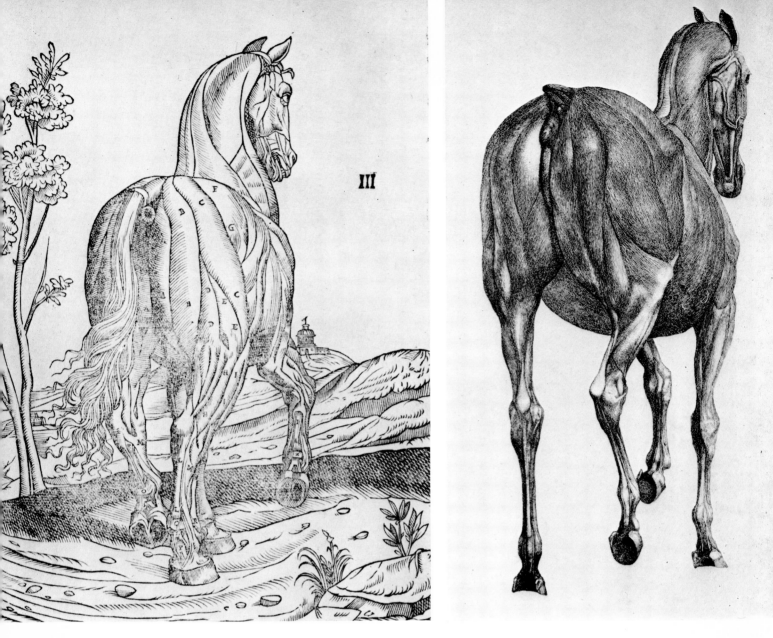

Figure 1 (left). Carlo Ruini (about 1530–98): *Dell'Anotomia, et dell'Infirmità del Cavallo...*
(1598), Book V, Table 5

Figure 2 (right). George Stubbs: *The Anatomy of the Horse* (1766), Table XII

Les poulins.

Figure 3. After Abraham van Diepenbeke: Plate 12 from the Duke of Newcastle's
A New Method to Dress Horses (1658)

long with a technique involving severe disciplines and one which immediately proved to have such slight appeal? The challenge of the technical problems no doubt satisfied his experimental instincts, and he was evidently a man of obstinate convictions, but there must also have been an artistic reason: perhaps the physical qualities of these works can tell us something about his aesthetic intentions. Even when dominated by greys and browns, the colour is clean and refulgent. The process of firing seems to give the compositions, in tone and atmosphere, a firm, concentrated unity of effect. And there was, of course, the material durability of the paintings, for, unless broken, these images would resist the normal assaults of time as surely as sculpture. Their physical permanence is in harmony with ǝɥʇ formal stability of Stubbs's art.

Paradoxically, however, the impaired condition shown by many of the later oil paintings has been caused through his using this robust medium, for the 1770s brought a considerable change in his oil method, attributable to the experiments with enamel colours and an acceptance of the technique's effects. In that process he worked on a firm, untextured ground, whether it be a white enamel flux applied to copper or the smooth, hard surface of a ceramic tablet; the colours not only had a substance like gouache, but had to be handled in the same way. Before 1770 he worked invariably on canvas, putting on to it a substantial body of opaque pigment. The painting of the cheetah (Plates 43–45) is a typical example of the solid impasto that his paint could have at an earlier date.

After 1770, and especially between that year and 1790, Stubbs frequently used panels, the alternative obviously most like the supports used for the enamel colours, and he reduced the body of pigment to a very thin layer, relieved by slight and sensitively placed impasti. The chemistry of his painting was perfectly sound, for where the pictures have been well cared for and skilfully cleaned, the colour has kept its purity, the craquelure is not disfiguring, and none of that obtrusive decay has occurred which so rapidly affected the work of contemporaries less skilled in the craft or tempted by the brilliant effects temporarily to be achieved through bitumen or some opportunistic way of working. Stubbs's delicate substances, however, can float away or be damaged forever when solvents are clumsily used. He seems to have added a waxy, or resinous material to his pigments to retard their drying and although these did not, under normal conditions, adversely affect the work, they have left a hidden snare for careless or incompetent restorers. And as his later works depended so much upon minute refinements, many of

them have suffered, frequently losing their unity of effect. The artist's management of tone in both the modelling of form and the creation of atmospheric balance was so fastidious and the effects so delicately balanced that replacement of what has gone is almost impossible, for it demands a sensitivity which few, if any, restorers can command. That irreplaceable outer layer or bloom which can contribute such marvellous subtleties of colour and light and such delicacy of touch is now to be seen only in a small proportion of the surviving works, especially of those painted after 1770. This is the most serious consequence of a century and a quarter's neglect.[12]

The alliance with Wedgwood provides, through the potter's correspondence with his partner Bentley, almost the only account we have of the artist at work, a few concrete and dependable clues to his character, and, indeed, an objective view of his professional outlook. We can observe him during three months in 1780 pursuing the stern professional routine which he must have imposed upon himself throughout his life. He was occupied in the painting and firing of enamels, making—in oils—the large family group, painting a portrait of his host's father-in-law (Plate 93), decorating—as an experiment initiated by Wedgwood—some jars, modelling—as another commission—two reliefs (Plate 95), teaching the family perspective, spending some time away from Etruria fulfilling other commissions in the district, and plainly establishing his own resolute presence in the household of a man endowed like himself with uncommon determination and vitality. Wedgwood had previously declared his intention that the family should be represented in two group portraits, the male members in one, the female in another, but by his own later decision, or perhaps at Stubbs's suggestion, the two indoor pictures became a single outdoor composition. The potter was hard to please over the likenesses and the painting is not among Stubbs's successes; it lacks the freedom of touch and lucid characterization which is so impressive in, say, the Melbourne group (Plate 55). The men differed, too, over the subjects for the reliefs. As well as the *Horse frightened by a lion*, which had not been Wedgwood's suggestion, Stubbs proposed a version of his *Phaeton with the Chariot of the Sun* (Plate 95). 'I have objected to this subject as a companion to the frightened horse', wrote Wedgwood to Bentley, 'as that is a piece of natural history, this is a piece of unnatural fiction and indeed I should prefer something less hackney'd and shall still endeavour to convert him, but would nevertheless wish to have the Phaeton [an engraving after the subject] sent lest he should be obstinate in which case I think it will be better to have that than nothing.' It seems, from this, that Wedgwood had a shrewd apprecia-

tion of Stubbs's true gifts, and it was unfortunate that his argument failed to alter the painter's obstinate determination.

Earlier in 1780, Stubbs had at last been received into the Academy, elected an Associate, and in the following year voted to full membership. He refused, however, to supply the Diploma work required for the ratification of his appointment and, after three years, another artist was chosen to take his place.[13] There is no full explanation of the dispute to be found, but at the heart of the affair, no doubt, was Stubbs's displeasure at the treatment of the five enamels sent to the 1781 exhibition, where they were not hung according to his desires. The Humphry manuscript states '. . . he had the mortification to find that almost all his pictures were so unfavourably placed, particularly those in enamel and most of the quotations, the subjects of the pictures in the catalogue omitted, all of which conduct he considered as highly disrespectful to himself; and it was also very much resented by his friends, for whom the pictures were painted. This treatment he felt with particular sensibility and he still considers it as cruel and unjust, for it has tended more than any other circumstances could have done to discredit the enamel pictures and to defeat the purpose of so much labour and study, not to mention his loss of time and great expense.' One may assume that the friends mentioned would have been Isabella Saltonstall, whom he had painted in the character of Spenser's Una (Plate 97); the young man in the portrait reproduced in Plate 96, probably William Huth; and a lawyer, Richard Thorold, who commissioned the artist's self-portrait (Plate 86).

So, this decade, which had begun so inauspiciously, must also have brought with it a more significant phase of disappointment and insecurity. Stubbs did not exhibit in the three years from 1783 to 1785. He was moving into his sixties and, having failed to be considered as a history and portrait painter, must have felt, with justification, that the Academy could not serve his artistic interests. There is some negative evidence that he was painting less then and acquiring or seeking fewer patrons. The works of the period suggest a deliberate turning away from the ambitions so recently voiced to Wedgwood and show a renewed attachment to intimate or common subjects. There were fewer wild animals and horses under attack, and, apparently, no more endeavours in the way of history painting. Despite the discouraging circumstances, however, the quality of his art, above all its natural composure and control, was unaffected, and indeed some of Stubbs's most lyrical, tender and suggestive paintings belong to this time. It was the period of his best farming pictures; although the series had been initiated

earlier, in the 1760s, with a version of the subject he called *Labourers* (Plate 108), the current popularity of rural scenes prompted him, no doubt in a quest for recognition, to develop his practice further in this direction. The examples reproduced in Plates 100 and 103 will be considered later in relation to the prevailing taste. With their deliberate design they show the painter working in that extroverted vein which was the more typical expression of his art, but the Bearsted Collection contains other versions of the subjects which express the pastoral themes in a very different spirit. They look as if they were less consciously composed, the arrangement of the figures and their position in space suggesting an instinctive rather than a carefully reasoned process of creation. In the *Haymakers* (Plate 105) it is nearly evening and, as the workers fork the last of the load on to the mountainous stack already in the cart, the field and the hedgerows lie in a haze beneath the declining sun. Without nostalgia or sententiousness Stubbs seems, in these honest and touching pictures, to be forming a pastoral refuge for his feelings; indeed, I believe that these works remained with him in the studio until his death.

For a time in the 1780s some of his paintings included a type of landscape setting in notable contrast to the spacious, high-toned backgrounds which had normally contained his subjects. With a less indomitable man, one might confidently interpret the motif as a symbol of his unhappy predicament; certainly the deeply shadowed glades, the dark trees so formalized and loosely figured, served to dramatize the people and animals placed therein and give them an affecting loneliness. The result is most felicitous in the painting of an empty blue carriage, a park phaeton, drawn by two cream ponies under the care and contemplation of a stable-lad wearing elegant livery in a paler blue (Plates 90, 91). The owner's pride in this smart equipage could have been the inspiration for a bright, polished picture like the one Stubbs was to make a few years later, representing the Prince of Wales's phaeton with its portly coachman (Plate 120). Instead, the work has a more tremulous if equally confident touch, and breathes an elusive melancholy. It also provides an instructive example of the painter's unfailing sense of visual effect. The fidgety dog intensifies the quiet stability of everything else in the scene, and the carriage's elegant presence matches in vitality the behaviour of the living creatures standing with it.

During this period Stubbs was to apply himself to a technical discipline of the kind which so constantly inspired him by making a return to engraving and, no doubt, hoping also to improve his fortunes thereby.[14] In the plates for *The Anatomy of the Horse* he had already shown his mastery of etching, and

in 1777–8 had issued two wild animal subjects of no great interest in the same technique. Now he tried a different process, a mixed tonal method in which the mezzotint rocker was the chief tool; but he used the technique so experimentally that in places it is difficult to discover or describe exactly how a tone was achieved. Although in most cases he was repeating the subjects of paintings or re-creating pictures quite literally, these are not essentially reproductive prints; they are the independent creations of a true painter-engraver, artistically as complete as anything he produced, and as original in their technical character as Whistler's etchings or the aquatints of Picasso (Plates 108–114). If their present rarity can be treated as evidence, they were commercially a failure, for in some instances only a single impression is known, and until recent years they have been almost disregarded. In view of the fragility of oil pigments and the damage suffered by many of his later paintings, these prints help to confirm Stubbs's continuing mastery of tone and modelling. He must have taken as much care over inking the plates and printing the impressions as he gave to the work on the metal, for at every point in the tonal scale the greys are lucid, firm and exact. The print of two foxhounds on the scent is a fine example of his sophisticated sense of design, which could produce a kind of pictorial, and wholly visual, wit (Plate 112). This is an exercise in tonal counterchange and the agreement of shapes. The leaves of the statuesque burdock—a plant he so frequently painted—make a pale silhouette against the darker fields and sky, and are countered by the patches on the dogs' flanks, while the pendulous form of the foliage is repeated by the animals' ears. Even in a period when the sporting print was beginning to be a popular commodity, it was improbable that works of such refinement and originality as this example and the three separate engravings of single foxhounds would have been in demand (Plates 110, 111). The superb engraved versions of the farming subjects would then have been compared unfavourably with the colour prints after Morland or Wheatley.

The 1790s brought further disappointment. He was commissioned by the *Turf Review*'s publisher to paint a series of portraits depicting famous racehorses (Plate 123), both for exhibition and to be reproduced in mezzotint by his son, George Townley Stubbs, himself a most skilful engraver. Like similar enterprises in which other artists were later concerned, this scheme did not fulfil its sponsor's hopes, although it is impossible to say whether the sixteen pictures which Stubbs completed were all that had been planned.[15] The quality of execution in those which have survived shows no decline in his technical command, but there is a certain lack of spirit and the portraits do

not transcend their limited documentary purpose. If he still wished (as he had fifteen years before) to be emancipated from the routines of horse painting, the commission cannot have been very attractive except as a way of earning his livelihood in a difficult time. (See also Appendix III.)

The series was dedicated to the Prince of Wales, for whom Stubbs was then working on a group of commissioned subjects.[16] The pictures, which are still in the Royal collection, represent the Prince himself, friends or members of his household, some of his horses and dogs, deer in Windsor Park, soldiers of his own regiment (Plates 117, 119, 120, 122, 126). If one is justified in finding a certain introspective character in Stubbs's work of the 1780s, then the *Turf Review* paintings and those produced for his royal patron show a reversion to the more objective manner of the pictures produced in the 1760s, to which they are often closely similar in tone, colour and drawing. If it were not for dated inscriptions, only a very evident difference in *matière* plainly distinguishes a work of, say, 1763, from some of those painted thirty years later, for he was still applying his pigments under the influence of his practice in enamel, a technique to which he also reverted after 1790, following a lapse of several years. In terms of patronage, at any rate, 1790–4 was an Indian summer, a period comparable with the early years in London, when there must always have been a commissioned work in progress on his easel, but the circumstances were not as favourable as they might appear. The *Turf Review* pictures remained unsold and were still in his studio in 1806 with all those enamels known to have been made between 1791 and 1795. The scarcity of pictures dated after 1794, moreover, supports the tradition that he lived through his later years in financial difficulty and had to be assisted by his friend Isabella Saltonstall, who, at the end, had a lien upon much of his unsold work.

If one cause of Stubbs's poverty was a lack of gainful employment, another reason must have been the decision, made as early as 1795, to tackle the most ambitious project of his life, and one which could bring him neither money nor a profitable reputation in artistic circles. He began his comparative study of the anatomy of a man, a tiger and a chicken (Plates 133–137). Mary Spencer is reported to have said that he intended to extend his investigations into the vegetable kingdom. Like *The Anatomy of the Horse* this was a private and lonely enterprise, involving dissection, drawing, engraving and writing an explanatory text.[17] His death in 1806 prevented the work's completion, but the finished or surviving products of his study, let alone the research it entailed, were certainly enough to have occupied even a younger

man fully over a long period. By 1806 he had issued fifteen plates and written in an immaculate, steady hand about 250,000 words similar in composition to the text in the horse book. Part of the manuscript is in French, a language which, according to Humphry, he had studied in York fifty years earlier. At the turn of the century, Paris was the chief centre of comparative anatomical studies and he may have hoped that his work would be welcomed there. The English text of this commentary was published in 1817, but it has never been analysed or assessed in detail. It was, perhaps, too much of an eighteenth-century conception to have any influence in the nineteenth; apart from his innate enthusiasm for this sort of investigation and his own intellectual bent, Stubbs was probably guided by the scientific outlook and researches of John Hunter. What survives now, unaffected by scientific considerations, is the beauty and power of the plates and those preparatory drawings which were mysteriously to find their way before 1850 to Worcester, Massachusetts.

To the final hour Stubbs kept his physical and mental vigour and that commanding strength of will which for sixty years had sustained his inspiration and shielded him against adversity. (I have no reason to doubt reports that at 75 he would reach Watford on foot by 10 a.m. and that from Somerset Street the day before his death he walked nine miles.) On the morning of 10 July 1806, having put aside his work on the *Comparative Anatomy*, he sat in his chair and, declaring that he was going to die, soon did so as simply as he seems to have lived. It is not surprising that a man who had so consistently done what he intended should at this moment have regretted only that his last work remained unfinished. Especially in relation to artistic events, the span of Stubbs's life had been uncommonly long. When he was in York, Mercier was still working in that city; in the year that he died, Turner showed his *Goddess of Discord* at the British Institution. The course that Stubbs had followed between these two points had been mainly of his own choosing and he had traversed it with an independence of spirit unmatched by any painter in his time. Only Paul Sandby, among the eminent artists belonging to his generation, was still alive in 1806, and of the painters who had attended the Society of Artists' first dinner in 1763, Benjamin West, fourteen years his junior, alone had survived.

Moving from the meagre records of Stubbs's career to the ample evidence of his art, it is proper to begin where that life ended, with his activity as an anatomist, for this obsessive enthusiasm was at the heart of his entire achievement. It accounts, of course, for that visual curiosity and trust in perception

revealed so plainly in his pictures. It explains his concern with the structure of natural forms and his consistent pursuit of a lucid, unequivocal style. It is connected with his assured craftsmanship, for the practice of dissection required not only manual skill and mental discipline but the habit of concentrating and controlling his faculties. For him, I suggest, anatomical study provided the kind of intellectual training which in English circumstances the native painter, unlike his continental fellows able to enjoy a more demanding artistic apprenticeship, could not expect to obtain from the local resources of art. If we compare the anatomical drawings with the finest scientific illustrations by most of his predecessors and many of his contemporaries, it is their particular realism which still seems, in the historical context, so striking. In that purity of vision and direct, informed draughtsmanship, devoid of all stylistic ornament, which they share with the anatomical and botanical studies of Leonardo, the subjects neither demanded nor acquired picturesque additions. Another aspect of this realism is perhaps better conveyed by using the word superrealism, given that the subjects which confronted the artist so forcefully were, nevertheless, inert masses of bone and flesh and that by restoring the property of life, the drawings pass far beyond the limits of fact and scientific record to achieve the status of imaginative art. When picturing the foetus for Burton's treatise on midwifery, he rekindled the life of the being in the womb and, in recording his dissections of the horse or the chicken, he made the structures more comprehensible as well as more momentous by restoring the creatures' vitality.

It is not surprising, therefore, that *The Anatomy of the Horse* should have won such immediate acclaim and that the leading anatomist of the age, the Dutchman Petrus Camper, himself a draughtsman and connoisseur, should have written to him, 'I am amazed to meet in the same person so great an anatomist, so accurate a painter and so excellent an engraver.'[18] Carlo Ruini's *Dell'Anotomia, et dell'Infirmità del Cavallo* of 1598 had radically enlarged the knowledge of its subject, but Stubbs's book made a more spectacular visual advance (Figs. 1, 2). The illustrations have lost little of their original modernity and their qualities can hardly be distinguished from those of his paintings, the portraits of Whistlejacket or Gimcrack, for example; in both, scientific knowledge and artistic empathy are united.

Apart from their economic and competitive aspects, hunting and racing have been extensions of horsemanship, and early English sporting art was closely tied to the plates in the equestrian literature published throughout western Europe during the sixteenth and seventeenth centuries. The Duke

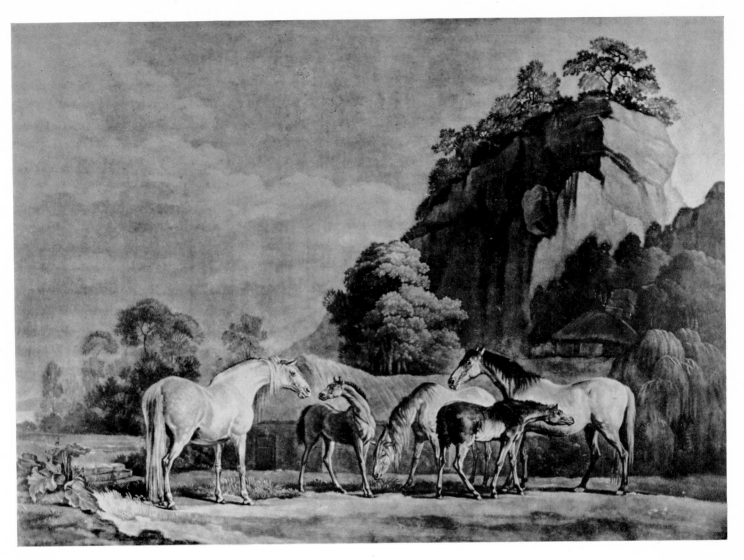

Figure 4. Benjamin Green, after George Stubbs: BROOD MARES. Mezzotint, published in 1768. The painting is in the Macclesfield collection

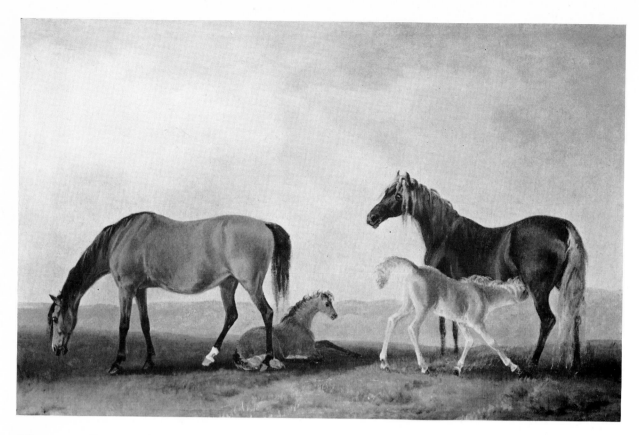

Figure 5. Sawrey Gilpin (1733–1807): MARES AND FOALS. 17 × 27½ in.
United States, Mr and Mrs Paul Mellon

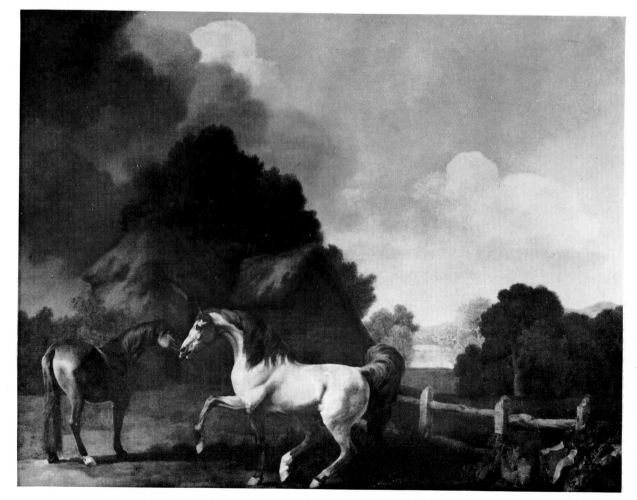

Figure 6.
George Stubbs:
JUPITER AND
A MARE. 1779.
37 × 48 in.
Sir Martyn
Beckett

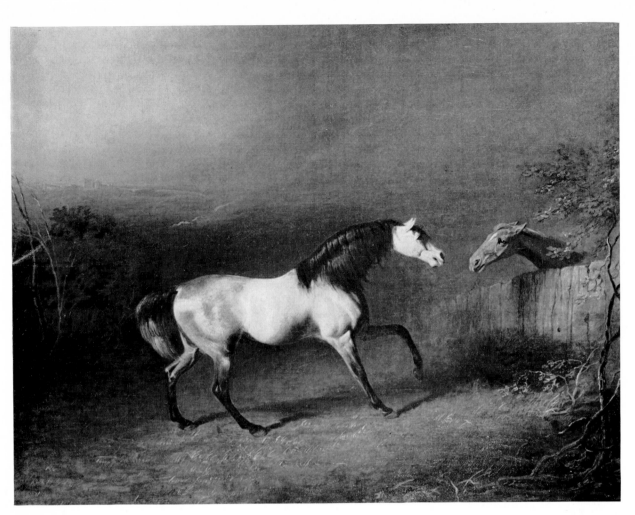

Figure 7.
Sawrey Gilpin:
GREY ARAB
AND A MARE.
1770–80.
Cambridge,
Fitzwilliam
Museum

Figure 8. James Ward (1769–1859): 'L'AMOUR DE CHEVAL'. 1827–8.
56 × 83 in. London, Tate Gallery

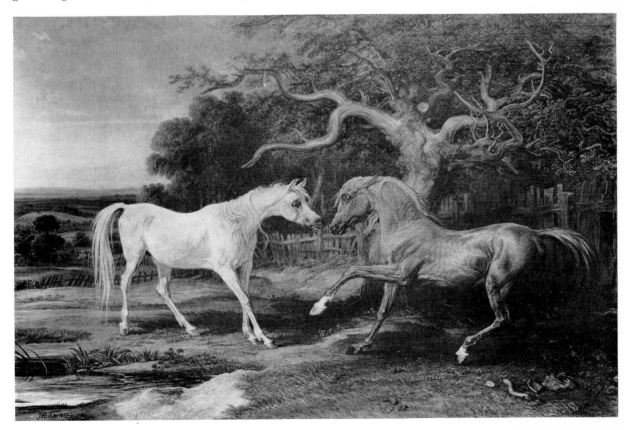

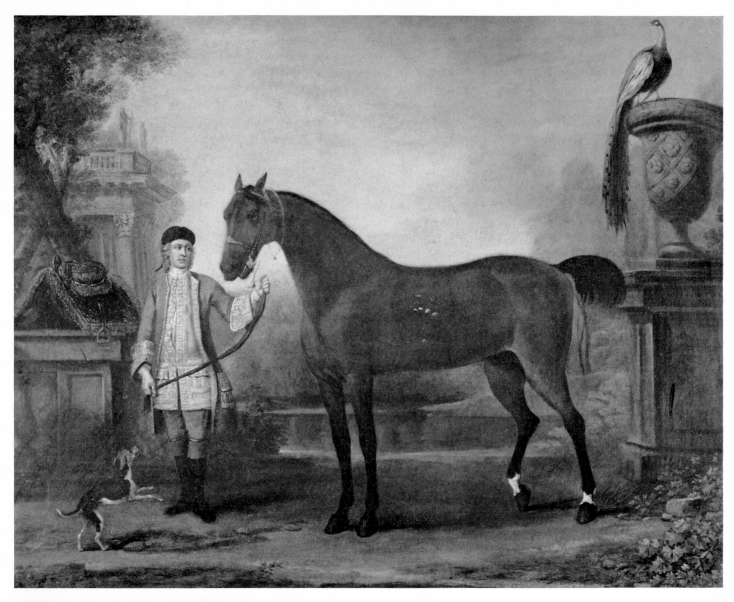

Figure 9. John Wootton (1686?–1764): THE DUCHESS OF BEAUFORT'S FAVOURITE HUNTER. 40 × 50 in. United States, Mr and Mrs Paul Mellon

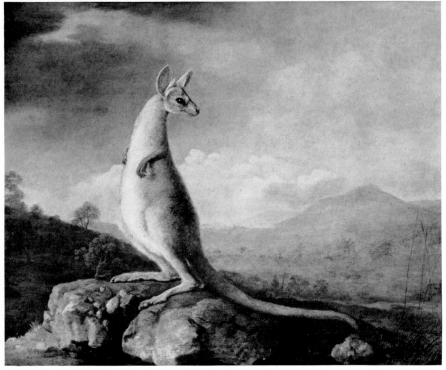

Figure 10. George Stubbs: KANGAROO. 1772–3. $23\frac{3}{4} \times 27\frac{1}{2}$ in. Sussex, Parham Park

of Newcastle's *A New Method to Dress Horses* (Fig. 3) was a characteristic and influential example of these books, and the engravings after Abraham van Diepenbeke undoubtedly provided an important source for painters not only here but abroad. The images of the horse appearing in such works were always formalized and sometimes crudely diagrammatic. The structure of the animal was clearly founded upon Ruini's *Anotomia* (or the less sophisticated publications by those who plagiarized his knowledge), formally regulated by certain honoured antique examples. John Wootton, relying upon pictorial models of this kind, composed hunting and racing scenes with some fluency and skill, but was clumsy and uncertain of himself when he had to serve the special English demand, growing in his lifetime, for those portraits of successful 'racers' which were required to record their particular appearance (Fig. 9). The horses he put into the backgrounds of some of his pictures were generally more convincing and alive than their chief subject, as were the animals in his hunting scenes, which could be freely invented. James Seymour, a more vigorous and interesting draughtsman than Wootton, is also reported to have had a closer connection with the sporting world, but he too was accustomed to transfer the conventional images from the equestrian treatises into the characteristic themes provided by English methods of hunting and racing. At Wilton House the relationship I have described can be readily studied, for there the equestrian paintings commissioned by the Earl of Pembroke from David Morier hang next door to a series of gouaches illustrating the management of the horse made by the eighteenth-century Austrian riding-master, Baron D'Eisenberg.

Within a year or two of 1760, Stubbs broke this stylistic mould and started to provide the same patronage with a new artistic experience and quite different standards of representation. By 1763 this work had closed the door upon the past and opened another upon the future practice in England of animal and sporting art which, from the 1770s, as racing and the field sports advanced in social importance, was to attract so many specialist painters. The compositions of mares and foals offer the most spectacular evidence of the change he introduced, but even the less ambitious works, such as that illustrated in Plate 38, presented an image of the horse which was not only to be a model in the future for the Marshalls and Ferneleys, but remained valid as long as any realistic style prevailed, for this is essentially the animal to be found in the work of Géricault or Degas, however differently they might use and interpret it. As Ruini's book had furnished the intellectual basis of horse painting for more than a century and a half, so Stubbs's

Anatomy marks a similar point of renewal.[19] His power to express the identity of the individual creature, an Eclipse or a Gimcrack, in a manner which was artistically so original was certainly the reason for his immediate success. His portraits were more eloquent than the images of the seventeenth-century Dutch *animaliers* with which they could, in their realism, be compared, and, as Whistlejacket or the noble equestrian group of the huntsman on his grey in the Grosvenor Hunt prove, they could, on any scale from the size of life to a few inches, have a nobility of form which would even then have been associated with a more elevated historical style. This was only a part of his current originality, for while accepting the established models of the English animal portrait, Stubbs abolished the conventional accessories which Wootton and others had crudely transferred from paintings of human subjects, the urns, broken columns and other architectural features of a decadent baroque (Fig. 9). The landscape and accompanying figures also had a new distinction and truth.

The compositions of mares, or mares and foals, form a splendid artistic monument to that particular English enthusiasm for horsebreeding which, like the taste for rural life, impressed foreign visitors at the time. There is no evidence about the origin of the series, but if the subject was suggested by an early patron—and either Grosvenor or Rockingham is the most likely candidate—the form, with all the visual sophistication which he brought to the interpretation of it, must have been his own idea. One example was exhibited as early as 1762 at the Society of Artists, although that particular work cannot certainly be identified; as soon as one version had been completed or shown, it was natural that other breeders should have wished to acquire something similar. We may assume that most, if not all, in the series were group portraits, not decorative designs suitable for a country house, and the painter used his natural inventiveness to give each one its individual character, organization and temper (Fig. 4). The nine versions known make a set of such deliberately composed variations that they invite a musical comparison, their differences being expressible in terms of rhythmical pattern and sequence, tonality and mood. The Tate picture (Plate 24) is inturned, peaceful and legato, while the one at Ascott (Plate 22) is more animated, open and strongly accented. The painting made for Bolingbroke (Plate 21) contains a small dramatic effect such as the others do not have, for a storm is in prospect; the angular composition of the frieze as well as the sparkling eyes of the horses suggest their nervous apprehension, which gives a particular vivacity to the group and is also expressed indirectly by the strong,

truthful contrast of leaden greys in sky and water, with the sharp, singing greens of the pasture. Indeed, in all but the Rockingham version, with its unfigured background, the landscapes not only, by their structure, support the arrangement of the horses but help to determine the particularity of each work. The picture of five foxhounds which Stubbs painted for Rockingham in the same period can be connected with the series, and there an imagined landscape of classical austerity and firmness makes an ideal setting for this elegantly severe conception (Plate 16).

The artist applied the pictorial inventiveness which he brought to these works just as effectively to the simpler horse portraits, whenever the commission allowed and within the limits set by this elementary kind of subject. The animal's posture or action, the behaviour and character of the human attendants, the type of landscape, the light, season, and weather conditions, were the variable elements which Stubbs treated with such inventive discrimination, especially in the 1760s and 1770s when his practice was secure and prosperously advancing. By the 1780s, however, he was, as already shown, seeking to change the nature of his practice. If this was one reason for the evident reduction in his sporting patronage, another is certainly that, by that date, the painting of animals and sporting subjects was developing a character very different in style and expression from anything that his gifts and inclinations could naturally provide. Stubbs's historical position is most ambivalent, for in terms of general influence his pictures of the 1760s were the source of so much that followed in the work produced by later generations of animal painters (Fig. 5), but, long before his own death, they also proved to have been a very atypical achievement within this particular tradition. While he was to have a host of artistic dependents, he had few notable imitators or followers; one of them, Sawrey Gilpin, was to show the advantages of having an adaptable style and outlook. These circumstances can be most easily studied in relation to hunting and racing subjects. Stubbs's few paintings of this type all belong to the 1760s, the *Racehorses exercising* (Plate 7) and the *Grosvenor Hunt* (Plate 11) being typical instances; they had made their predecessors seem crude and unsophisticated, but however appreciatively they may have been received at the time, they did not in the longer historical term really satisfy the expectations which the sporting artist had to recognize. They are not records of everyday happenings, even to the degree that Wootton's Newmarket scenes are, for essentially they are not images of events. Stubbs was never a documentary painter interested by the activity and spirit of an occasion, for he did not possess a talent for

pictorial narrative. The sporting artist was encouraged to develop this gift, however simply, just as the history painters of his time were predisposed and encouraged to create plausible reconstructions of historical events, ancient and modern, or notable scenes from dramatic and narrative literature. The wish to discover this degree of 'actuality' increased as the century advanced and, by 1800, had become an important criterion of artistic excellence. Ben Marshall's vivid racing pictures, the energetic foxhunting scenes by the elder Ferneley and the facile, journalistic drawings of Henry Alken, all these renewed the tradition established in the first half of the century more effectively than the comparable works by Stubbs, a greater artist, could ever have done.

The same condition applied to most of Stubbs's animal portraits; they were also to lose their earlier appeal in the last twenty-five years of his life, when the human relationship to all wild and domestic creatures was changing most profoundly. Here we have more specific evidence bearing upon the decline in the artist's reputation. There was the failure of the *Turf Review* series, which cannot wholly be explained by its sponsor's excuse that the war against France had created circumstances unfavourable to the project. A few years later Stubbs tried to sell at auction the watercolour versions of these horse portraits; only one found a buyer. The veterinary surgeon, Bracey Clark, visited the painter's studio six months before his death and reported that he had then 'complained heavily of the little encouragement he had experienced, even from those who were expending thousands, in one way or another, in their pleasure and sport with these animals'.[20] His complaint could only justifiably have referred to the last twenty years, for in the 1760s and some time thereafter, many of the most eminent sportsmen in England had supported Stubbs faithfully. If Grosvenor at one time spent about £7,000 a year on his racing activities, he also spent a considerable sum upon the employment of Stubbs. In 1809, in his book *The History and Delineation of the Horse*, John Lawrence, an ardent defender of the artist, noted that 'it had been lately discovered that Stubbs was merely an anatomist without any genius as a painter'.[21] Out of his own experience Lawrence defended Stubbs's ability to express the individual character of the horses he painted, the current view being that he made them all look alike.

As early as 1783, Thomas Gooch had exhibited six pictures devoted to the life of a racehorse, and nine years later he published a set of aquatints derived from them with an accompanying essay by a Dr Hawksworth, whose purpose was 'to excite a benevolent conduct to the Brute Creation'. This naïve series, an eighteenth-century *Black Beauty* in pictorial form, was a

sporting counterpart of Hogarth's modern moral subjects as well as anticipating those works by Landseer and Ward which were sentimentally to treat animals in human terms. In the 1840s Ward was to paint a sequence of horse pictures in which the animals were intended to display such emotions as confidence and depression. Without going so far in the direction of anthropomorphism, animal portraiture in the last two decades of the eighteenth century had moved towards a more overtly characterized and emotive style, very different in spirit and form from the cool, controlled detachment o Stubbs's art. The nature of the change can be illustrated by three works— by himself, Gilpin and Ward (Figs. 6–8)—which have the same subject, the encounter of a stallion and a mare. Stubbs renders the excitement of the male animal by quite unobtrusive and indirect means, by symbolic implication rather than realistic description. Storm clouds rising into a clear sky like the smoke from an erupting volcano repeat the erect plume of the stallion's tail, while the mare stands placidly apart, neither animal's head showing an excited expression. Gilpin, painting the same horse, Jupiter, treats the matter quite explicitly, bringing the two creatures face to face in lively confrontation. Thirty years later Ward not only intensified the physical action but used the resources of his vigorous technique to emphasize the situation; he called the picture '*L'Amour de Cheval*'.

At the time in his career when Stubbs's reputation had been so much overtaken by this change of artistic spirit and style he produced a work which, without any sacrifice of his identity and without borrowing the marks of a more romantic art, achieved an expressive force unmatched by any comparable work of the period. This was the life-size portrait of the racehorse *Hambletonian* (Plate 131), which he made for Sir Henry Vane Tempest in 1799. The fact that he had apparently attempted nothing like this for many years and the formidable, oppressive power of this far from ingratiating picture make it seem a masterpiece in the original sense, a work designed to prove mastery in a particular genre, as if the seventy-five-year-old painter was indeed offering a challenge to his contemporaries and to those who might then be inclined to question his powers. A comparison of this portrait with that of *Whistlejacket* (Plate 10), painted nearly forty years earlier, shows how much the qualities and resonance of his work had deepened with age and his testing experience of artistic practice.

Hambletonian had been matched at Newmarket against its foremost rival, Diamond, over a four-mile course. After a relentless duel and having been furiously whipped to victory by a short head in the last few strides,

Hambletonian was so exhausted that it never raced again. The event would have fitted Gooch's sentimental fable or provided for Landseer's excessive demonstrations of pathos. Stubbs's portrait embraces all the implications of the subject except any moral ones. It is the image of a creature enduring the aftermath of a terrible, almost sacrificial, triumph of which it has been the hero. It is a controlled and stable image of a convulsive animal, and one whose dramatic intensity was achieved within the terms of realism, without the rhetoric or expedients of an expressionist style or any exploitation of emotional signs. It is a purer statement of physical stress than he had earlier presented in the lion and horse pictures. He expressed Hambletonian's condition without departing from the identity of an animal, the horse, which he had studied forty-five years before at Horkstow. In its union of feeling, intellectual understanding and creative control, this is the most remarkable work of his life. The picture provoked a legal action but apparently no critical enthusiasm, nor the recovery of the painter's reputation. It is easy to recognize why its particular dramatic energy should have failed to touch or impress the public of 1800, who demanded more explicit and spectacular effects. John Lawrence[21] was to scorn those critics of Stubbs who had objected to a picture of bulls fighting because they wished the animals to behave with the picturesque ferocity of tigers. Fuseli, in view of his previous qualification that the style of Stubbs's animals depended entirely upon the individual before him, was surprisingly enthusiastic about his tigers, which 'for grandeur', he wrote, 'have never been equalled'.[22] The former statement, taken as a matter of fact rather than judgment, was quite apt, for Stubbs's treatment of wild animals was founded upon the same spontaneous curiosity as his approach to the horse and began almost as early, the portrait of a zebra belonging to Queen Charlotte being among the works he painted and exhibited during the first years in London.

Stubbs painted for Joseph Banks one of the kangaroos[23] which Banks, as a member of Captain Cook's first expedition, had brought back from Australia, and managed to make quite a convincing image, if one not accurate in every particular, from a stuffed or blown-up specimen (Fig. 10). His portrait of a rhinoceros (Plate 72) proves how confidently he would trust his observation, in this case disregarding what had become almost a convention, for the picture is probably the first account of the creature not strongly influenced, immediately or at second hand, by Dürer's splendid, fanciful print, which had presented it as if it were a giant reptile armoured with plates and scales. The beast was studied at Pidcock's menagerie in the Strand, the

commission coming from John Hunter, who obtained from the artist other animal portraits; and for Hunter's elder brother William, Stubbs painted a nylghau, a moose and some cavies. Warren Hastings, too, employed him to depict the yak which he had imported from India to his country estate. The earlier, life-size portrait of a cheetah (Plate 43) had been conceived in a grander form and style, suitable to the large aspirations and energetic personality of the patron, George Pigot, a rich, ambitious Governor of Madras, who, according to tradition, had presented the creature to George III. The gift was nobly commemorated, but the artist was not tempted to give his subject an unnaturally picturesque savagery.[24]

Agasse alone among the animal painters of the English school, illustrators apart, portrayed such a variety of wild beasts, and Stubbs's interest in them reveals his communion with the intellectual curiosity of a period when study of the living world was a particularly active part of scientific research and when the amateurs' enthusiasm for zoology was inspiring an abundant illustrated literature. Although the figures in these books were often crude or inexact, like the writer's understanding of taxonomy, the time had passed when a horse could share space with a unicorn, an elephant with a gorgon, as they had done in the most popular work of the previous century, Edward Topsell's *A Historie of Fourfooted Beastes*. European knowledge was being increasingly enlarged by the appearance of specimens, dead and alive, brought back by explorers and travellers from Africa, Asia and the Pacific. Collections of natural curiosities were beginning to be systematically arranged with a disciplined intellectual purpose. That development explains the commissions from John Hunter, whose museum was to have a most important place in the progress of biology and medicine, and who must have respected the painter not simply as a master of expressive realism, but for being an observer as exact and resolute as himself.

To regard most of the pictures depicting lions, tigers and leopards (Plate 39) as if they were portraits of the same type would be to neglect the animals' significance in the European consciousness. For centuries the great cats, symbolically or as captive, living specimens, had been the chief embodiments of the power and energy possessed by savage creatures. In either condition they signalled their owner's authority or valour (as heraldic usage indicates), typified strength and instinctive tenacity, or, when under human control, asserted man's command of nature. Their occurrence in art usually involved such associations, and Stubbs's pictures were probably the first works of the English school, apart from illustrations, decorative devices and

heraldry, which belong with this tradition of symbolism and imagery. In the history of art they exist between the late baroque works of Oudry, for example, and the animal painting of nineteenth-century romanticism found in Géricault, Delacroix or Ward; but Stubbs's vision of a lion or tiger is quite distinct from either, being influenced no less than other subjects by his intellectual objectivity and emotional restraints (Figs. 11–13). He regarded them like all other animals as having their own life and identity, sharing with man only a physical presence in the world. He obviously enjoyed their beauty and was disinterestedly responsive to their wildness, but if his paintings, as well as showing scientific curiosity, may also seem to imply the same enquiries that Blake put to *his* tiger, then the questions were coolly asked, without superstition or impassioned amazement.

Ward and Géricault were to find in the being and behaviour of wild animals an expression of their own emotional restlessness and quest for certain liberties; so, their images of a comparable kind, if not quite anthropomorphic, were as deeply interfused with human feeling as Constable's landscapes. An authentic clue to Stubbs's personality is the fact that in the years when he was most beset by adversity and frustration, he should, apparently, have abandoned the wild animal subjects which he had treated so numerously a short time before. That also applies to a third type of subject, showing animals in conflict or at bay: a lion killing a stag, frightening or attacking a horse (Plates 60–62). With these works he was again bringing for the first time into English art themes already used in continental painting and sculpture, which had their true sources in Hellenistic art. Like other Europeans, the English, besides following those ancient sports such as falconry which exploited the instinctive behaviour of predatory creatures, had arranged 'entertainments' which involved either baiting animals so as to provoke them into violence, or matching them one with another. Stow reports that in 1604 the lions in the royal menagerie at the Tower were contested with dogs to prove their temper and courage,[25] and animal fights were still being arranged in the eighteenth century. English painting, however, had not, before the 1760s, produced works which satisfied the same response as paintings by Snyders or Fyt. In the nineteenth century the advance of humanitarianism reduced the exploitation of animals, and those pictorial subjects which earlier offered a vicarious experience of brutal enjoyments came to have a different significance for artists and for their public. For Stubbs a lion savaging a horse was certainly a subject to exercise his command of form, but the theme would also enable him to prove something more

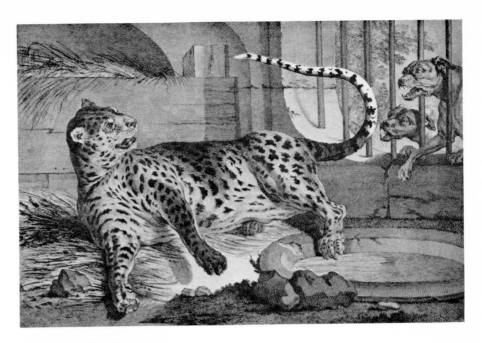

Figure 11.
After Jean-Baptiste Oudry
(1686–1755): 'LA PANTERRE'.
1739. Engraving by F. Basan

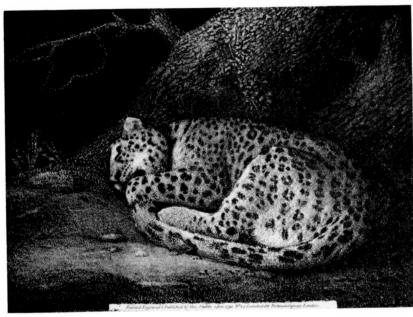

Figure 12. George Stubbs:
SLEEPING LEOPARD. 1791.
Mezzotint (mixed method).
$7 \times 9\frac{1}{4}$ in.

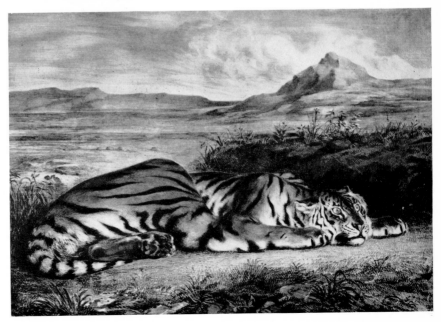

Figure 13.
Eugène Delacroix (1798–1863):
TIGRE ROYAL. Lithograph

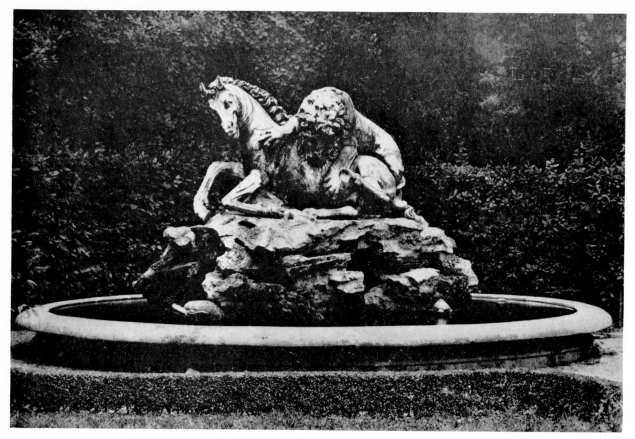

Figure 14. HORSE ATTACKED BY A LION. Roman copy of a late Pergamene original. Marble. 58 in. high. Rome, Museo del Palazzo dei Conservatori

Figure 15. Panini (about 1692–1765/8): Detail from a CAPRICCIO OF CLASSICAL SCULPTURES AND ARCHITECTURE. New Haven, Conn., Yale University Art Gallery

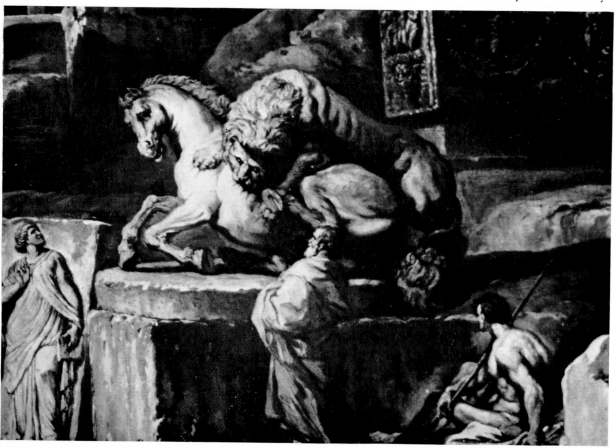

important to those connoisseurs whose opinion he could not afford wholly to disregard, and with some of whose ideals he might indeed have sympathized. It could support his claim to be 'considered' as an interpreter of dramatic themes. Here was an occasion for working in the mode of the Sublime, because a lion with its massive, physical nobility and fearful grandeur could be an equivalent of towering peaks and dark, awful chasms in the vocabulary of an ambitious landscape painter, offering a range of forms which would extend the artist's imagination, invite a suitably elevated style and, by association, evoke in the spectator a sense of heightened feeling. It is not surprising, therefore, that he should have repeated his lion and horse subjects so often in all the media he used or that the pictures should have been admired in his lifetime, engraved, and even treated admiringly for a brief period after his death.

The understanding of the lion and horse subjects has since been confused by two references which were for some years uncritically accepted and seemed to be complementary.[26] One is an anecdote included in the brief biography of the artist published by the *Sporting Magazine* in 1808, which stated that Stubbs was prompted by seeing such an encounter at Ceuta during his journey back from Rome in the 1750s. The other is the statement attributed to him by Humphry that he had gone to Italy to prove to himself that 'nature was and is always superior to art whether Greek or Roman, and having received this conviction he immediately resolved upon returning home'. As for the story, there is nothing to support an implausible explanation bearing all the marks of a conventional artistic legend; and it may be supposed that Stubbs's account of his early motives—assuming that Humphry recorded the remark fully and exactly as it was uttered forty years after the events mentioned—was prompted or at least influenced by the current state of his reputation, depending, as that did, so much upon the authoritative taste of those who worshipped antiquity as the source of everything artistically valuable and dignified. In fact, all the visual evidence compels the belief that he had been originally inspired by an antique sculpture, then famous, easily seen, and occasionally included in seventeenth- and eighteenth-century pictures (Figs. 14, 15). The marble, still in being and then in the courtyard of the Palazzo Senatorio, is a restored Roman version or copy of a Hellenistic original. Richard Wilson sketched the piece during his stay in Rome and put it into one version of his *Niobe*;[27] its influence had previously touched English art, for Scheemakers must have used it as a model, in making his sculpture of the same subject for General Dormer's park at Rousham in

the 1740s.[28] Stubbs was to interpret the original so freely as to change its expressive character as well as its forms and design.

He retained the collapsed position of the horse in only one of the examples known (Fig. 17); elsewhere the animal is shown standing and still defiant. By bringing the heads together, but more effectively by introducing the striking detail of the horse's taut, extended neck, he found a pictorial substitute for the sculptor's quite different rendering of physical strain and affliction. The original also has a centrifugal, 'baroque' composition, whereas Stubbs joined the two creatures into one closely unified mass, constructed planimetrically; by so doing he created an image which is pictorial rather than sculptural and does not seem merely to be a portrait of a famous monument, which is how it appears in certain works by Panini and Jan Weenix. He made the horse's mane stream out like a tattered ensign on a stricken man-of-war, using the motif both to emphasize the animal's distress and extend the group's dominant planes into the landscape. If his transformation of the original were to be reconstructed in three dimensions, it would become a high relief. Although he exploited his superior, anatomical knowledge for dramatic purposes, the Roman marble is a more realistic treatment of the event, for Stubbs not only formalized the physical elements of the contest but removed it from any world of conceivable actuality. The struggle occurs, noiselessly, in some remote continent inhabited only by the two antagonists.

He also composed a pendant subject which, when the pictures were in fact paired, provided some degree of narrative, for it shows the horse frightened by the lion in the moments before his attack. Here too the horse's attitude seems partly to have been derived from the same antique source, although there is another anecdote, reported in Humphry's manuscript, explaining the animal's posture by an event that Stubbs had seen. These works, several versions of which were publicly exhibited, certainly influenced other animal painters, such as Sawrey Gilpin, who quoted directly from the *Horse frightened by a lion* in his paintings and drawings of horses terrified by lightning or snakes, and, in various compositions, James Ward. A free treatment of the subject in the Louvre, generally accepted as being by Géricault, was probably based upon the mezzotint of 1769 engraved by Benjamin Green after a version of the *Lion attacking a horse*. In every case the later works show treatments of the violent theme very different from Stubbs's impassive images. They were made within the style which contemporary taste would have preferred for such subjects. Although his rigorously organized, 'classical' compositions were apparently respected, their language was unsuitable, either

by eighteenth-century standards or the prejudices of romantic taste. A younger artist, James Northcote, was to interpret animals fighting or hunting in exactly the approved manner when, by using Snyders's vigorous methods, he revived the Flemish mode (Fig. 16).

Stubbs's compositions, since re-assessed as early products of English romanticism, have also tempted some historians to put the artist within the orbit, at least, of Neoclassicism; and that idea might seem to be supported by other works such as the *Phaeton with the Chariot of the Sun* (Plates 94, 95) and a few more classical subjects known today only by their titles. His opinion, already quoted, that nature was always superior to art is not the most persuasive nor, indeed, the most important evidence to be set against that interpretation, granted that the remark might be treated as an old man's response to his prevailing reputation and not as the consistent principle of a lifetime. Certainly he did, according to Wedgwood, advise students to draw from nature rather than copy works of art, and one must suppose that this encouragement implied more than the study from life, which was anyway part of Academic training and apprenticeship. It is unthinkable that he would have accepted Reynolds's concept of a 'central form' of nature from which 'every deviation is deformity', or would have agreed that the investigation of this form (that is, the study of nature) is 'painful' by any interpretation of the word. Equally Stubbs's art is not to be defined just by some naïve concept of painting things literally as the eye observes them or of being enslaved by those particulars which nature visibly provides. Although in the 1760s especially there was abundant evidence of the 'low' style then associated with the Dutch masters and reminders of their common material, his vision was always subtly selective, and the compulsion to refine and simplify natural forms, a constant influence upon his art. This possessive instinct for abstraction, like his rational approach to design, was clearly not inspired by any current classicist theory, but answered the demands of his own nature, served the claims of expression and fulfilled a most individual sense of pictorial form arising from his sensitivity to visual effects. There is no reason, therefore, to believe that he experienced any vision of antiquity, or even to imagine that his scientific enquiries were coloured by any of those moral or philosophical considerations which influenced the Encyclopaedists and other conscientious intellectuals in an age of enlightenment. In England, more than anywhere else, the treatment of classical subjects, especially if the artist were an animal painter, need indicate nothing more than a desire for advancement within a profession still socially precarious and the hope of securing

prestige among his colleagues by showing both the will and the capacity to re-create resonant, time-honoured themes with a scholarly sense of the tradition to which they belonged. Stubbs was probably the first English animal painter of his kind to attempt this, in the *Phaeton* shown at the Society of Artists in 1762; he was followed in the same direction, as in other ways, by Sawrey Gilpin, who, in 1769, exhibited there a sketch for his *Election of Darius* (the King was nominated by his horse). The opportunity provided by Wedgwood to make a modelled relief of *Phaeton* did not lead to any more works of that kind, and Stubbs cannot have been closer to the world of Neoclassical taste than he was during the three months spent at Etruria.

The history pieces form the most elusive part of his work. Apart from the Phaeton, the following subjects are recorded, all of them being derived from the cycles of Hercules myths: *Hercules and Achelous, Nessus and Dejanira, The Judgment of Hercules* and *The Choice of Hercules.* Surely Stubbs's concern with this particular hero was not entirely due to the obvious pictorial suitability of his exploits; even if the motivation was partly unconscious it must have been determined by the course of his own labours and struggles. The surviving evidence about these works, however, is very slight and mainly unrevealing. The *Hercules and Achelous* was exhibited at the Society of Artists in 1770, the *Nessus and Dejanira* in 1772. *The Judgment of Hercules* and two studies for *The Choice of Hercules* (which may not have issued in any finished composition) were in his posthumous sale. The first-mentioned picture, now undiscoverable like the others, was at least until 1900 in the collection of Sir Walter Gilbey (who called it *Hercules and the Cretan Bull*). According to the entry in his catalogue the painting measured five feet by eight[29] and it may be supposed that the others were conceived on that scale. The year 1770 is certainly an indicative date for the showing of such a work, the only history piece apart from two by Mortimer appearing at the Society of Artists on that occasion, for Stubbs no doubt intended, in the second year of the Royal Academy's existence, to prove that he could successfully treat the kind of subject which fitted the highest ideals of that body and the aesthetics of its President. His subsequent complaint to Wedgwood and the absence from exhibitions after 1774 of any works of the kind argue that they had not been gratefully received, and after 1780 his ambition to be a history painter, whatever its original strength, seems to have faded.

Stubbs's failure to be seriously considered also as a portrait painter in his lifetime has largely persisted owing to the inaccessibility of his work, but his contribution to English portraiture is artistically remarkable. Throughout

his life he was consistently as interested in the human face and figure as in animals. There must surely survive more of the portraits painted in his twenties and thirties than the two Nelthorpe pictures (Plate 3), which alone represent that period today, although confident attribution would be difficult without the presence of a signature. To judge by the works mentioned they would have been made in the most prevalent style of the 1740s and 1750s, that plain masculine manner revealed in Hudson's *Admiral Byng* in the National Maritime Museum, for instance, and also adopted by such painters as Wright and Romney in *their* immature years, a style outdated by Reynolds's new portraiture before Stubbs came south. Confronted by the Indian servants in the cheetah painting (Plates 43, 45) or the commanding figure of Hambletonian's trainer (Plate 131), the only full-size full-lengths belonging to his mature years, it is tantalizing to imagine what large-scale portraits he might have created with his command of form and response to character if his practice had developed differently. Even in the adamantine medium of enamel, the head of Josiah Wedgwood (Plate 87) has the physical realism and strong characterization to be found in Allan Ramsay's finest male portraits, while the bust-length of Richard Wedgwood (Plate 93) shows a response to the spirit and physique of old age which is tenderly sympathetic without being sentimental.

The scarcity of Stubbs's work on this scale is redeemed by numerous small or incidental portraits which present the subjects in informal situations or, if they are artisans, at work. There are the conversation pieces, represented here by *Colonel Pocklington with his sisters* (Plates 57–59) and the *Melbourne–Milbanke* group (Plate 55), which belong to the tradition first given substance and quality in English art by Hogarth, but which are markedly distinct from his pictures or indeed from those by other successors like Devis and Zoffany. The smallness of Stubbs's figures does not involve a reduction in their physical presence or vitality for, like those of Chardin, they survive any enlargement, retaining their structural firmness and strong characterization. If these men and women show their private faces and are discovered in domestic ease, the compositions they inhabit are strictly organized, for it would not have been in Stubbs's nature to seek that fidgety informality which marks so many of Zoffany's portrait groups. The Pocklington picture was made when he was painting landscape in the grandest of his various styles, the scene being dominated by great trees with broad trunks and large, simple masses of foliage. In spite of its intimate details—one of the ladies is offering the horse a bunch of flowers—the figures are not overwhelmed by their

surroundings. The work is conceived, perhaps with a deliberate professional intention, in the spirit of Reynolds's Fane group of 1766, and maybe, having secured a large and eminent patronage, he was not only pursuing more commissions of the same kind but hoping for opportunities to work on the larger scale expected from the leading portraitists of the Royal Academy. The Melbourne group also has its own particular formality, for there Stubbs used the same design that he had developed in the mares and foals series, on a canvas with similar proportions.

Besides these elaborate and explicitly formal works there are simpler portraits, no less fastidiously organized, most of them dating from the 1760s and 1770s and illustrated here by *John and Sophia Musters* (Plates 82, 83), *The Duke of Portland with his brother* (Plate 37), *Sir John Nelthorpe out shooting* (Plate 68), and the gravely lyrical picture of a lady reading (Plate 54). In each case, while achieving a very elemental image, Stubbs formed a relationship between his subjects and their surroundings which provided the patron with a strikingly individual design as well as being responsive to their lives and recreations. There is also, in purely formal terms, a connection between figures and settings rarely found in English conversation pieces. The view of the Musters couple on horseback, taken from below, projects the woman's scarlet riding-habit brilliantly against the sky and expresses the hauteur of two self-assured people. Placing the horse's legs against the regular pattern of the architectural façade created a vigorous optical effect, reinforcing the sense of motion as the riders cross the scene. In the Portland picture the jumping posts not only provided a suitable context for the two sportsmen, but make an internal structure, a kind of space frame which holds together the composition's various elements. Nelthorpe, with his own acres around him, appears, silhouetted thus against the wide sky, as something more than himself: a representative of the country landlord, the man of property, master of his small domain.

In addition to these patrons and others, there is that large company of servants who attend the horses, the jockeys, grooms, stable-boys, most of them nameless but made individually as memorable as their social superiors by an intensity of physical characterization which Stubbs managed so effortlessly without contrived effects (Plates 42, 79, 91). These men could not have been more penetratingly observed if they had enjoyed social rank or intellectual repute and had paid a hundred guineas for their likenesses. Their working dress was treated as sensuously as if it were an expensive and fashionable costume. The metal and leather of the saddlery was rendered as something visually precious, and the actions of a jockey's hands and legs

were studied as scrupulously as the anatomy of his mount, for the painter was a master of the physical relationship between horse and rider.

Among the figure paintings are some which, like Hogarth's account of his servants, have a unique particularity. A comparison with Hogarth has sometimes been offered but Stubbs's portraits are less consciously characterized. There is the picture, commissioned by the Prince of Wales, of four soldiers serving in the 10th Light Dragoons, whose Colonel Commandant he was (Plate 117). Apart from its formal niceties and the expression, in the heads, of personal character competing, inside a uniform, with regimental anonymity, the design's severity perfectly conveys parade-ground disciplines and military routine. The Colonel Commandant could feel that the men, one of whom is presenting arms, were saluting him from his wall. (Was it the Prince's wit or the painter's, one wonders, which suggested the form for this picture?) To turn from this downright work of precise description to a strange, suggestive picture painted seven years later is to be reminded of the complexity of Stubbs's inner nature. The work shows the Earl of Clarendon's gamekeeper with a hound and a wounded doe (Plate 132). It was made within a year of the *Hambletonian* and although the figure is so much smaller, the man looks out upon the world with the same challenging gaze and air of self-possession presented by the trainer in charge of the racehorse. The artist must have been pleased with this mysterious creation for, apart from two versions in oil colours, he made a fine mezzotint of the subject, now extremely rare. The painting eludes all those categories into which most English pictures of the time were devised to fit. When exhibited, it was described as 'A park scene', but that title merely indicates the subject of a work whose deeper content is verbally inexpressible. The picture's nearest relatives in the history of art are, I suggest, those woodland scenes with animals and sporting figures by Courbet, which likewise evoke so much more than they represent and, by their departure from the traditions of sporting art, leave us unsure of the painter's latent intentions.

The farming pictures, which contribute another aspect to Stubbs's figure painting, had, in the 1780s, also asserted the independence of his vision. They were made during years when rustic subjects were especially fashionable, this being the time of Gainsborough's *Cottage Door* and similar compositions and of the more explicitly sentimental paintings by Wheatley, Morland, Bigg and Ibbetson, contrived to satisfy an urban or sophisticated taste for bucolic simplicities and innocence, as well as to exploit the fashionable qualities of the Picturesque. These confections not only attracted the same

popularity as rural ballads like *Sweet Lass of Richmond Hill*, but popularized conventions of form and feeling which were to imprison so much painting of country life for several generations. In these circumstances Stubbs might seem to have been quietly defying all the demands of the taste—not just the facile imagery which satisfied it but the pictorial manner which, with slight variations of emphasis between one exponent and another, was adopted by the most favoured artists. His men and women are individuals, not the 'rustic figures' which, in their character-parts, embodied virtues, humours and affecting poses; they are uncommissioned portraits of actual people, the companions of the jockeys and grooms. These countrymen, so serenely and seriously observed, were not actors in a repertoire of pastoral entertainments with sentimental or moral undertones, but the inhabitants of a wholly different form of artistic construction, which had no literary source or counterpart, for the separate subjects are not connected or individually designed to tell a story, imply emotional encounters or make some glancing social comment. Even in the *Labourers* (Plate 108), where the apposition of the figures may imply a slightly dramatic tension between them, there is no hint of past or future actions such as can be found in Dutch genre and they do not have the studied solemnity of the Le Nains' peasant pictures. Certainly the works do not belong to that range of eighteenth-century subject painting, already defined by Hogarth and Greuze, to which the rustic Picturesque in its various forms may be connected. They are proletarian conversation pieces, although that term probably suggests too much premeditation on the painter's part about expressing his way of regarding humanity and of translating human life into pictorial form.

The Humphry manuscript includes a description of the origin of the *Labourers* which helps to explain the particular objectivity of all these pictures: 'At Southill the Seat of Lord viscount Torrington he painted the celebrated picture of the labourers/Bricklayers, loading Bricks into a Cart – This Commission he recd from the Noble Viscount in London who had often seen them at their Labours appearing like a Flemish subject and therefore he desired to have them represented – Mr: Stubbs arrived at Southill a little before dinner where he found with Lord Torrington the duke of Portland and other Noblemen and Gentlemen. during dinner the old men were ordered to prepare themselves for their Labours with a little cart drawn by Lord Torrington's favourite old Hunter wch was used only for these easy tasks – for this being the first Horse his Lordship ever rode was the principal motive for ordering this picture——

'Mr Stubbs was a long time loitering about drawing the old Men without drawing anything that engaged them *all* so as to make a fit subject for a picture till at length they fell into a dispute abt the manner of putting the Tail piece into the Cart, wch dispute so favourable for his purpose lasted long enough for him to make a sketch of the picture Men, Horse and Cart as they have been represented. Thus having made the design as far as opportunity served he removed the Cart Horse and Men to a Neighbouring barn where they were kept well pleas'd and well fed till the picture was completed . . .'

To the same period as this early commission belong the four shooting subjects (Plates 47–52), which are, in character, so similar to the farming pictures. Gainsborough, among Stubbs's contemporaries, had inserted sporting figures into landscapes, during his Suffolk years, in the way of those Dutch painters by whom he was then much influenced, but these had been merely staffage. Stubbs's compositions still seem rather more original, and were at that moment peculiar to himself, although without further knowledge of their history it is difficult to be specific about his intentions. They show four characteristic episodes in a shooting expedition: the sportsmen's departure; firing at a partridge; reloading the guns; counting the bag at the day's end. Francis Barlow's prints entitled *Severall Wayes of Hunting, Hawking and Fishing according to the English manner* (1671) and the illustrations for Blome's *Gentlemen's Recreation* (1678) had previously described similar occasions and through the popular engravings by Woollett Stubbs's pictures certainly inspired the numerous groups of shooting scenes by Henry Alken, James Pollard and others. The Woollett prints embodied crude couplets referring to the times of day at which the events were happening and served to generalize the subjects, but Stubbs may have made the originals as a form of portraiture. The man in the light coat in the first of the sequence (Plate 47) is presented with his head turned towards us, and as a similar pose is not repeated this may have been the patron who commissioned the series. (It has been suggested[30] that another figure—and the same individuals do not appear together throughout the set—was the artist, but although there is certainly a likeness to him, this cannot be confirmed.)

In any event the landscapes also were carefully studied and composed; in one subject the place is identified as Cresswell Crags in Derbyshire. Although no pure landscape paintings apart from studies (Plates 33, 34) have been discovered, this part of Stubbs's visual interests needs to be considered separately and certainly not taken for granted. He did not derive his backgrounds from a limited and conventional stock of motifs, but painted scenery

in a range of styles which in its variety is matched among eighteenth-century painters only by Gainsborough. Plates 25 and 38 offer a fair sample of these variations. The manner and approach he adopted from one work to another was primarily influenced by the picture's main subject or at least deter- mined by some personal compulsion, rather than being suggested by the prevailing current of taste, although it is noticeable that for a time after 1767 he did introduce grander settings at a moment when the more sophisti- cated English art was in general aspiring towards an elevated style. The realistic or topographical manner which was predominant in the 1760s was to be revived thirty years later and even in the earlier period his inclination to be flexible in the use of a style is quite obvious. The Cheshire landscape in the *Grosvenor Hunt* (Plate 11) is as truthful in its expression of the local scene and of a diffused English light as any work of the eighteenth century, but in its free treatment of the details provides a suitably reticent background to such an elaborate design of men and animals. In the zebra portrait (Plate 56) he used an even looser version of the same style and so thereby formed a most effective contrast with the firm pattern of the creature's coat. In the *Huntsmen setting out from Southill* (Plate 41) the detailed topographical descrip- tion of the village street fitted both the commission and the painter's treat- ment of the figures and animals. For his lions and tigers he invented rocky lairs, and for monumental compositions such as the cheetah portrait or the largest version of the *Horse attacked by a lion* (Plate 60) he has settings with the scale and breadth of handling necessary to contain the animal's weight of form and powerful outlines. The scenery in the farming subjects of the 1780s is more loosely treated than it would have been twenty years earlier, but the sense of locality was, by different means, preserved, while at the same period he was also using those dark, formalized woodland settings which give a poignant and dramatic loneliness to the animals and figures inhabiting them. In spite of some suggestions to the contrary, there are only a handful of pictures where the landscape was put in by another hand, and in most of these cases the patron must have been responsible for the decision.

Although nearly all the material evidence is lost, the catalogue of the posthumous sale proved that in his studio Stubbs kept studies for every kind of subject as well as finished and sometimes coloured preparatory drawings for compositions. The Newmarket landscapes (Plates 33, 34) are the only examples of his oil studies known to survive; examined in connection with the pictures to which they were related, they show that he was accustomed to refine the original drawing and simplify what had first been minutely

recorded so as to exclude any details liable to weaken the planes or limit the vitality of the contours. Thus, in the ultimate work, the subject's individual elements, treated with a concentrated realism, were organized into a formal structure which was not determined by any quest for actuality or indeed by a naturalistic conception of time or space. An understanding of his work's character demands the most exact identification of this subtle balance of realism and abstraction; for that purpose, the portrait of Gimcrack is an ideal picture to study (Plate 32).

On the wide stage of Newmarket Heath—the landscape being a simplified and formalized enlargement of the oil study—the horse and its jockey appear twice: in the foreground, before the race, and in the distance, winning it. There are no spectators or bystanders, none of the minor figures which Marshall was to put so skilfully into his racing scenes to establish the mood of the occasion; the crowds which Wootton also had included in his Newmarket scenes are absent. Here the trainer and the stable-boy are necessary to the essential theme, and Stubbs obviously intended something more than a plain horse portrait. Indeed, I do not know any of his works which contain animals or persons rightly to be defined as staffage. The painting's open, apparently loose, structure conceals the composition's formality and the exact placing of its parts, while the vital realism of the horse and men obscures the essential artificiality of Stubbs's pictorial idea.

The cheetah portrait demonstrates the same intention, for it does not describe an actual or even an imagined occasion, although most of the ingredients to be found in such a sporting event are included. Instead, the creature's identity as a hunting animal is presented as if in a brief zoological thesis. Here is the cheetah with its scarlet hood and the sash used to hold it; here are the attendants responsible for its management, showing their traditional function; here is an example of its prey, by the standards of natural behaviour unnaturally close and unafraid; the landscape is unconvincing as hunting country, but its massive features are necessary to contain the weight of the animals and figures. The same cheetah may have been used by the Duke of Cumberland to hunt a stag in Windsor Park during the period when the picture was being made, but, if so, an occasion which other artists might gratefully have used as a suitable context for the portrait has been disregarded, in favour of a conception which wholly established its own artistic reality. The effect of a most dramatic image is achieved by the power of the physical presences, by qualities of design and by a gesture which has, nevertheless, little to do with the animals and their instinctive hostility. This work,

even more than the *Gimcrack*, expresses the most interesting artistic paradox offered by Stubbs's career; an intense commitment to the particular, combined with a command of generalization, not given in like measure to any of his English contemporaries. For Stubbs this ability and urge to generalize was not the operation of an entirely intuitive gift, not even the spontaneous working of instincts formed through a long and profound visual experience and study. A careful examination of his painting—including the *pentimenti* visible in some works—shows how deliberately he endeavoured to achieve his ends and how much his performance consistently demanded a reasoned calculation of method and effect. Hogarth, a man of similar independence, had, during the age of rococo ornament, discovered in his sinuous 'line of beauty' a source of formal grace and vitality, but there was a much older and more sophisticated pictorial geometry than that simple picturesque principle, the metaphysical mathematics concerned with intervals, linear proportions and regular geometric figures which had inspired, sometimes to a point of obsession, so many individuals in the Classical era, the Middle Ages and the Renaissance, affecting a great body of architecture and literature as well as painting. We may safely assume that Stubbs was, by temperament, no metaphysician or idealist, and anyway, the normal subjects of his art could hardly have been enriched in a spiritual or ideological way, by any Platonic grammar of divinely established relationships. It is equally certain, however, that in pursuit of his own purpose he did employ a deeply rooted pictorial geometry; he was probably the only English painter of the eighteenth century who did so consistently and with deliberation. Thus he applied to composition not just the simpler devices of academic practice, its stabilizing triangles and diagonals for example, but less obtrusive and more flexible principles of design. This essay is not the place for a detailed account of it, but his constant use of the most famous regulating proportion found in 'classical' design, namely the golden section, can be immediately discovered in the illustrations here by anyone with an eye for the ratio or possessing a pair of proportional dividers. Simply stated, he used it, as other artists from Piero to Seurat have done, to divide the breadth of a picture, sometimes its height as well, into harmonious parts or to stress thereby the focal points of a subject. In Plate 54 the focus of the composition, as of the girl's attention, is the book in her hand, which is placed exactly where golden sections of the canvas's length and height intersect. In the Fitzwilliam *Mares and foals* (Plate 20), visually the most dynamic point is at the muzzle of the third horse from the left, to which, as an area of maximum tonal contrast also,

the attention is immediately drawn. A vertical line drawn through that point, also passing through the tensely poised hoof below, would again be a golden section. In *Gimcrack* (Plate 32), the group which comprises the horse, trainer and stable-lad silhouetted against the building and forming one distinct part of the image is contained within a rectangle formed by the painting's vertical dimension and a line which is the golden section of the canvas's length.

It was natural for a man with Stubbs's interests and mental disposition to have worked so, because a painter who studied natural form in such depth and with such conviction, analysing so exactly the structure of a horse, a tiger or a chicken, investigating what John Hunter called 'the internal machine', would, like Leonardo and Dürer, have wished to give a similar order and coherence to what he himself created, to discover and declare some regulating principles by which to guide his practice and to exploit their effects. What remains mysterious and perhaps undiscoverable, however, is the source of a practice that he must have learnt or deduced from some part of a tradition no longer having a lively influence in the eighteenth century, and especially slight in England, where this mathematical ideology had even at an earlier date affected the pictorial arts so much less than literature.

This means of establishing points of focus and emphasis was all the more valuable in subjects which had no dramatic or narrative content and in which, otherwise, one feature was liable to be visually as important or impressive as any other. It was also a useful resource for an artist given to reducing every subject to its most essential components, expressed with economy of form. In an art of this character, quite insignificant details can have a peculiar importance. So, the line of direction formed by the barrel of Nelthorpe's gun is stopped by the pointer's rear foot placed on the work's central axis (Plate 68), while the direction established along the line of the dog's gaze and the carriage of its head is held at the edge of the canvas by a little distant building, serving as a full-stop in the subtle punctuation of this fastidiously designed picture. In *Gimcrack* the profiles of the roof gables on the two buildings, near and far, are of great effect in the composition, forming the diagonals in this panorama with its horizontal emphasis. The gables are placed not only in parallel but so that, if produced, two of them would connect with the separate figures of the same jockey, one walking towards the main horse, the other riding it in the distant race. In the portrait of Hambletonian, the scale and dynamic force of the convulsive animal are together so powerful that the trainer had to be more than a mere attendant; his physical

presence had to balance the horse. The fact that the man's gaze so magnetically commands our attention gives him a weight out of proportion to his size, while the curve of his shoulder and back matches the contours of the horse's hindquarters. Stubbs, in his anatomical studies, had measured and recorded with minute accuracy the dimensions of skeletons and must thereby have discovered by direct manual experience that internal order which determines the strength, order and free motion of the whole creature. The serene firmness, which is so characteristic of his work, was achieved as much by these structural refinements as by the control which his drawing imposed upon the diversities of nature.

In the *Grosvenor Hunt* (Plate 11) occur similar details which, in microcosm, express the very essence of Stubbs's vision and the nature of his artistic identity. At two points foxhounds jumping into the pond create a splash. The pattern which water-drops assume under such conditions are too fleeting for the unaided eye to apprehend: they would certainly have been physically invisible (and intellectually 'invisible' too) in an age before the camera had influenced human vision and when the true gait of animals was apparently beyond human perception. A comparison of the shape which Stubbs gave to this phenomenon with modern high-speed photographs proves his profound structural intuition (Figs. 18, 19). It would be impossible to say whether he was giving form to his incomplete visual experience or even to a mental speculation based upon it, or whether a deeply rooted sense of order, albeit with respect to something as insignificant as a scattering of pond water, was at work here in an instinctual manner. Either way, this minute part of a large and complex design epitomizes the qualities of the whole, for if one had to select a single work to represent his constructive gifts most fully, the choice could well be this masterly painting. As suggested earlier, it is not a description of an occasion but a picture about hunting, an elaborate generalization containing—if this does not seem too paradoxical a statement—a wealth of particular evidence. It was commissioned by the first Earl Grosvenor, and Stubbs, by various unobtrusive or, at least, unemphatic devices, gave this modest man a dominant position in the design. He is the only figure who directly faces the spectator. He occupies a space deliberately left open in the crowd of men and animals. He and his mount are placed above the quarry, a stag towards which the torrent of hounds is converging. His riding-coat is the strongest piece of colour in the work. The rider whose action is most dynamic is placed immediately next to him and seems to be indicating him with his whip. The foreshortened posture of Grosvenor's horse and its turning

in the direction of the other riders forms the point at which the two movements within the composition meet and are resolved, the right to left flow of the chase and the left to right line of direction marked by the attitude of the isolated huntsman and the inclination of the massive oak. And Grosvenor is placed along the vertical line of a golden section division of the canvas's width.

There is, of course, another detail of the picture which was given a prominence and emphasis similar to the portrait of Grosvenor, although for quite different reasons. That is the man in green mounted on his splendid grey, the huntsman and leader of the pack. In its vitality and rhythmical *élan* this equestrian group seems to evoke the summoning notes of the horn the figure is blowing, and thus becomes an evocative symbol of the Chase. The group's other function is compositional; its relatively larger size, the intense silvery brilliance of the horse's coat and the animal's decisive movement, diagonally turned into the picture space, provide a weight sufficient to sustain this side of the design against the advance of the other horsemen and the hounds.

In his great study of early Netherlandish painting, Panofsky has shown the double significance of that brilliant naturalism to be found in Jan van Eyck or Rogier van der Weyden and which seemed so marvellous to their contemporaries. A dog or a glass flagon of water exist there both as symbols and as common attributes of that ordinary world which these artists so precisely depicted. A similarly double-edged naturalism is to be found in Stubbs's art, especially in the work of the 1760s. Here, however, his sharp sense of actuality involves not symbolic references, but important compositional devices. In the *Huntsmen setting out* (Plates 41, 42) the spotted handkerchief used by the groom to leash his dog serves not only as a delightfully truth-giving detail but as a forceful note of colour in the design. A flash of sunlight reflected by a cottage window in the *Grosvenor Hunt* (Plate 11) gives the landscape an almost impressionistic vitality while again forming a constructive accent. In the Bolingbroke *Mares and foals* (Plate 21) some of the outlines of the horses' hooves are broken by delicate and botanically exact clusters of leafage, at once real and compositionally effective. It is indeed a mark of his rare mental and visual concentration that Stubbs should so consistently attend to such minute incidentals and calculate their pictorial effect.

It is hardly an exaggeration to say that the ultimate contemporary judgment of Stubbs's art was contained in Fuseli's remark: 'his skill in comparative anatomy never suggested to him the propriety of style in forms.' These words were written about ten years into the nineteenth century, an age when

47

the very concept of a 'propriety of style' was to become quite discredited as well as being irrelevant to the vital development of painting and to the free expression of the imagination. Most English artists of the eighteenth century who did observe the ruling proprieties or earnestly sought the opportunity to do so, are now significant, if at all, as historical entities or as the interesting victims of circumstance. They failed in the way indicated in Burke's injunction to an ambitious but ultimately frustrated James Barry. They were like Browning's 'high man', who 'aiming at a million, misses an unit'. And the artists who have since commanded the greatest respect and affection— Hogarth, Gainsborough, Constable, for example—are found among those who resisted or were sceptical of stylistic propriety. There are, however, more obvious paradoxes to be derived from Fuseli's comment than that and more important reversals to be found, also, of his typical judgment. As Turner is now the accepted English master of light and colour, Stubbs can be regarded as the greatest English exponent of form within a tradition which eighteenth-century taste had revered but from which it had excluded him; he now seems as well the most authoritative English draughtsman. His talent for pictorial design seems today effective and uncommon by being at once intelligent and free from the conventions of Academic practice, for the order which he conferred upon his subjects was so absolutely an expression of his own deepest consciousness both of nature and of art. His images of animals and figures now seem eloquent because their poignant reality comes from his response to them as individuals. In spite of a wavering desire to be considered as a history painter, he did not allow his gifts to be unprofitably diverted or his personality to be deranged by unrealistic ambitions.

It is instructive to compare his response to adversity with the reactions of Barry, Haydon or Ward, whose personalities were irremediably wounded by discouraging experience and by the destructive sense of rejection or non-fulfilment. Perhaps the most revealing fragment of evidence we have in respect of Stubbs's nature is the fact, already mentioned, that he should so frequently have chosen Hercules as the protagonist of his history pieces. One subject among these lost works, *The Choice of Hercules*, would have been derived from a once famous moral fable by the Greek philosopher, Prodicus. The choice to be made was between a life of labour and hardship, and a condition of ease. From the first day's work upon *The Anatomy of the Horse* to the last hours of his life, half a century later, Stubbs was faced by a similar alternative: to accept the dictates of his own intellectual curiosity and the artistic conditions which that curiosity imposed or to pursue his career under less

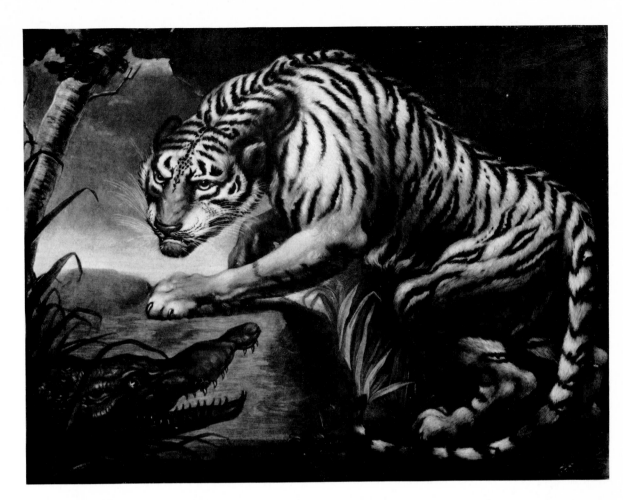

Figure 16.
After James
Northcote
(1746–1831):
TIGER
ATTACKED
BY A
CROCODILE.
Mezzotint by
C. Turner

Figure 17.
George
Stubbs:
HORSE
ATTACKED
BY A LION.
1762–5.
$27\frac{1}{2} \times 40\frac{3}{4}$ in.
London, Tate
Gallery
(on loan)

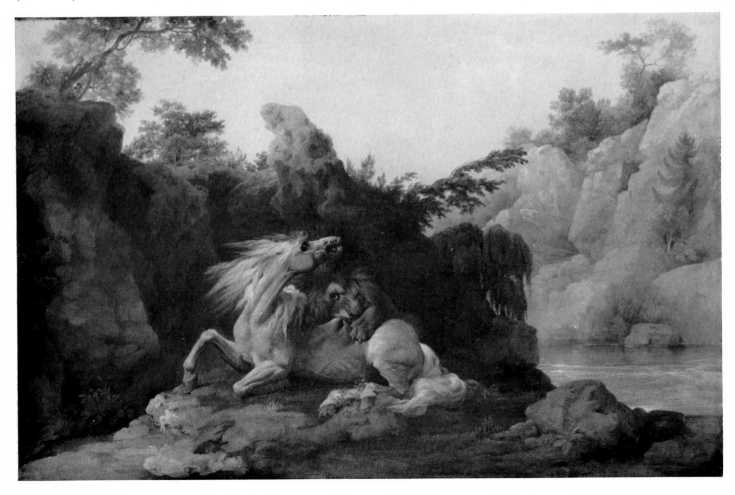

Figure 18. George Stubbs: Detail from THE GROSVENOR HUNT (see Plate 11). Trustees of the Grosvenor Estate

Figure 19. High-speed photograph of a splash. Photography by Bob Donaldson, Camera Press, London

arduous circumstances. We may be sure that he recognized the reality of such a choice, that he had an exact appreciation of his own talents and a secure confidence in his own powers which gives his work its affirmative strength. It was a final irony that when William Upcott obtained, probably from Mary Spencer, a description of the painter's death, he should have been impelled, on this private document, to modify the affectionate estimate of the artist's greatness. Even there the demon of faint praise pursued him.

Notes to the text

1. Stubbs is not mentioned in any of Ruskin's writings and Fry omitted him from the lectures he delivered on the occasion of the Royal Academy Winter Exhibition of British Art (1934), in which the artist was fairly represented.

2. In the Picton Library, Liverpool, are two copies of these biographical notes. One is in Humphry's hand and the other, essentially a transcript, was made by his natural son, William Upcott. This insubstantial document was the basis of the first two studies of Stubbs, both of which were published privately: Joseph Mayer, 'Notes for a Memoir of George Stubbs R.A.' [*sic*] in *Early Art in Liverpool* (1876) and in *Memoirs of Thomas Dodd, William Upcott and George Stubbs R.A.* (1879); Sir Walter Gilbey, *Life of George Stubbs R.A.* [*sic*] (1898).

3. *Letters of Josiah Wedgwood, 1772–1780*, 1903 (private publication).

4. *The Gentleman's Magazine*, 1806, p. 978.

5. The catalogue of Stubbs's sale is reprinted in Gilbey, *Life of George Stubbs R.A.*, pp. 190–206.

6. Stubbs's residence in the Piazza di Spagna is established by the parish registers of S. Lorenzo in Lucina, where his name appears in the census known as the Stato delle Anime. I am grateful to Mr Brinsley Ford for this reference.

7. This phrase occurs in a letter from Sir Thomas Frankland to Joseph Banks dated 12 March 1786 (Banksian correspondence, British Museum, Natural History).

8. *The Works of James Barry, Historical Painter* (ed. Fryer), 1809, Vol. 1, p. 88.

9. *Reminiscences of Henry Angelo*, London, 1830.

10. Evidence of Stubbs's association with Reynolds comes from two sources. The Humphry manuscript states that Reynolds was the first to commission a horse painting, and that he also acquired the original version of the *Phaeton*. The catalogue of the posthumous sale includes the following lot (First day, no 67): 'Portrait of the Managed Horse, originally painted by Mr Stubbs for Sir J. Reynolds'. If we may presume that this was the work mentioned by Humphry, that it was commissioned about 1759 and was painted in connection with a portrait, it seems likely that it provided the model for Lord Ligonier's charger in the picture of that sitter exhibited at the Society of Artists in 1761 and now in the Tate Gallery.

11. For a more detailed study of the enamels and a reprinting of that part of the Wedgwood–Bentley correspondence relating to Stubbs, see B. Taylor, 'Josiah Wedgwood and George Stubbs', *Proceedings of the Wedgwood Society*, No. 4, 1961, pp. 209–24.

12. The problems presented by the cleaning and restorations of Stubbs's works, especially those painted on panel, can only be slightly and most inadequately referred to here. My purpose is to draw attention to the dangers; it is to be hoped that before long some professional account of the technical problems and findings will be published.

13. Indicative evidence relating to this important episode in Stubbs's life comes almost entirely from his side, through the Humphry manuscript. He seems not only to have been offended by the treatment of his enamels, but also by the demand for a Diploma work. The fact that both Mayer and Gilbey in their writings on the artist called him R.A. probably derives from the appearance of the letters after his name in the Academy exhibition catalogue for 1805, but there is no evidence that he was ultimately elected to full membership.

14. Although seven of the prints were exhibited in London at the Vokins Gallery in 1885 and another seven included in the catalogue section of F. Siltzer's *The Story of British Sporting Prints*, the first appreciative mention of them was in G. Grigson's essay published in *The Harp of Aeolus*, 1947. The first complete showing of them was at the Aldeburgh Festival in 1969 and subsequently at the Victoria and Albert Museum. The catalogue of that exhibition, *The Prints of George Stubbs*, Paul Mellon Foundation for British Art, 1969, provides a detailed study by the

present author and illustrations of all the prints.

15. The catalogue of the *Turf Review* exhibition is reprinted in Sir Walter Gilbey, *Life of George Stubbs R.A.*, pp. 184–9.

16. For a study of the pictures commissioned by the Prince of Wales, see O. Millar, *Later Georgian Pictures in the Royal Collection*, Text vol., pp. xxix, 122–6.

17. The drawings for the *Comparative Anatomical Exposition* were rediscovered in 1957 in the Free Public Library, Worcester, Mass., where they had been for nearly a century. For a more detailed account of this work and of Stubbs's anatomical activities as a whole, see the catalogue of the Arts Council Exhibition, *George Stubbs: Rediscovered Anatomical Drawings*, 1958.

18. See J. Mayer, 'Notes for a Memoir of George Stubbs R.A.' [*sic*] in *Early Art in Liverpool*, 1876 (privately published), where the whole of a long letter from Camper to the artist is quoted (pp. 105–6).

19. As far as English animal and sporting art was concerned in the period between 1770 and 1830, Stubbs's early horse portraits and *The Anatomy of the Horse* had a very powerful and instructive influence. In another respect, and within a larger context, his concept and representations of the horse provide some of the most artistically distinguished evidence of the change then taking place in the treatment of the animal, a change from the conventions and formalities which had earlier prevailed to the realistic images which were to be normal in the nineteenth century. Another most important manifestation of the change is found in Pierre Falconet's equestrian sculpture of Peter the Great (executed in St Petersburg

between 1766 and 1778). Falconet in his treatment of the horse not only rejected the antique precedents, notably the statue of Marcus Aurelius on the Campidoglio and later examples based upon classical models, but articulated his objections in his *Observations sur la Statue de Marc-Aurèle*, which he published in St Petersburg in 1770.

20. Bracey Clark, *A Short History of the Horse and the Progress of Horse Knowledge*, 1824, p. 47.

21. John Lawrence, *The History and Delineation of the Horse*, 1809, p. 274.

22. Fuseli contributed the entry on Stubbs to the 1810 edition of the Rev. M. Pilkington's *A Dictionary of Painters . . .*, from which the remarks quoted are taken.

23. For further information about this picture see A. Lysaght, 'Captain Cook's Kangaroo', *New Scientist*, xxii (1957), pp. 17–23; P. J. P. Whitehead, 'Zoological Specimens from Captain Cook's Voyages', *J. Soc. Biblphy. nat. Hist.*, 1969, pp. 161–201.

24. For a longer account of the history of this picture see B. Taylor, 'George Stubbs's Cheetah' in *Art at Auction, 1969–70*, 1970.

25. J. Stow, *Survey of London*, 1764 edition, I, p. 123.

26. For a more detailed discussion of this series of pictures see B. Taylor, 'George Stubbs: The Lion and Horse Theme', *Burlington Magazine*, vol. cvii, February 1965, pp. 81–6.

27. See D. Sutton ed., *Richard Wilson, An Italian Sketchbook*, 1968, vol. 2, pp. 36–7.

28. For an illustration of this work see C. Hussey, *English Gardens and Landscapes 1700–1750*, 1967, pl. 218.

29. I quote from Gilbey's description of this picture (in *Life of George Stubbs R.A.*, 1898, p. 150) in the hope that this may assist in its rediscovery. 'Hercules, entirely nude, has seized the bull as he charged at him, and holds him by the horn with both hands, twisting the head of the furious creature in whose rough shaggy white face, fierce flashing eyes and foaming mouth are seen all the wild ferocity of the brute. The bull's back leg is thrust across the thigh of the heroic giant, and he lashes the air with his angry tail. The figure of Hercules is very finely painted, in tremendous action, with his left leg bent and planted firmly on a huge tortoise, emblematic of strength, while with his right leg stretched out, he has made his spring upon the bull and gripped him at once, without striking him with his club which lies where he has thrown it on the ground.'

30. W. Shaw Sparrow, *George Stubbs and Ben Marshall*, 1929, p. 21.

ADDENDUM. *Since this book went to press an early portrait — of a Mr James Stanley — dated 1755 has emerged. Its character and style accord with my observations on page 37.*

Lists of exhibited works

The following are the works exhibited by Stubbs at *The Society of Artists*, the *Royal Academy*, and *The Society for Promoting Painting and Design in Liverpool* under the titles given in the relevant catalogues. They have been included here to indicate the range of what Stubbs exhibited publicly in his lifetime. Any attempt to analyse their contents and consider their relationship to his known corpus is beyond the scope of this book. Those works which are identifiable among the pictures by the artist presently known are marked with an asterisk and, if reproduced here, indicated accordingly.

SOCIETY OF ARTISTS OF GREAT BRITAIN

1762	109	Phaeton
	110	A brood of mares
	111	A Portrait of a horse called Tristram Shandy*
	112	Its Companion, Molly Long Legs* (Plate 17)
1763	119	A horse and a lion
	120	Its companion (*A stag and hound*)
	121	The Zebra* (Plate 56)
	122	A horse belonging to the Right Hon. Lord Grosvenor, called Bandy from his crooked leg*
1764	110	Phaeton
	111	A Tiger and Lion
	112	A hunting piece (*The Grosvenor Hunt*)* (Plate 11)
	113	A Lion seizing a horse
	114	Brood mares and foals
	115	Antinous, a Horse belonging to His Grace the Duke of Grafton*
1765	126	Portrait of a hunting tyger* (Plate 43)
	127	Brood mares
	128	Portrait of a hunter
1766	163	Brood mares
	164	A lion and stag
	165	Two hunters, with portrait of a gentleman and dog
	166	An Arabian horse
1767	156	A nobleman on horseback*
	157	Two gentlemen going ashooting, with a view of Cresswell Craggs, taken on the spot* (Plate 48)
1768	165	Brood mares and foals
	166	Landscape with cattle*
	167	Two gentlemen going a-shooting* (Plate 47)

1769　　175　A tiger
　　　　　176　A lion devouring a stag
　　　　　177　Two gentlemen shooting* (detail, Plate 51)
　　　　　178　A horse and mare
　　　　　179　A gentleman and lady
　　　　　180　A cat

1770　　132　Hercules and Achelous
　　　　　133　A conversation* (Plate 55)
　　　　　134　A repose after shooting* (Plate 50)
　　　　　135　A lion devouring a horse, painted in enamel

1771　　153　A lion and lioness
　　　　　154　A lioness and tiger
　　　　　155　A horse and lion, in enamel*
　　　　　156　A portrait of the famous horse, Eclipse

1772　　301　The portraits of two Horses, Snap and Goldfinger
　　　　　302　The portraits of three colts*
　　　　　306　A den of lions*
　　　　　307　The Centaur, Nessus and Dejanira
　　　　　308　Hope nursing Love

1773　　314　A lion and lioness
　　　　　315　Portrait of a greyhound
　　　　　316　Ditto of a pointer
　　　　　317　Ditto of a horse turning to pasture
　　　　　318　Ditto of the Kongouro, from New Holland, 1770* (Fig. 10)
　　　　　319　Ditto of a large dog
　　　　　320　Portrait of a gentleman on horseback, with a dog
　　　　　321　Ditto
　　　　　322　A Landscape, a farmyard with cattle
　　　　　　　　Two views of the Torpedo, male and female
　　　　　459　A hunting piece

1774　　269　Portrait of a horse

ROYAL ACADEMY

1775　　301　Portrait of a horse, named Euston, belonging to Mr Wildman
　　　　　302　Portrait of a Pomeranian dog, belonging to Earl Spencer*
　　　　　303　Ditto, a Spanish dog belonging to Mr Cosway
　　　　　304　Portrait of a monkey

1776	293	Tigers at play*
	294	Mares and foals
	295	Portrait of a dog
	296	Ditto

1777	298	Portrait of a horse
	299	Ditto dog
	300	Ditto two dogs
	301	Portrait of a gentleman preparing to shoot*
	405	Portrait of a dog
	406	Portrait of a dog

1779	319	Portrait of a mare and dog
	320	Ditto of a dog
	321	A gentleman on horseback
	322	Labourers

1780	110	Portraits of horses
	137	Portraits of two heifers
	176	Portraits of hunters
	183	Portrait of a dog
	191	Portraits of figures and animals
	326	Portrait of a horse

| 1781 | 17 | Two horses: in enamel |

1782	32	Portrait of a dog
	70	Portrait of a young Lady in the character of Una, from Spenser's Faerie Queen* (Plate 97)
	79	Portrait of a young gentleman shooting* *Enamel* (Plate 96)
	120	The Farmer's Wife and Raven (Gay's Fables)* *Enamel* (Plate 99)
	173	Portrait of an artist* *Enamel*
	209	Portrait of a very old horse and dog*
	363	Portrait of a dog *Enamel*

1786	77	Reapers* (Plate 100)
	94	Haymakers (Plate 103)

1787	83	Fighting bulls*
	95	Fighting horses*
	126	Portrait of a hunter

| 1789 | 32 | Carrying of corn |

1790 112 Portrait of the Lincolnshire ox, now to be seen at the Lyceum, Strand*

1791 7 A Pomeranian dog
 91 Portrait of His Royal Highness the Prince of Wales*
 275 A shepherd's dog, from the South of France
 391 A buffalo

1799 41 A trotting horse
 177 A monkey* (Plate 129)

1800 222 Hambletonian beating Diamond at Newmarket
 744 Hambletonian, rubbing down* (Plate 131)

1801 120 Portrait of a mare, the property of the Earl of Clarendon
 175 A park scene at the Grove, near Watford, Herts, the seat of the Earl of Clarendon*

1802 208 Portraits of two horses and dogs, in the possession of G. Townley Stubbs
 866 Portrait of an Indian Bull, in the possession of the Earl of Clarendon

1803 183 Portrait of a Newfoundland dog, the property of his R.H. the Duke of York

 THE SOCIETY FOR PROMOTING PAINTING AND DESIGN IN LIVERPOOL

1787 Reapers
 Haymakers

A critical note on the Stubbs literature

HOWEVER FRAGMENTARY and imprecise it is, the basic primary source for the student of Stubbs remains the Humphry manuscript in the Picton Library, Liverpool. Evidently formed from conversations with the artist, it is little more than a collection of biographical facts (mainly confined to his first thirty-five years, his enamel experiments and relationship to the Royal Academy), random anecdotes and references to individual works, with an occasional quotation from Stubbs's opinions. It has yet to be published in full or critically analysed in detail.

The only other contemporary written source which is significantly informative is a group of letters containing references to the painter written by Josiah Wedgwood to his business partner, Thomas Bentley, between November 1777 and December 1780, that is, before and during Stubbs's visit to Etruria. This correspondence was originally published in *Letters of Josiah Wedgwood, 1772–1780*, printed for private circulation in 1903. It was reprinted as an appendix to a paper read to the Wedgwood Society by the present author (see below).

After Stubbs's death and the appearance of several relatively uninformative obituaries, the first account of any substance to appear was an essay by Joseph Mayer, based narrowly upon the Humphry manuscript, which he formerly owned and bequeathed with other Stubbs material to the Liverpool library. His essay— *Notes for a Memoir of George Stubbs R.A.* [*sic*]—appeared in two privately printed volumes: *Early Art in Liverpool* (1876) and *Memoirs of Thomas Dodd, William Upcott and George Stubbs R.A.* [*sic*] (1879).

In 1898, Sir Walter Gilbey, the most assiduous and resourceful of all the Stubbs collectors, published, again privately, his *Life of George Stubbs R.A.* [*sic*]. In so far as Gilbey was a student of English animal painting as a whole, his book went considerably beyond the limits of the Mayer essay without greatly enlarging the available view of Stubbs's life and art. Unfortunately he seldom declared the sources of his evidence. There is, for example, in Chapter X a quite detailed account of the artist's house in Somerset Street, but he does not declare the identity of his description—evidential or speculative—or refer to any source for his statements; so, it is unusable. At the present date, the chief value of the book lies in the various documents which he reprints with an acceptable degree of accuracy: the catalogue of the artist's posthumous sale; the prospectus of the *Turf Review* series; a list of the works exhibited at the Society of Artists and the Royal Academy; the catalogue of the important exhibition held at Vokins's Gallery in 1885. Gilbey's incomplete and selective catalogue of pictures still has some value, although I have found to my cost that he is not always to be followed on those matters, such as the colour of a horse's coat, where his sportsman's guidance would be respected.

The next conscientious student of the painter, regarding him from a vantage-point similar to Gilbey's, was Walter Shaw Sparrow, whose main writings on Stubbs are to be found in: *British Sporting Artists* (1923); *George Stubbs and Ben Marshall* (1929); *A Book of Sporting Painters* (1931). Apart from his enthusiasm, his main achievement was to enlarge the biographical material, mainly through antiquarian study and knowledge of sporting matters.

In 1938, Geoffrey Grigson published in *Signature* an essay, based upon shrewdly inquisitive research, which not only showed literary skill and an acute visual perception but a sense of relationship and a critical sophistication not previously applied to this artist. It remains, thirty years later, the appreciation first to be recommended to any enquirer.

Since 1945, and on the way to a larger book, the present author has published several limited catalogues or studies of particular subjects. Since their appearance most of these have had to be modified or corrected through later work; the reader is warned, therefore, to treat them with reserve. The examples currently most useful are: catalogue of the Arts Council exhibition, *George Stubbs: Rediscovered Anatomical Drawings from the Free Public Library, Worcester, Massachusetts* (1958); 'George Stubbs: The Lion and Horse Theme', *Burlington Magazine*, CVII, pp. 81 ff; 'Josiah Wedgwood and George Stubbs', *Proceedings of the Wedgwood Society*, No. 4, 1961, pp. 209–24 (with a summary catalogue of the known and recorded enamel paintings); catalogue of the exhibition 'The Prints of George Stubbs', Aldeburgh Festival and Victoria and Albert Museum, 1969, Paul Mellon Foundation for British Art (a catalogue of all Stubbs's known or recorded prints); 'George Stubbs's Cheetah', in *Art at Auction, 1969–70*, Sotheby & Co; catalogue of the exhibition 'Stubbs in the 1760s', Thomas Agnew & Sons Ltd, 1970.

The catalogues of the following collections are also useful: Oliver Millar, *Later Georgian Pictures in the Royal Collection*, 1968 (Phaidon, London & New York); the catalogues of the three exhibitions of pictures from the collection of Mr and Mrs Paul Mellon as follows: 'English Painting 1700–1850', Virginia Museum of Fine Arts, 1963; 'Painting in England, 1700–1850', Royal Academy Winter Exhibition, 1964–5, and thereafter at the Yale University Art Gallery, 1965.

The bibliography of Stubbs's *Anatomy of the Horse* is too large and specialized a problem to be treated here, but the three posthumous reprints of it should be mentioned. The first was almost certainly printed from the original plates, the others being facsimile editions; in every case the illustrations have been folded to fit into an upright folio.

(i) Published by Henry G. Bohn, York Street, Covent Garden, London, 1853 (Stubbs's text and plates only);

(ii) Published by Seeley Service & Co Ltd, 1932 (with a modern veterinary paraphrase by James McCunn and C. W. Ottaway);

(iii) Published by J. A. Allen & Co, London, 1965 (with the same modern veterinary paraphrase as the previous edition, additional notes by James McCunn and Constance-Anne Parker, and twenty-four illustrations of the related drawings in the Royal Academy Library, many of these plates showing a crude trimming of the drawing).

The 'Turf Review' portraits

ALTHOUGH THIS ENTERPRISE was not artistically very fruitful, it was an important episode in the painter's life and as ambitious a project as any in which he was engaged.

The scheme was initiated, probably in 1790, by the sporting periodical *The Turf Review*. Stubbs was due to be paid £9,000, but how much of this he received cannot be determined. George Townley Stubbs was apparently to be the engraver of all the paintings by his father. The gallery, in Conduit Street, was opened to the public on 20 January 1794, when pictures of the following subjects were on view: the Godolphin Arabian; Marske; Eclipse; Dungannon; Volunteer; Gimcrack; Mambrino; Sweetbriar; Sweet-william; Protector; Shark; Baronet; Pumpkin; Bandy; Anvil; and a painting of three colts, including one called Gnawpost. Engravings of all these works were published and in most cases are not uncommon. The most revealing account of the enterprise was published in *The Sporting Magazine* of January 1794 and is reprinted here:

Description of the pictures now exhibiting at the Turf Gallery, in Conduit-street painted by G. Stubbs, R.A., [*sic*] for 'the Turf Review' work to be published by subscription, and delivered periodically.

Dedicated by Permission to his Royal Highness the Prince of Wales.

This singular publication will be embellished with beautiful engravings, and present a complete and accurate Review of the Turf, from the year 1750, to the present time, under the direction of Messrs G. and G. T. Stubbs. Mr Stubbs, in his introduction to this curious undertaking, has the following address:

At a period when protection is daily solicited for embellished editions of various authors, it may be deemed extraordinary to submit one of a different cast to the public consideration, where the chief merit consists in the actions and not in the language, of the heroes and heroines it proposes to record, and with whom, possibly, literature may exclaim: 'She neither desires connection, nor allows utility.'

As such an history of an animal peculiar to this country, the horse surely may put in its claim to general notice; and although the numerous volumes of Cheney and Heber, downwards, may give critical knowledge to the diligent and deep explorer, they certainly do not impart sufficient information to a superficial observer; yet both may regret that there is not a regular series of paintings and engravings of these horses, with their histories, which have been, or are now, famous.

It is therefore proposed to publish, by subscription,

A REVIEW OF THE TURF

or an accurate account of the performance of every horse of note that has started from the year 1750 to the present time; together with the pedigrees; interspersed with various anecdotes of the most remarkable races; the whole embellished with upwards of one hundred and forty-five prints, engraved in the best manner, from

original portraits of the most famous racers, painted by G. Stubbs, R.A. at an immense expense, and solely for this work.

CONDITIONS

I

Upwards of one hundred and forty-five subjects, either the portraits of some favourite horse, or representation of some remarkable match or sweepstakes, will be printed.

II

The whole to be published in numbers, each containing three capital prints, *twenty inches by sixteen*, in addition to three smaller, engraved from the same subject, as embellished to the letter-press, which will consist of three sheets.

III

An elegant house is open in a central situation, under the title of the 'Turf Gallery', to which subscribers have a free admission.

IV

Each subscriber to pay TWO GUINEAS per number, ONE GUINEA to be paid at the time of subscribing, and ONE GUINEA on the delivery of the number.

V

On delivery of the first number, one guinea to be advanced for the number immediately following.

VI

The whole to be contained in forty numbers, at all events not to exceed forty-five.

VII

A beautiful engraving of THE GODOLPHIN ARABIAN will be presented to subscribers *gratis*, as a frontispiece to the work.

VIII

The plates when printed off, will be scrupulously delivered in the order they are subscribed for; so that the EARLIEST SUBSCRIBERS will consequently have the best impressions.

IX

ONE HUNDRED PROOFS will be taken, at four guineas each number. . . .

Following descriptions of the portraits, *The Sporting Magazine* appended a further announcement from Stubbs as follows:

Repeated applications having been made to Messrs Stubbs to form some mode by which the public in general might be accommodated with such favourite subjects of

THE TURF REVIEW

as they may choose without subscribing to the whole of the work, they have for that purpose adopted the following plan:

	£	s	d
Subscribers to the whole work, per number ..	2	2	0
Subscribers to the work with small prints only ..		18	0
A single number complete to a non-subscriber ..	2	12	6
A single ditto, with small prints only to ditto ..	1	1	0
Single large prints, each		15	0
Single small prints, each		6	0

There is no evidence that the scheme advanced any further than this and no information about the subjects of the other works mentioned in the advertisement. The contemporary explanation for its abandonment was the outbreak of the war with France and its financial consequences. Other reasons, however—the sheer scale of the enterprise and the decline in Stubb's reputation—may also have contributed to the failure. Such a project, although uncommonly ambitious in its scope, was by no means original in its purpose, for earlier in the century various sets of horse portraits had been published, engraved after paintings by Wootton, Seymour, Spencer and James Roberts. The idea was later to be taken up by Herring in his series of Derby and St Leger winners.

Plates

The order of the plates, having been influenced by considerations of design and production, is not strictly chronological, but with few exceptions the works belonging to a particular decade have been grouped together; in Stubbs's case the decades, at least from 1760 to 1800, happen to have a biographical, historical and stylistic significance.

The captions provide dates where these are established by the inscriptions or can be deduced from historical or stylistic evidence. The following conventions have been adopted: 'Dated 1770' means that the picture bears that date; '1770' means that persuasive evidence exists to establish that precise date; '1770–2' indicates that the work was probably executed during those years. Details of signatures, dates and other inscriptions are given in the notes to the plates (see page 205). Measurements are given in inches, height first. Unless otherwise stated the pictures reproduced are paintings on canvas in oil colours.

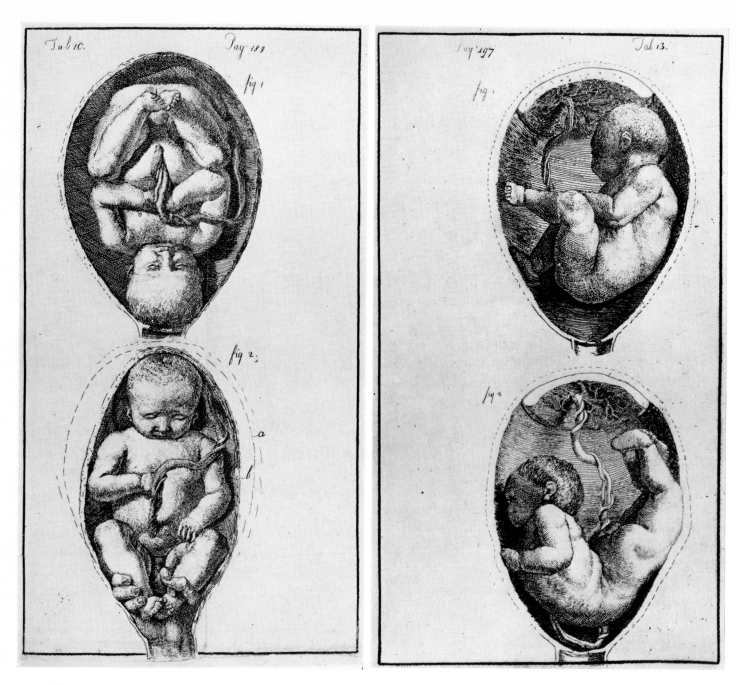

1, 2. Two tables from Dr John Burton's *An Essay towards a Complete New System of Midwifery* . . .
$7\frac{1}{2} \times 4\frac{1}{8}$ in. Etchings. Published 1751

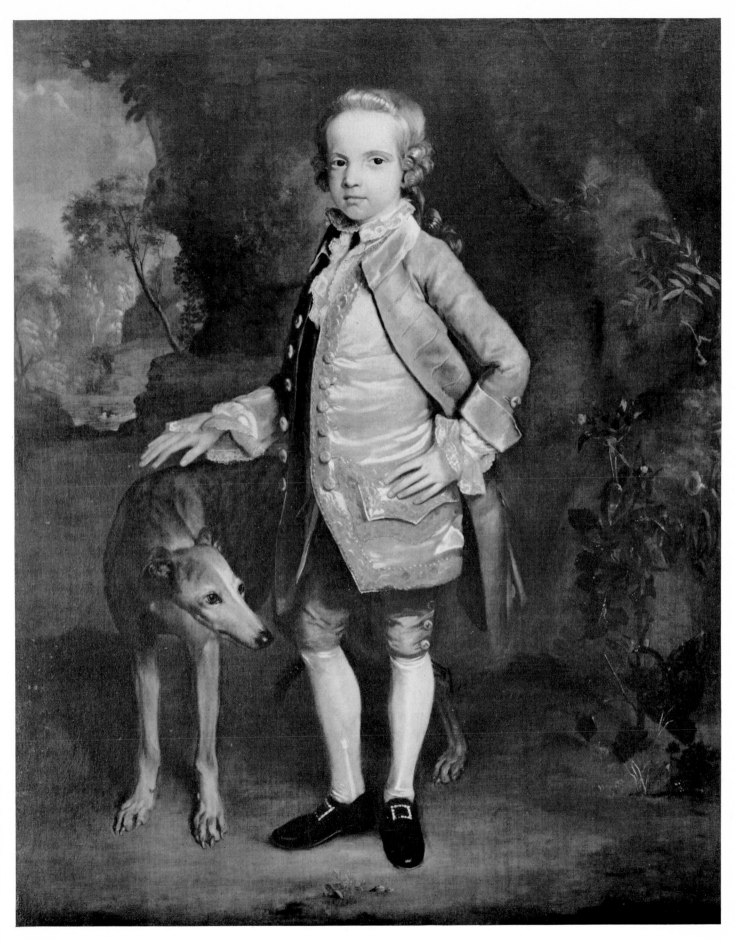

3. JOHN NELTHORPE. 1755–8. 40 × 50 in. Private Collection

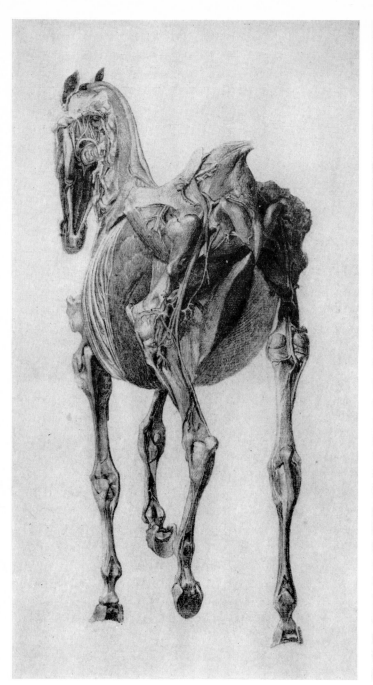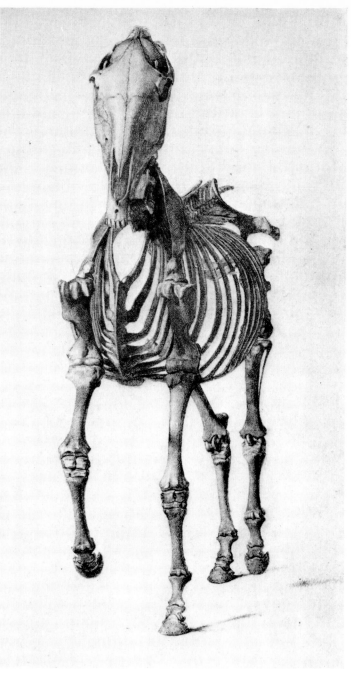

4, 5. Two drawings for *The Anatomy of the Horse*. 1758–9. $14\frac{1}{2} \times 7\frac{1}{2}$ in. London, Royal Academy of Art

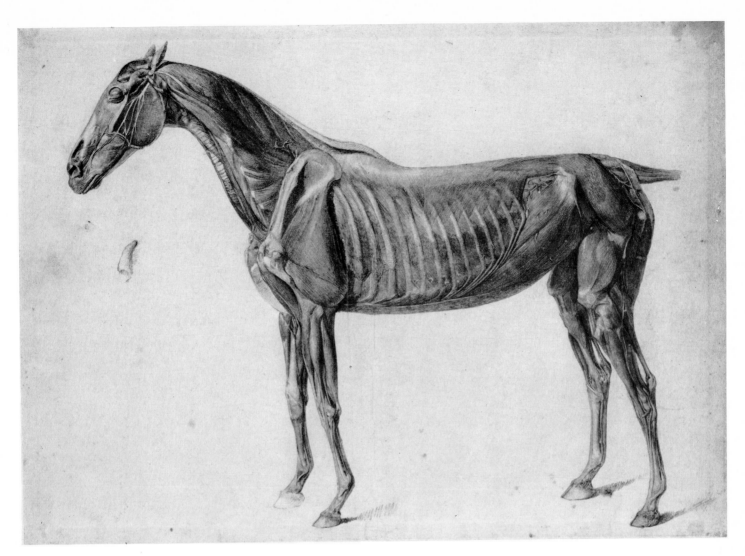

6. Drawing for *The Anatomy of the Horse*. 1758–9. 14½ × 19½ in. London, Royal Academy of Art

Plate 4 is related to Table xiv in the publication which appeared in 1766, Plate 5 to Table ii and Plate 6 to Table iii.

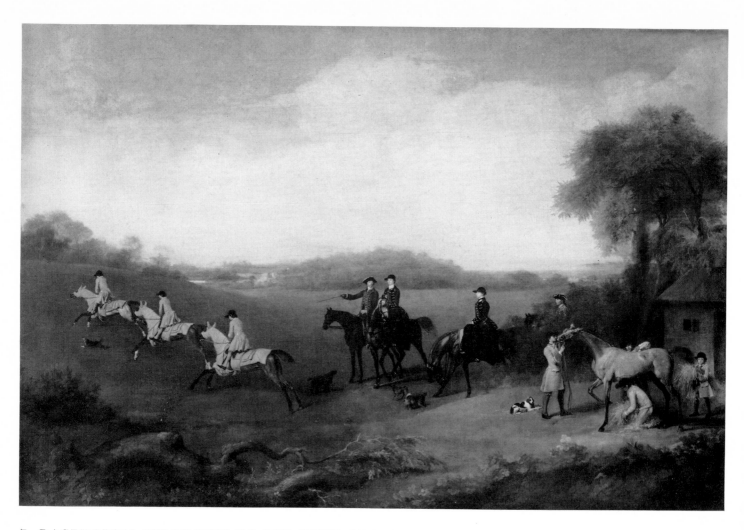

7. RACEHORSES BELONGING TO THE DUKE OF RICHMOND EXERCISING AT GOODWOOD. 1760–1. 50¼ × 80¾ in. Goodwood House, Sussex

The sporting pictures made at Goodwood for the Duke of Richmond were probably the first works which Stubbs executed after his move south from Lincolnshire. The Duke is shown here accompanied by his wife, the other female rider being his sister-in-law, Lady Louisa Lennox.

8. Detail from Plate 7

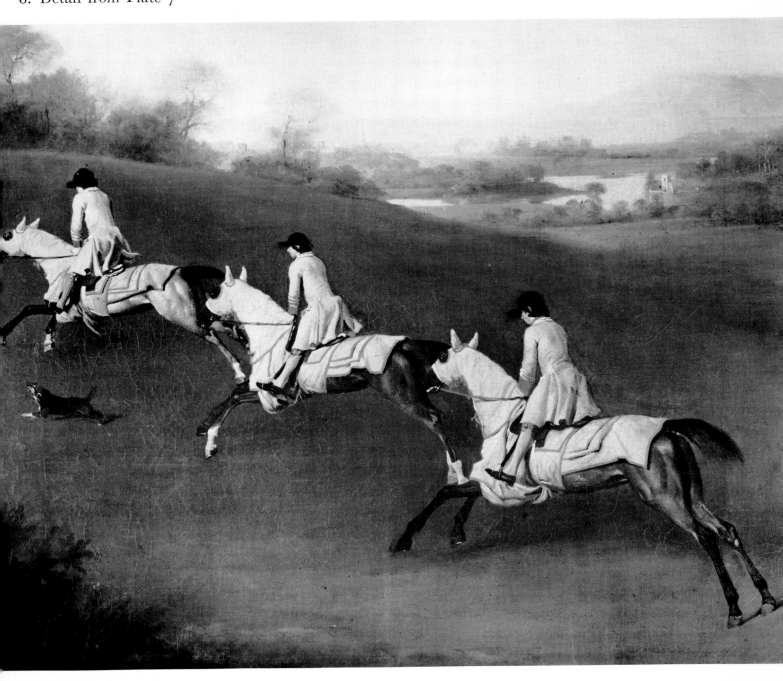

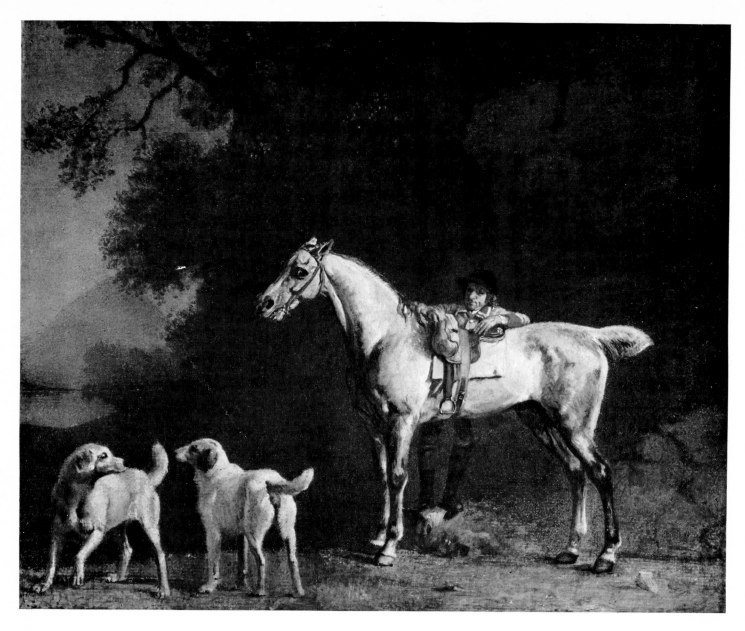

9. HUNTSMAN WITH A GREY HUNTER AND TWO FOXHOUNDS. Date unknown. $10\frac{1}{4} \times 11\frac{7}{8}$ in. United States, Mr and Mrs Paul Mellon

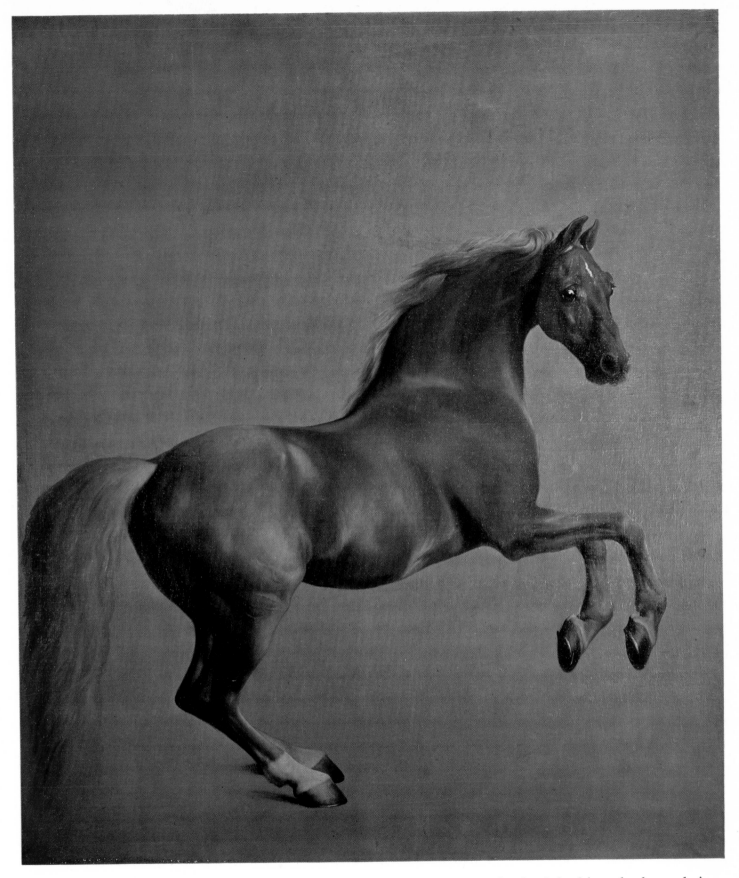

10. WHISTLEJACKET. 1761–2. The painting measures about 10 ft. 8 in. by 8 ft. 6 in., the horse being roughly life-size. Earl Fitzwilliam

Stubbs is reported to have moved from Goodwood to Eaton Hall, the Cheshire estate of Lord Grosvenor, which is represented in this hunting piece. Grosvenor himself is the figure immediately to the right of the tree (see also Plate 14). His brother, Thomas, Sir Roger Mostyn and Mr Bell are also included in the group. The prominent feature on the horizon is Eddisbury Hill.

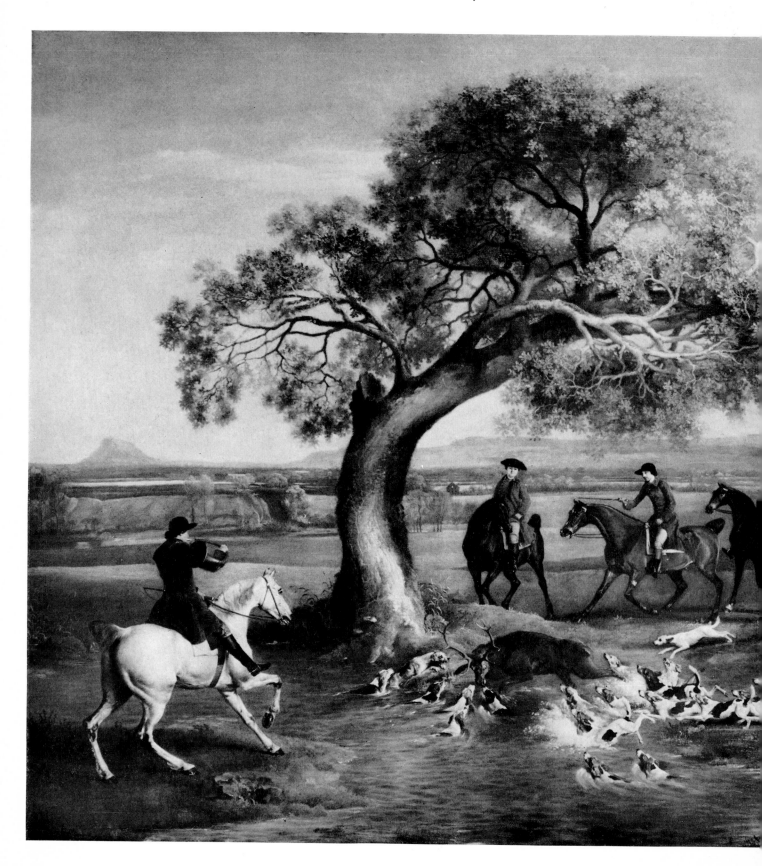

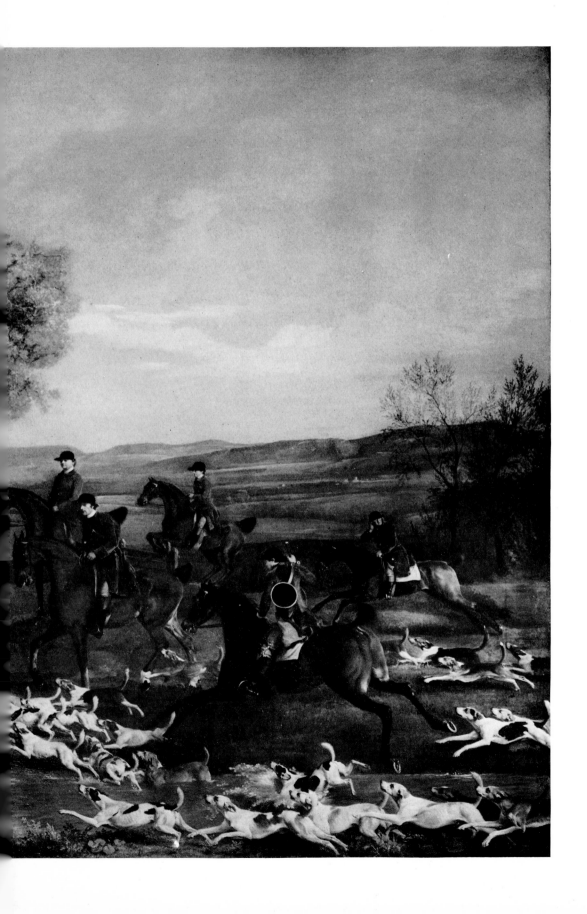

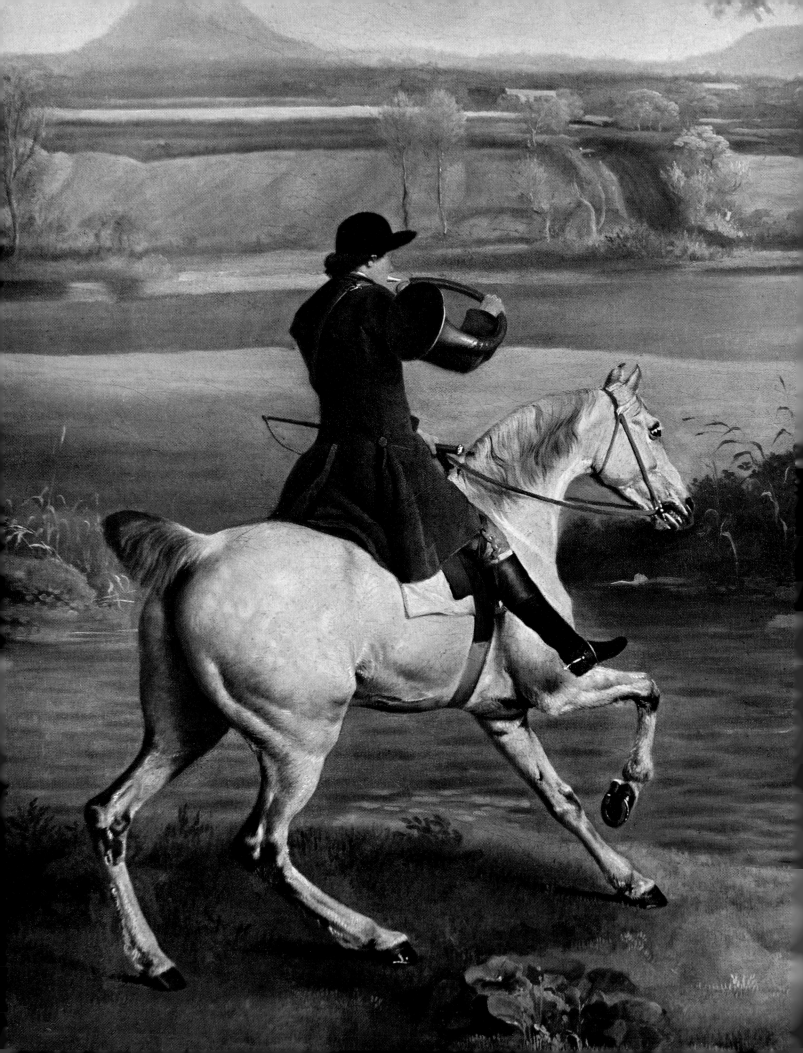

12, 13. Details from THE GROSVENOR HUNT (Plate 11)

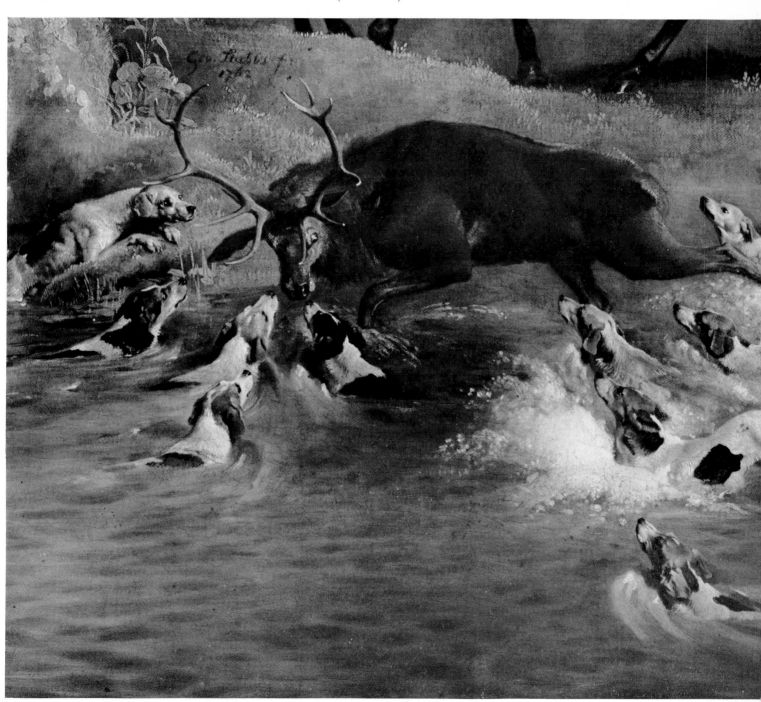

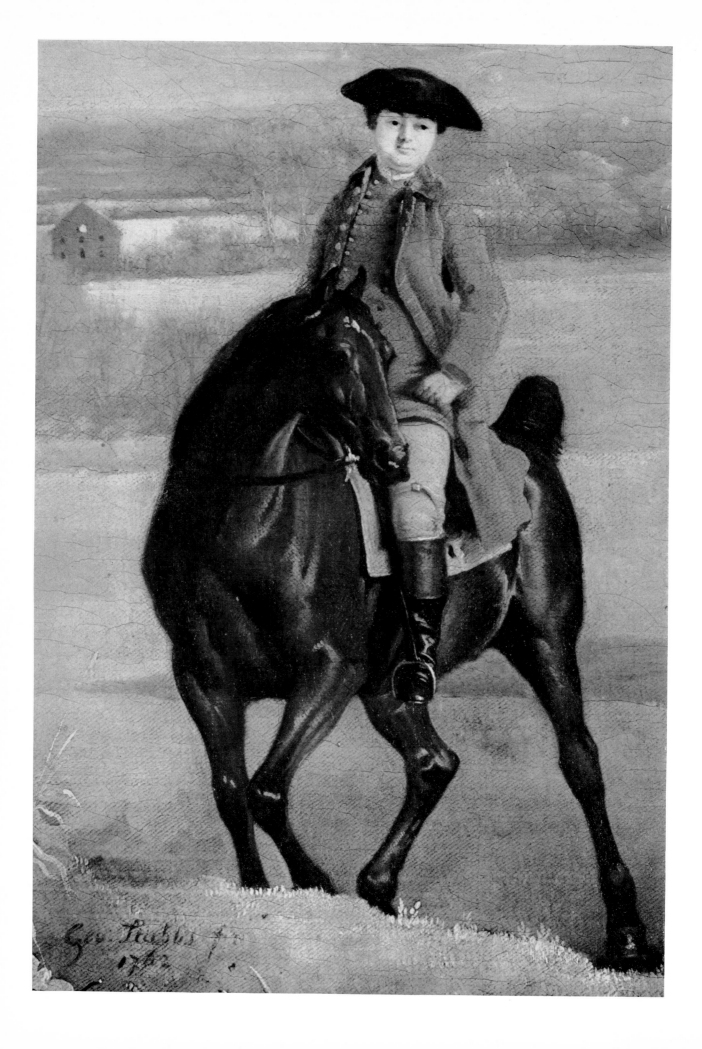

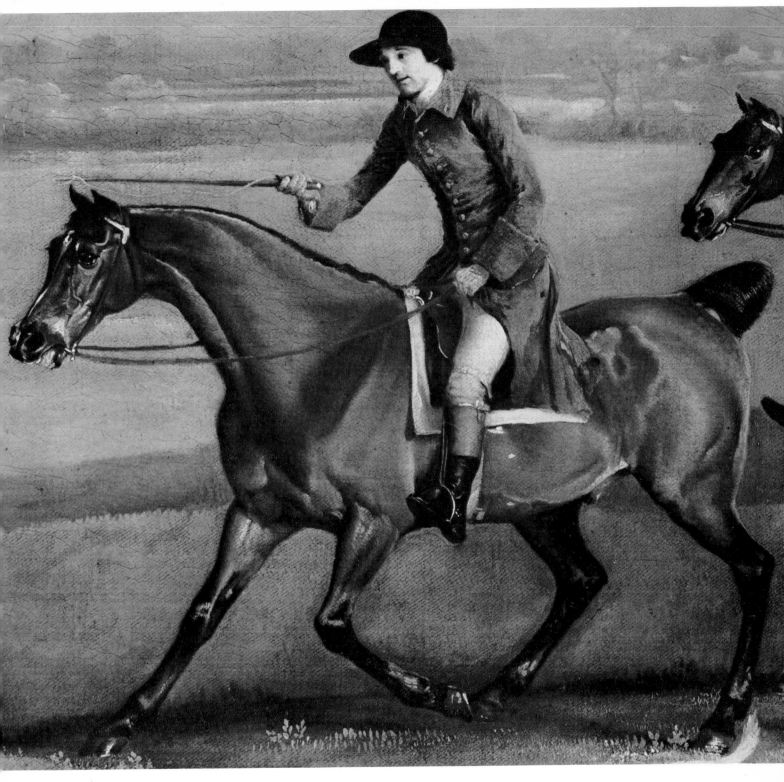

15. Detail from THE GROSVENOR HUNT (Plate 11)

14. Lord Grosvenor. Detail from THE GROSVENOR HUNT (Plate 11)

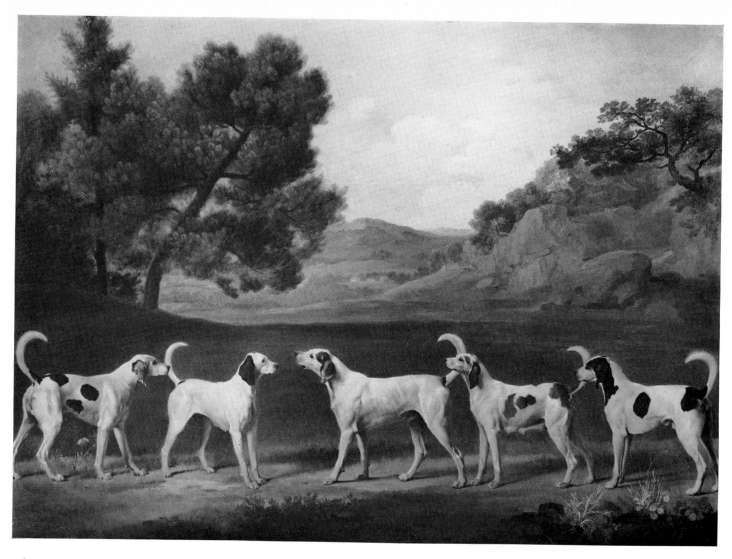

16. FIVE FOXHOUNDS IN A LANDSCAPE. 1762. 40 × 50 in. Earl Fitzwilliam

17. MOLLY LONG LEGS. 1761–2. 40 × 50 in.
Liverpool, Walker Art Gallery

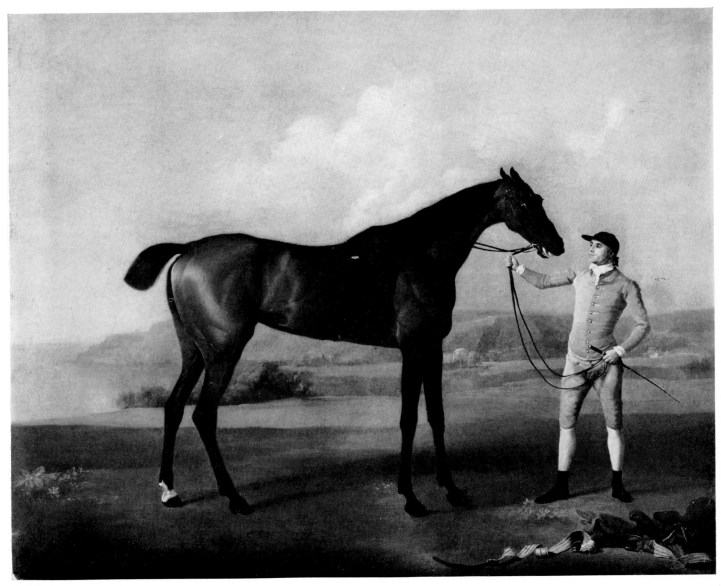

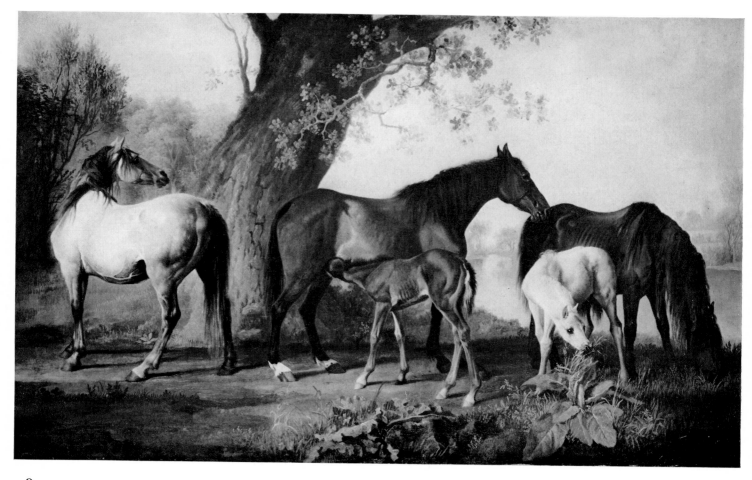

18. MARES AND FOALS BY A STREAM. 1763–4. $23\frac{1}{2} \times 39\frac{1}{2}$ in. The Duke of Grafton

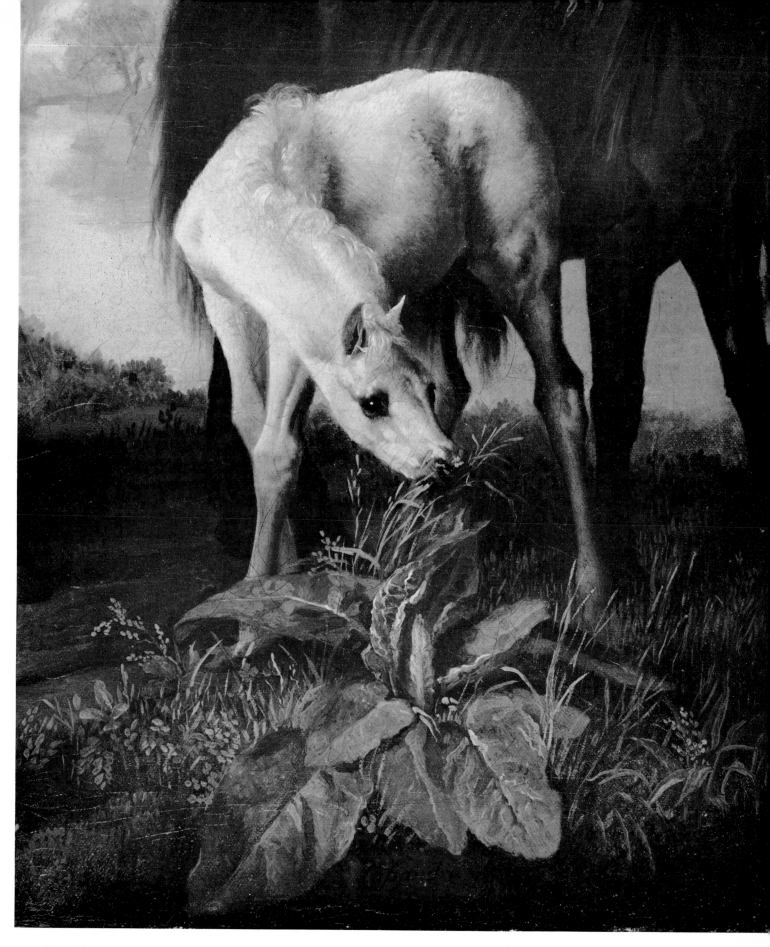

19. Detail from Plate 18

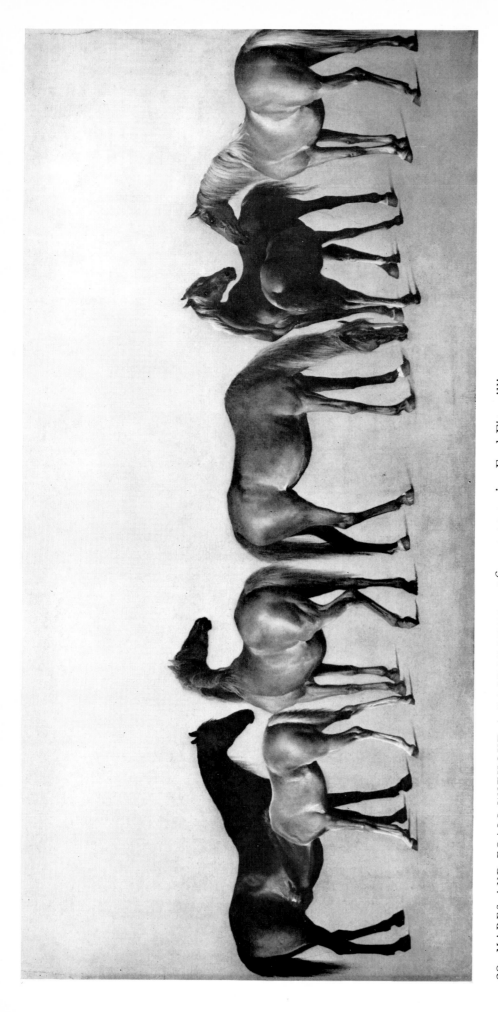

20. MARES AND FOALS WITHOUT A BACKGROUND. 1762. 39 × 75 in. Earl Fitzwilliam

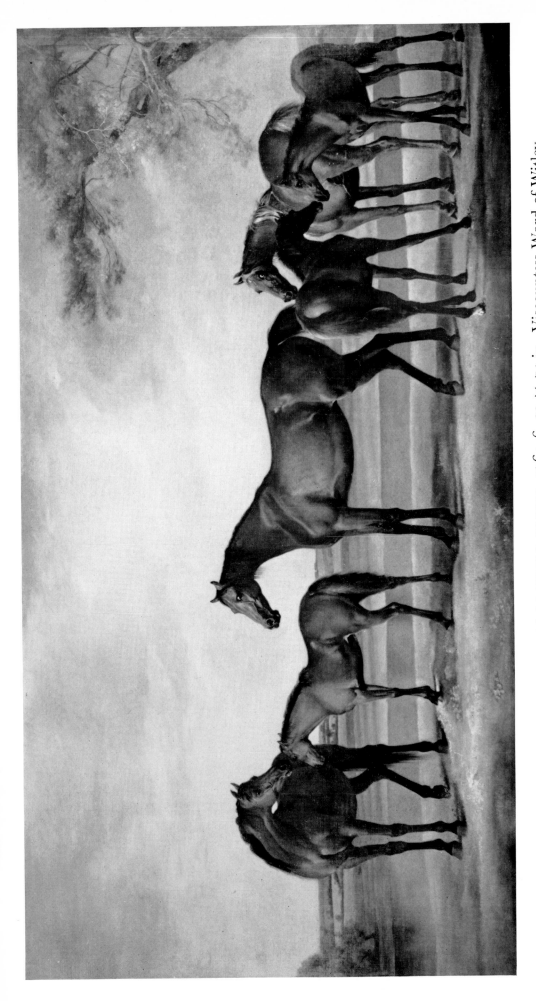

21. MARES AND FOALS DISTURBED BY AN APPROACHING STORM. 1764–6. 39 × 74 in. Viscountess Ward of Witley

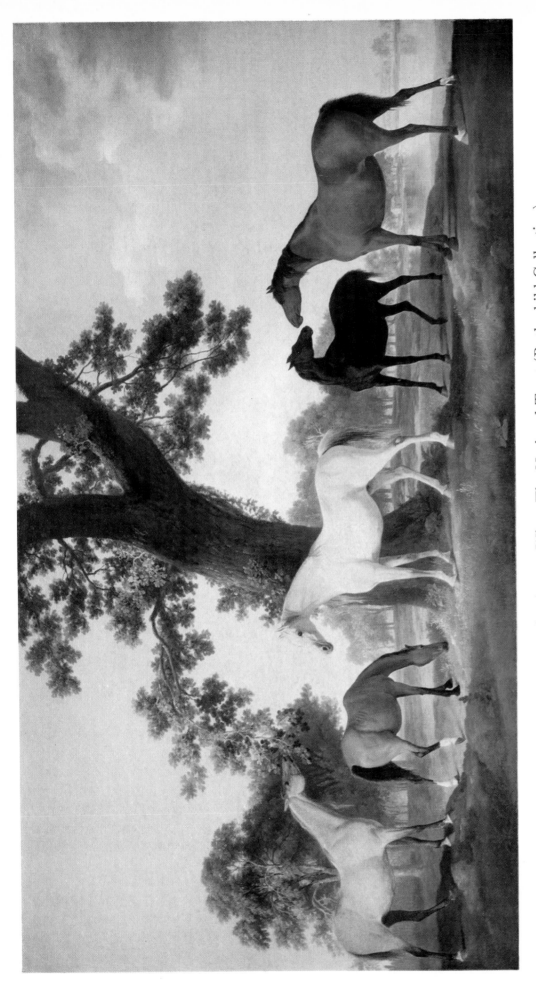

22. MARES BY AN OAK-TREE. 1764–5. 39 × 74 in. Ascott, Wing, The National Trust (Rothschild Collection)

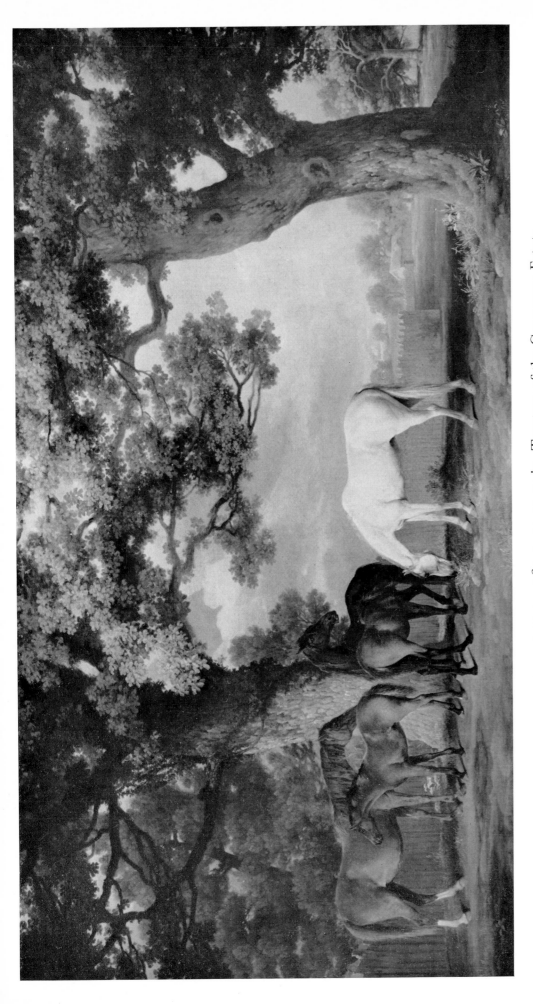

23. MARES AND FOALS IN A WOODED LANDSCAPE. 1760–2. 39 × 74 in. Trustees of the Grosvenor Estate

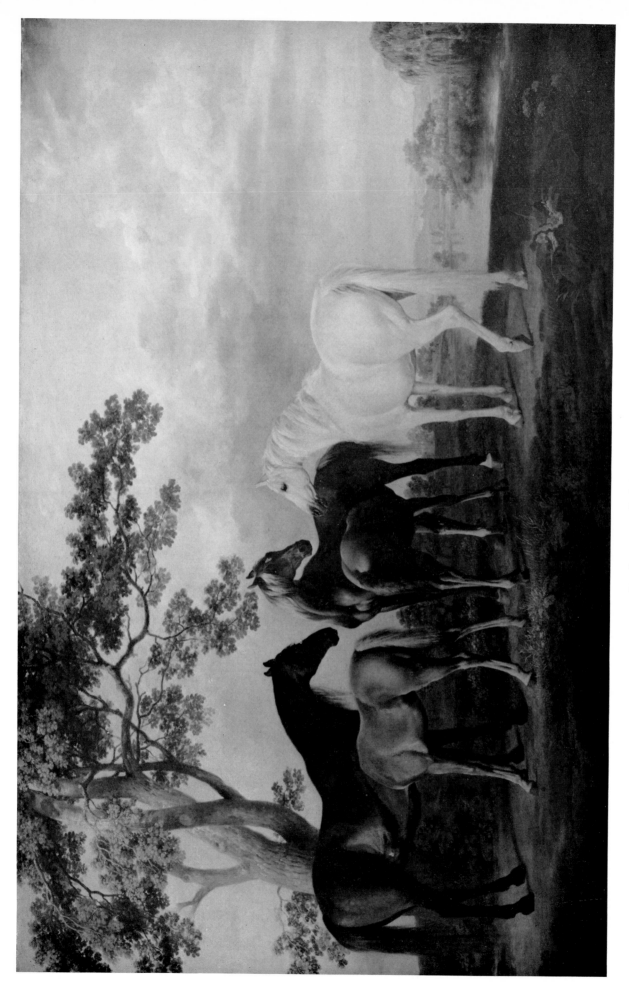

24. MARES AND FOALS IN A RIVER LANDSCAPE. 1763–8. 39 × 62½ in. London, Tate Gallery

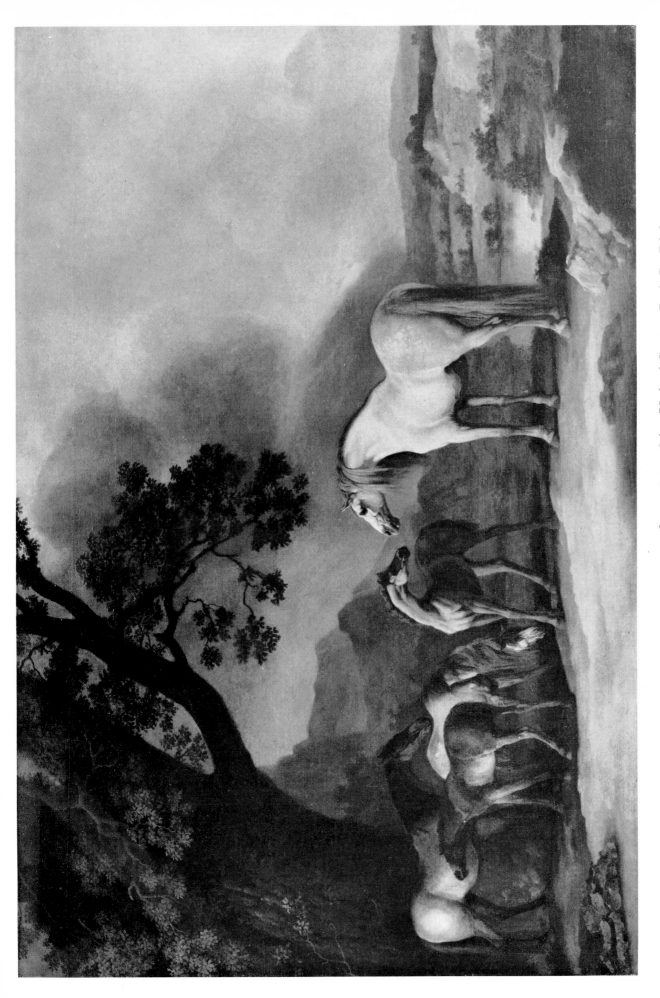

25. MARES AND FOALS IN A MOUNTAINOUS LANDSCAPE. 1769. 72 × 108 in. United States, Jack R. Dick

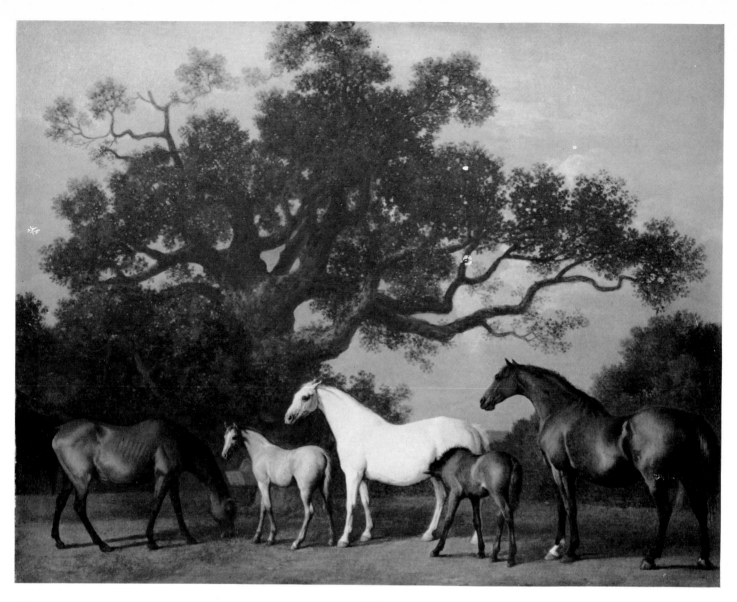

26. MARES AND FOALS UNDER AN OAK-TREE. Dated 1773. $32\frac{1}{2} \times 40$ in. Oil on panel. Trustees of the Grosvenor Estate

27. Detail from MARES AND FOALS WITHOUT A BACKGROUND (Plate 20)

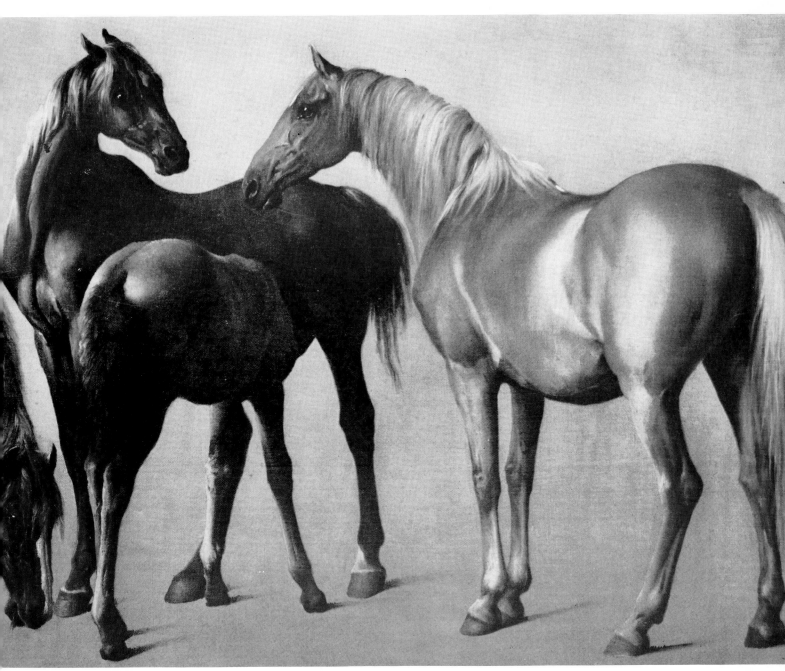

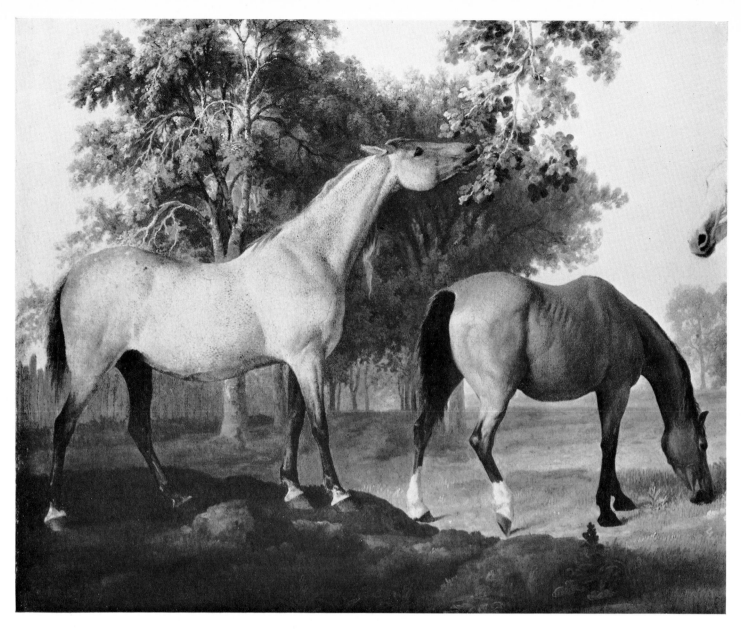

28. Detail from MARES BY AN OAK-TREE (Plate 22)

29. CHESTNUT HUNTER AND GREY ARAB WITH A GROOM. 1763–8. 40 × 50 in. Private Collection

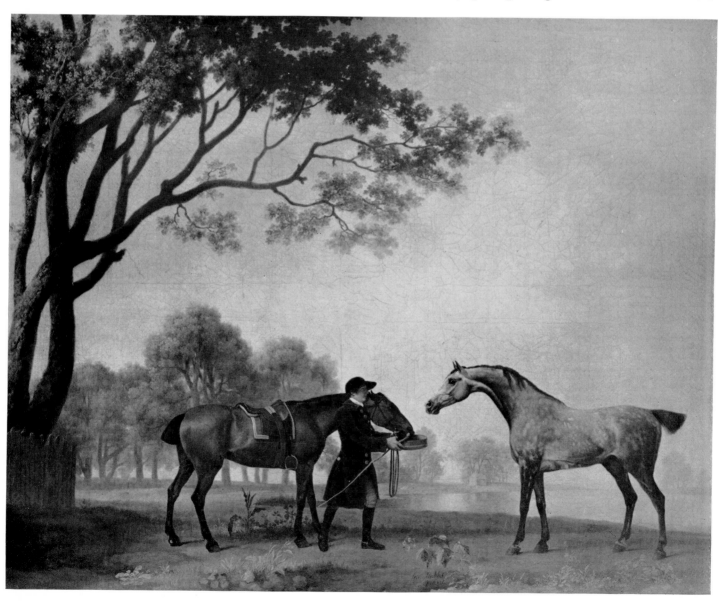

30, 31. Details from GIMCRACK ON NEWMARKET HEATH (Plate 32)

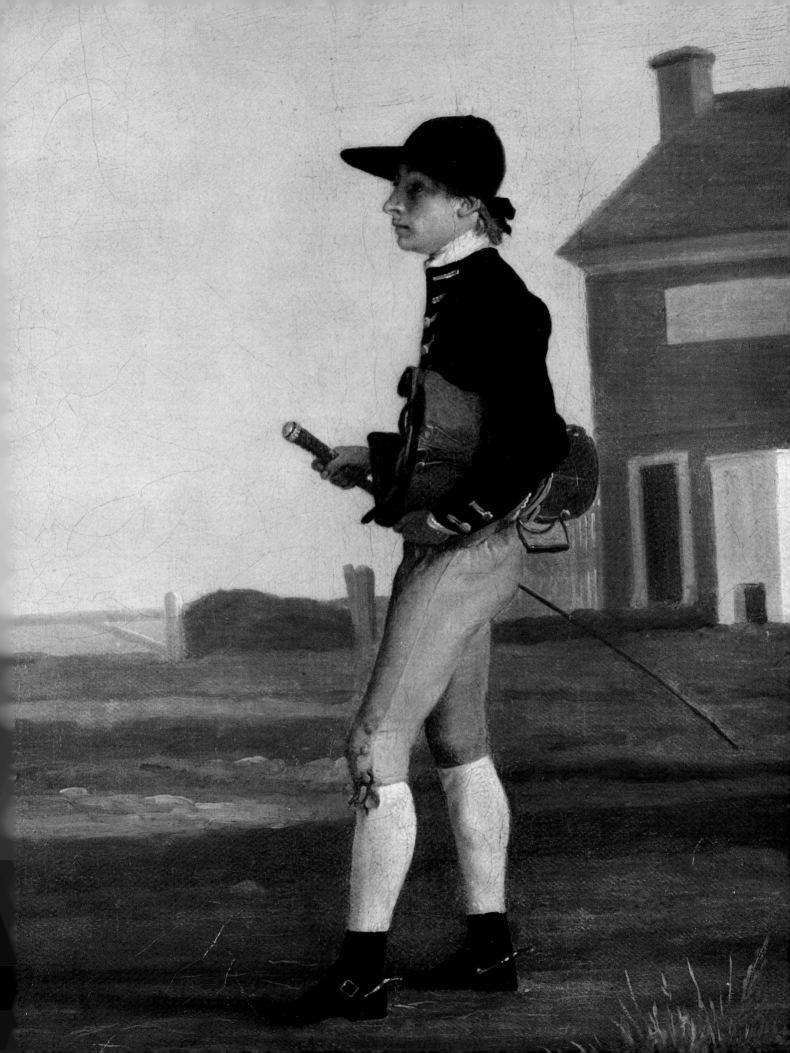

32. GIMCRACK ON NEWMARKET HEATH, WITH A TRAINER, JOCKEY AND STABLE-LAD. 1765. 40 × 76 in. Private Collection

This is one of the few cases in which Stubbs chose to place the portrait of a racehorse in the context of a race, as Wootton, Marshall and other animal painters commonly did.

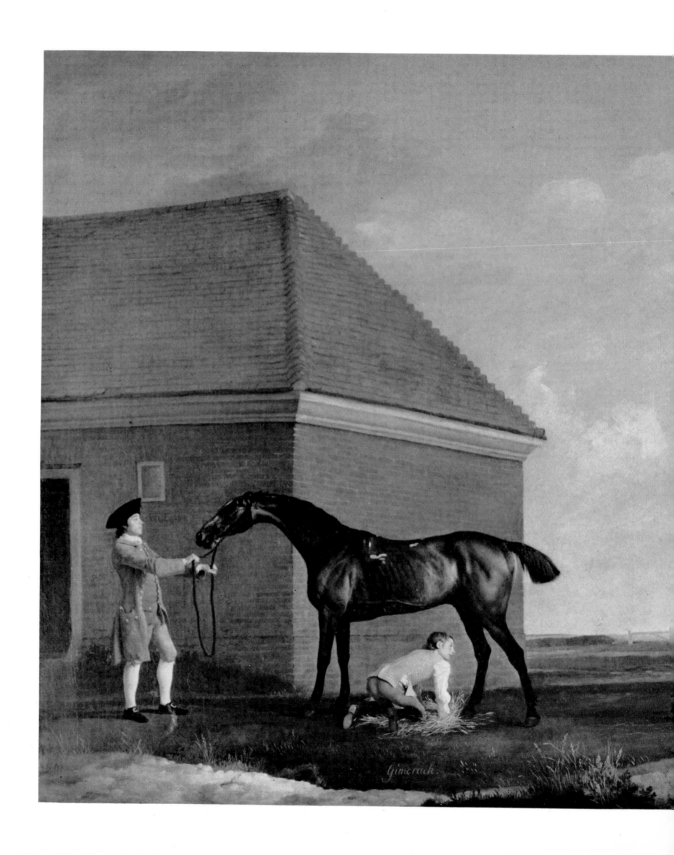

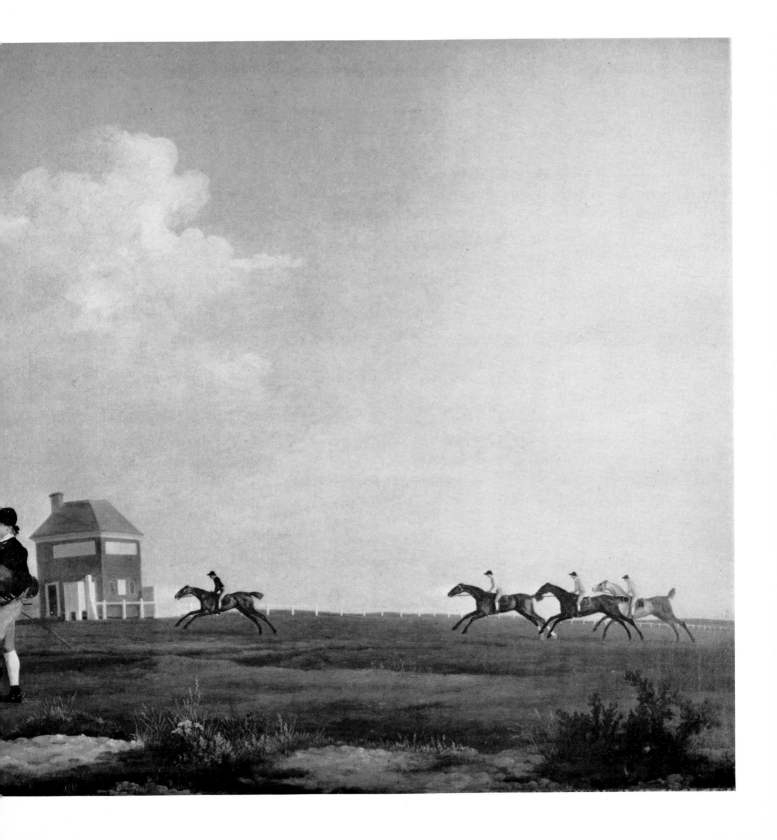

33. THE RUBBING-DOWN HOUSE, NEWMARKET HEATH. 1764–5. 12 × 16¼ in. United States, Mr and Mrs Paul Mellon

This simple building was a prominent and most familiar feature of Newmarket Heath and a frequent element in Stubbs's horse portraits (see Plates 32, 69, 131). Having used Plate 34 as a study for the portrait of Gimcrack, he perhaps turned to it again more than thirty years later in painting Hambletonian (Plate 131).

34. NEWMARKET HEATH, WITH THE RUBBING-DOWN HOUSE. 1764–5. 12 × 16¼ in.
United States, Mr and Mrs Paul Mellon

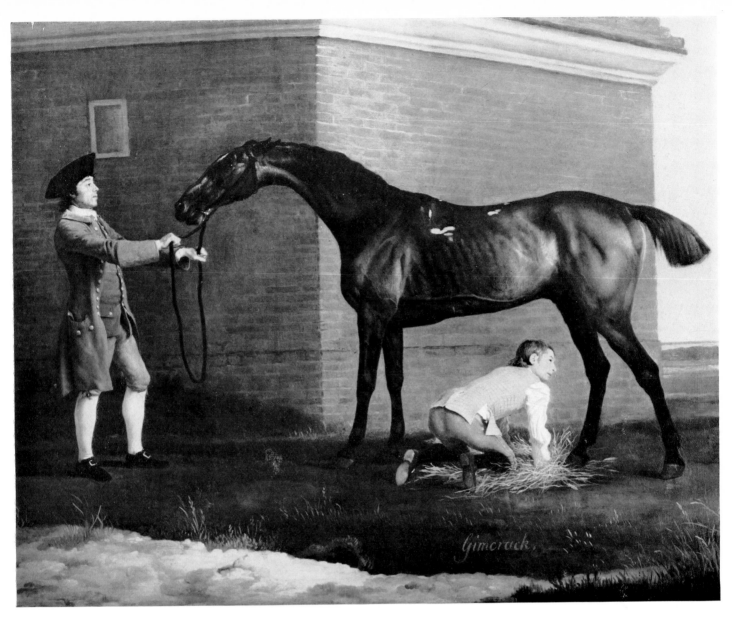

35, 36. Details from GIMCRACK ON NEWMARKET HEATH (Plate 32)

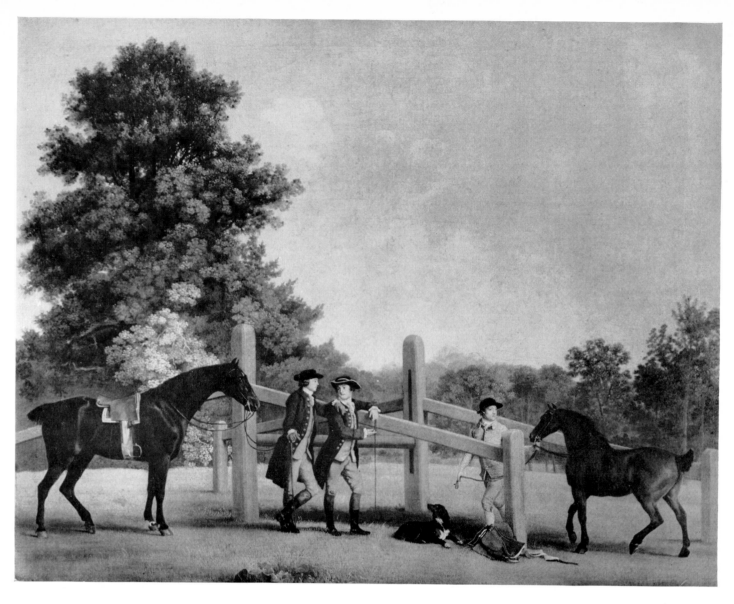

37. WILLIAM, THIRD DUKE OF PORTLAND, AND LORD EDWARD BENTINCK, WITH A GROOM
AND HORSES. 1766–7. 39 × 49 in. The Duke of Portland

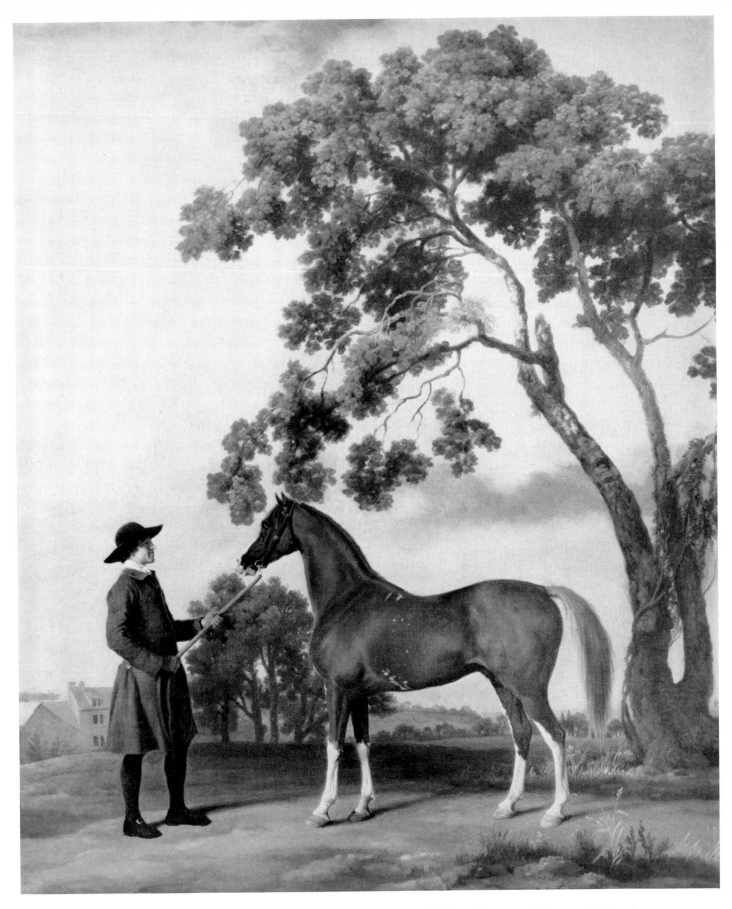

38. HUNTER WITH A GROOM. 1763–8. About 30 × 25 in. United States, Private Collection

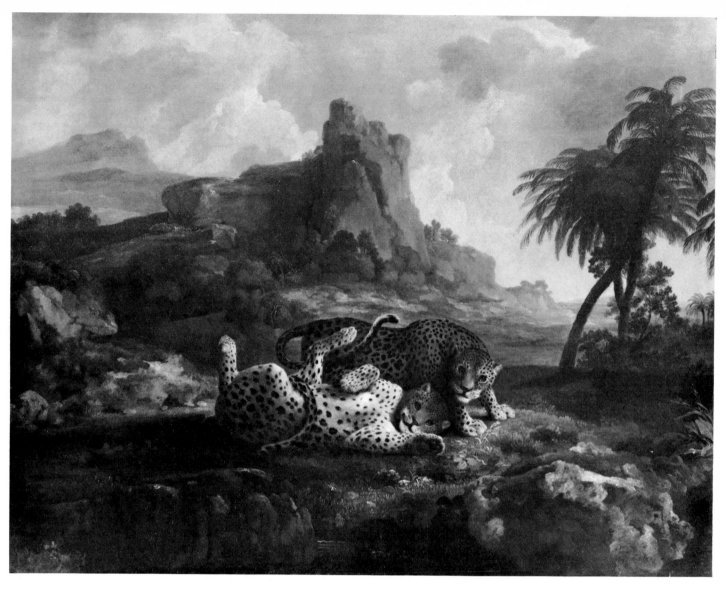

39. LEOPARDS PLAYING IN A ROCKY LANDSCAPE. 1763–8. 40 × 50 in. Private Collection

40. TIGER. 1763–8. $53\frac{1}{2} \times 83\frac{1}{2}$ in. Viscount Portman

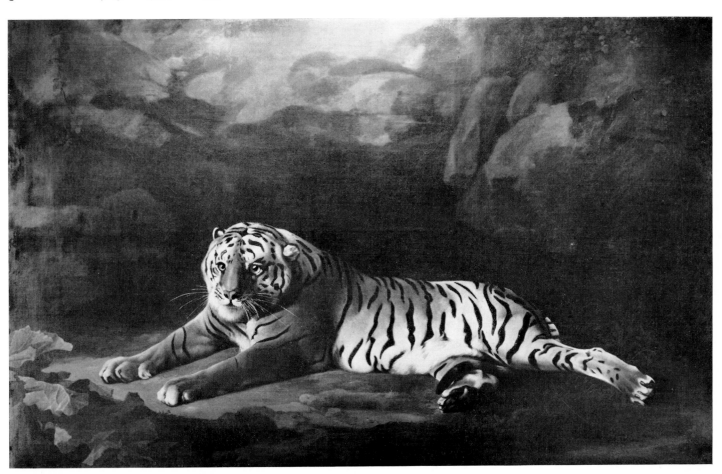

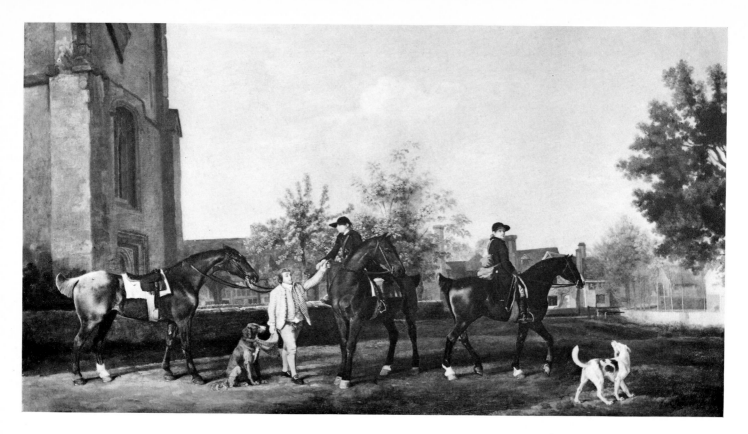

41, 42. HUNTSMEN SETTING OUT FROM SOUTHILL, BEDFORDSHIRE. 1763–8. 24 × 41½ in. The Marquis of Bute

The west face of All Saints' Church, Southill, appears today very much as it is shown here. The other buildings have gone, probably removed when Samuel Whitbread reshaped the Torrington estate, which he acquired later in the century.

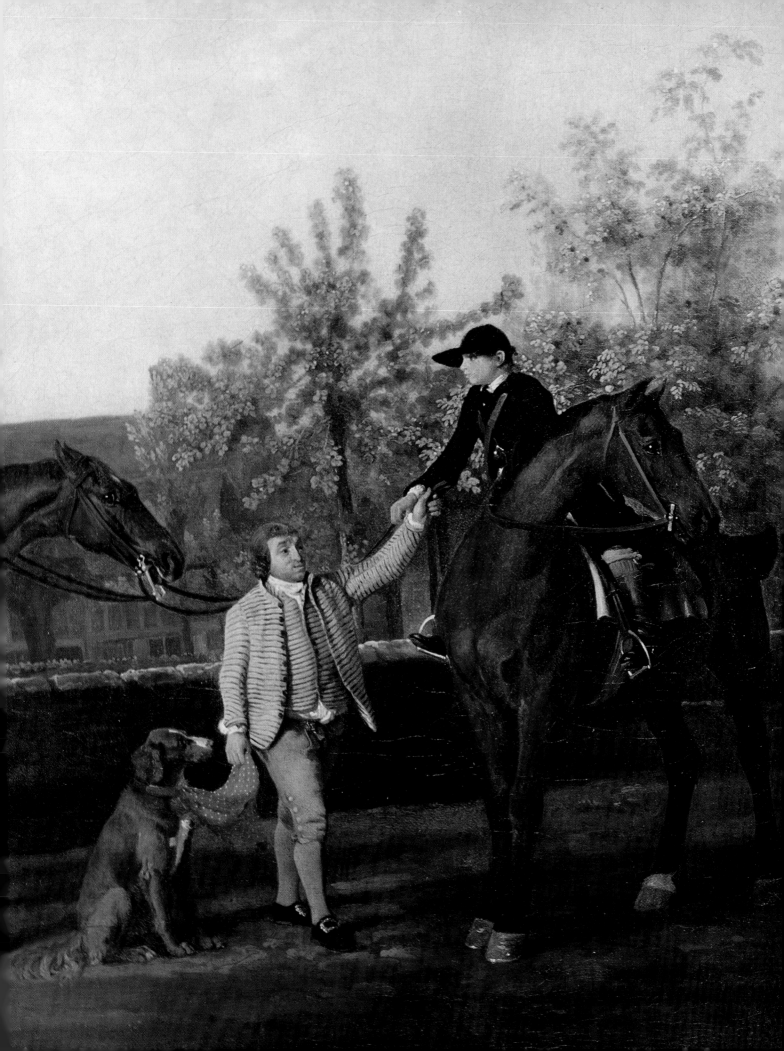

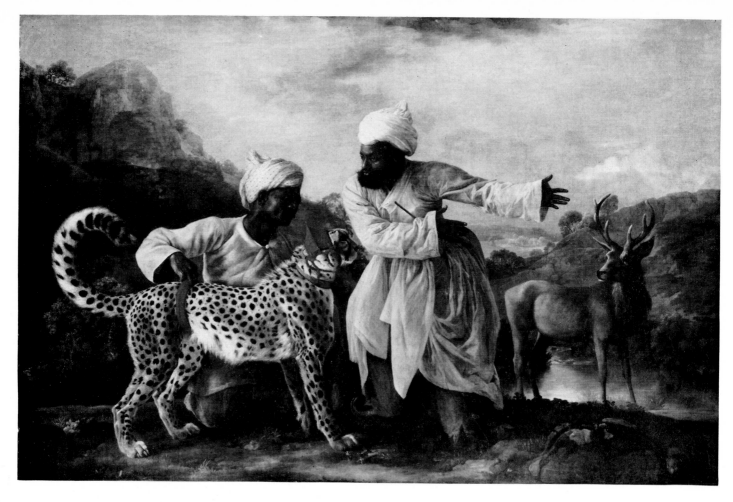

43. CHEETAH WITH TWO INDIAN ATTENDANTS AND A STAG. 1764–5. 81 × 107 in.
Manchester, City Art Gallery

This is not only the largest of Stubbs's wild animal portraits, but the only one which is known to
have been commissioned for a purpose other than zoological record, commemorating as it does a
gift made by George Pigot to the King.

44. Detail from Plate 43

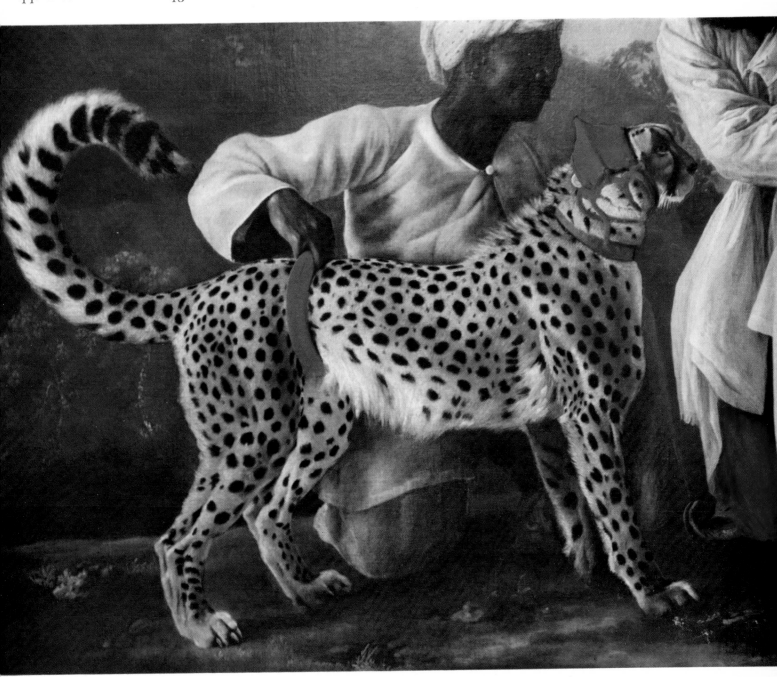

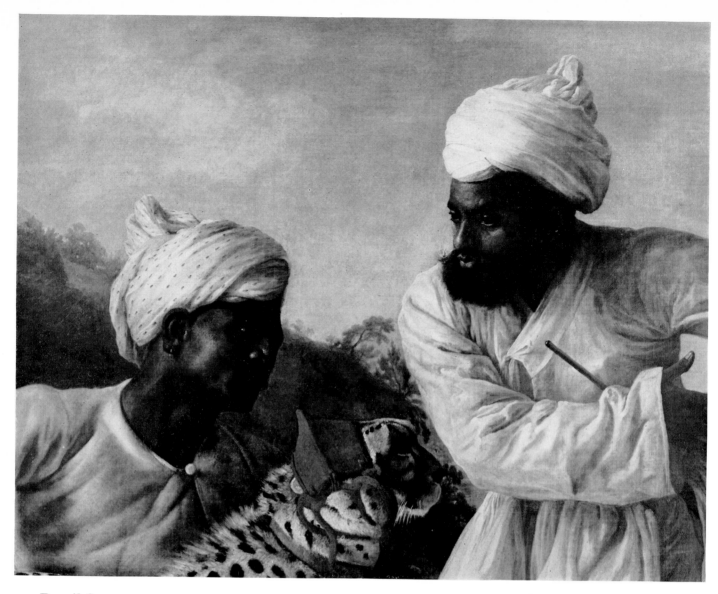

45. Detail from CHEETAH WITH TWO INDIAN ATTENDANTS AND A STAG (Plate 43)

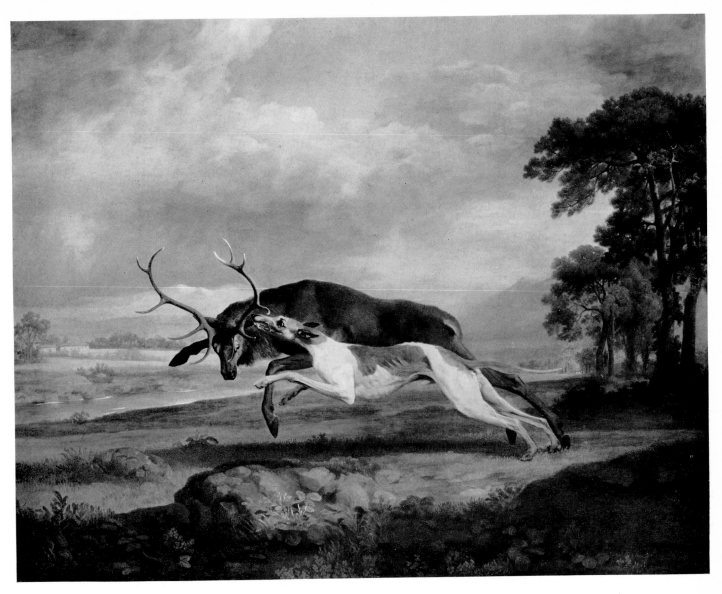

46. HOUND HUNTING A STAG. Dated 1769. 40 × 50 in. United States, Private Collection

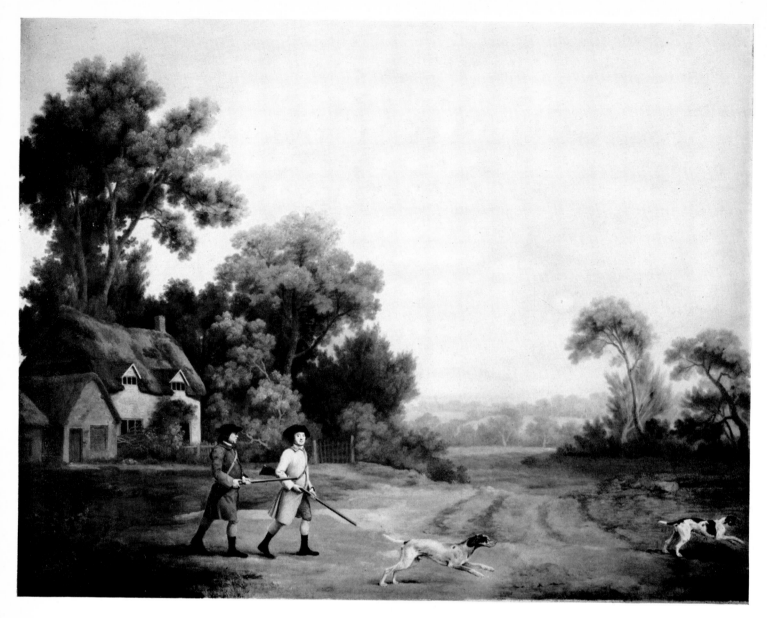

47. TWO GENTLEMEN GOING SHOOTING. 1767–8. 40 × 50 in. United States, Private Collection

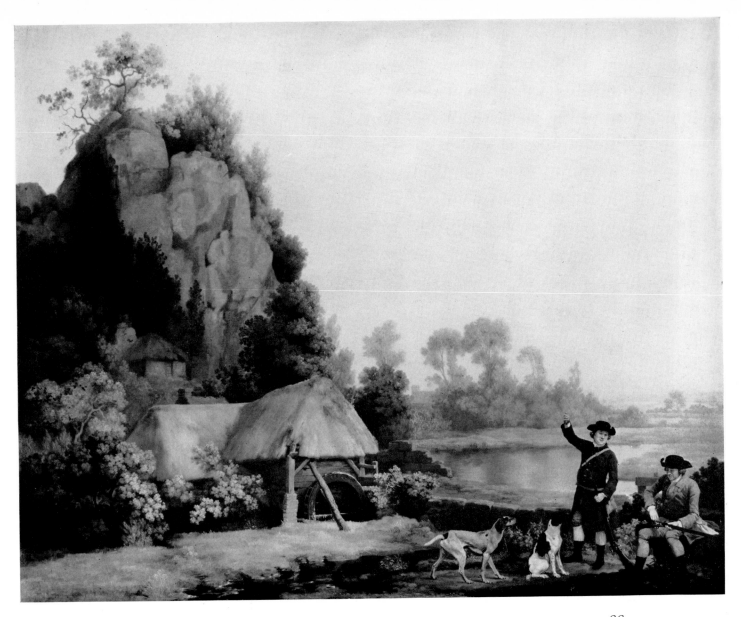

48. TWO GENTLEMEN OUT SHOOTING AT CRESSWELL CRAGS, DERBYSHIRE. 1766–7.
About 40 × 50 in. United States, Private Collection

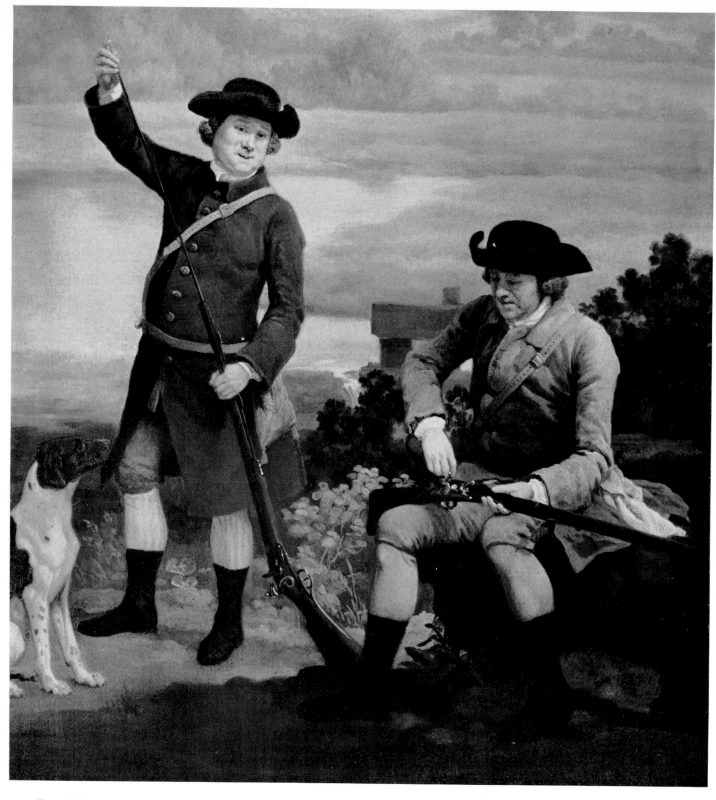

49. Detail from TWO GENTLEMEN OUT SHOOTING AT CRESSWELL CRAGS (Plate 48)

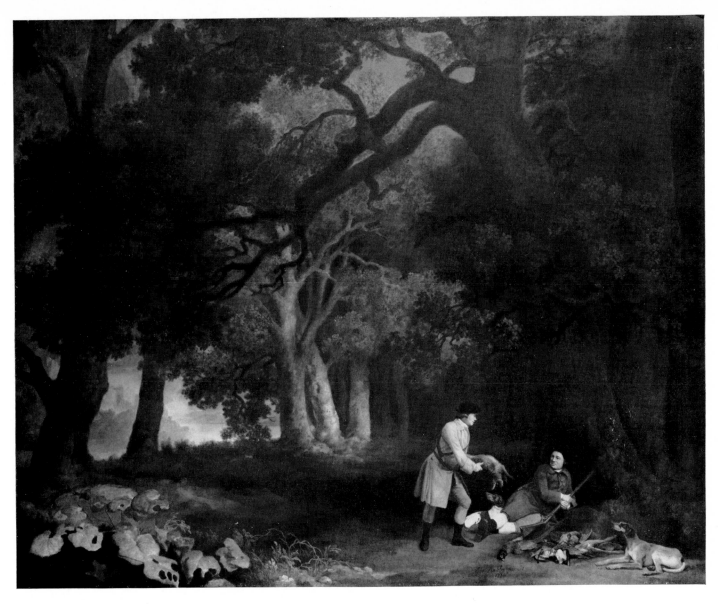

50. TWO GENTLEMEN RESTING IN A WOOD AFTER SHOOTING. 1769–70. About 40 × 50 in.
United States, Private Collection

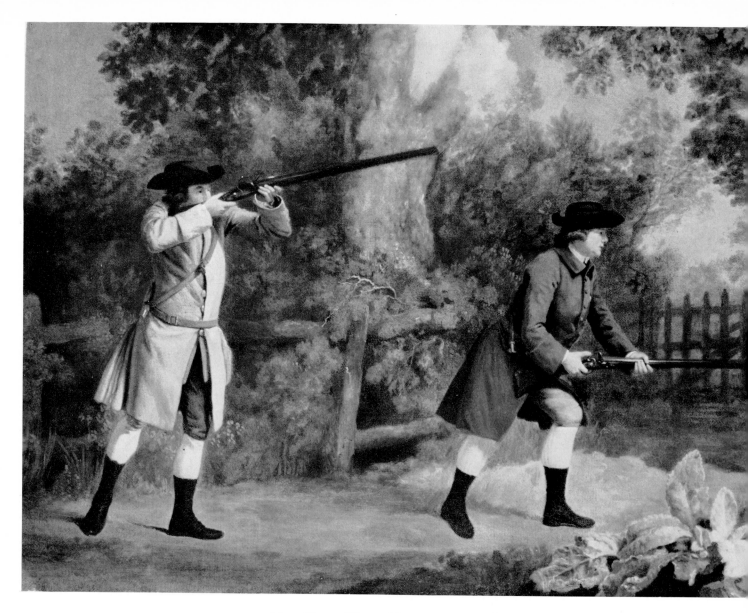

51. TWO GENTLEMEN SHOOTING (detail). 1768–9. About 40 × 50 in. United States, Private Collection

52. Detail from Plate 51

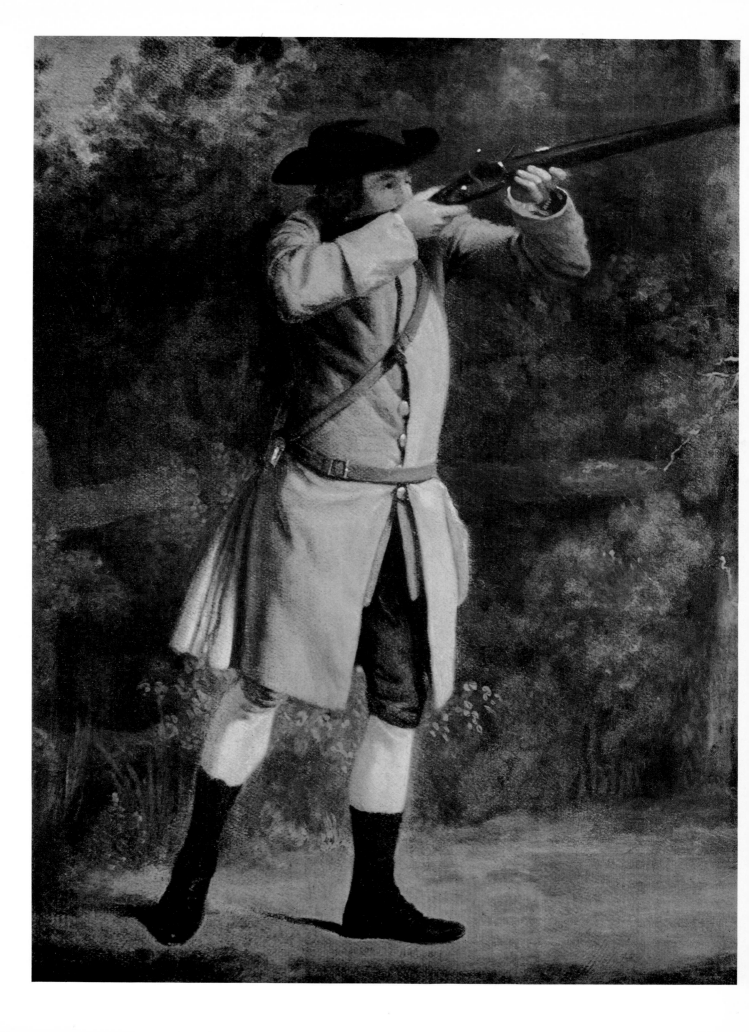

53. Detail from Plate 54

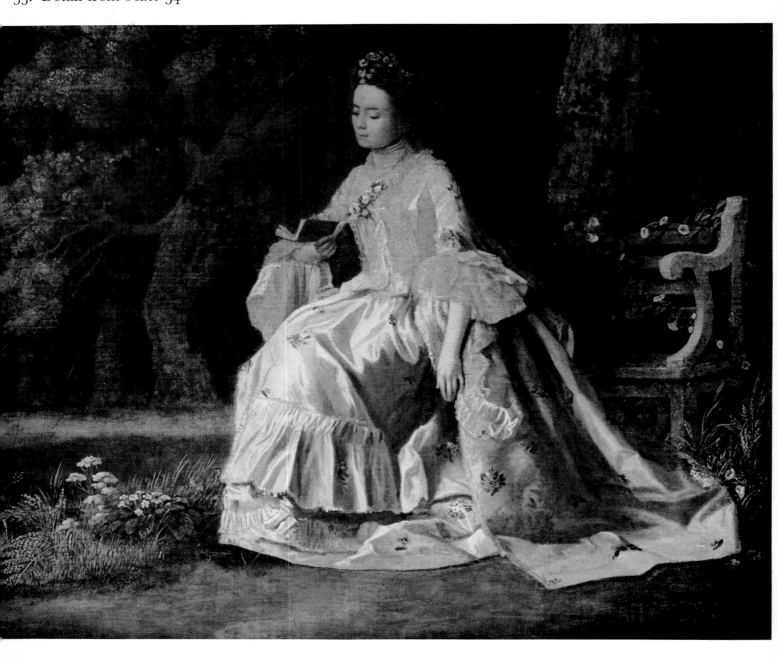

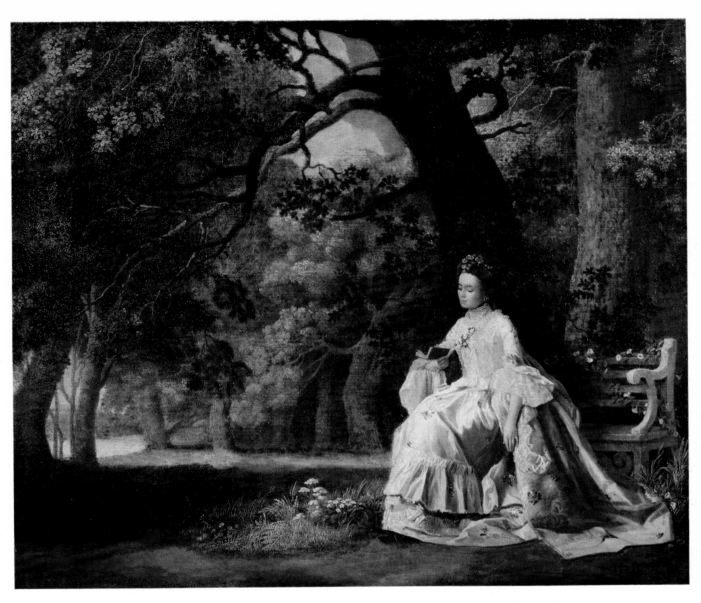

54. LADY READING IN A WOODED PARK. 1768–70. $24\frac{1}{2} \times 29\frac{1}{2}$ in. Private Collection

The sitter has formerly been identified as the Princess Royal but this suggestion is not supported by any evidence and cannot be accepted.

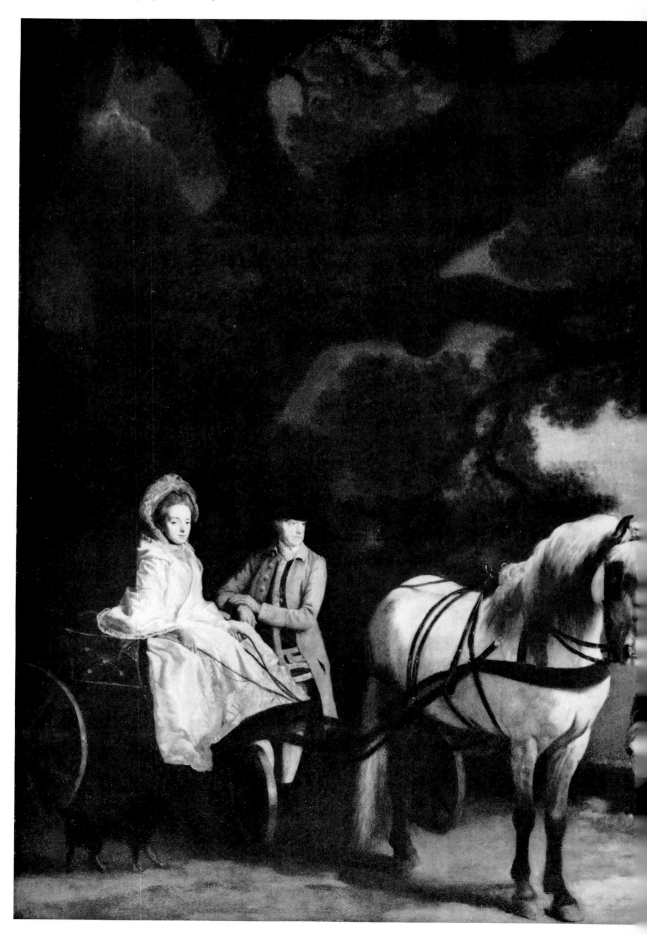

55. LORD AND LADY MELBOURNE, SIR RALPH MILBANKE AND JOHN MILBANKE. 1769–70. $38\frac{1}{4} \times 58\frac{3}{4}$ in. Mr Julian Salmond

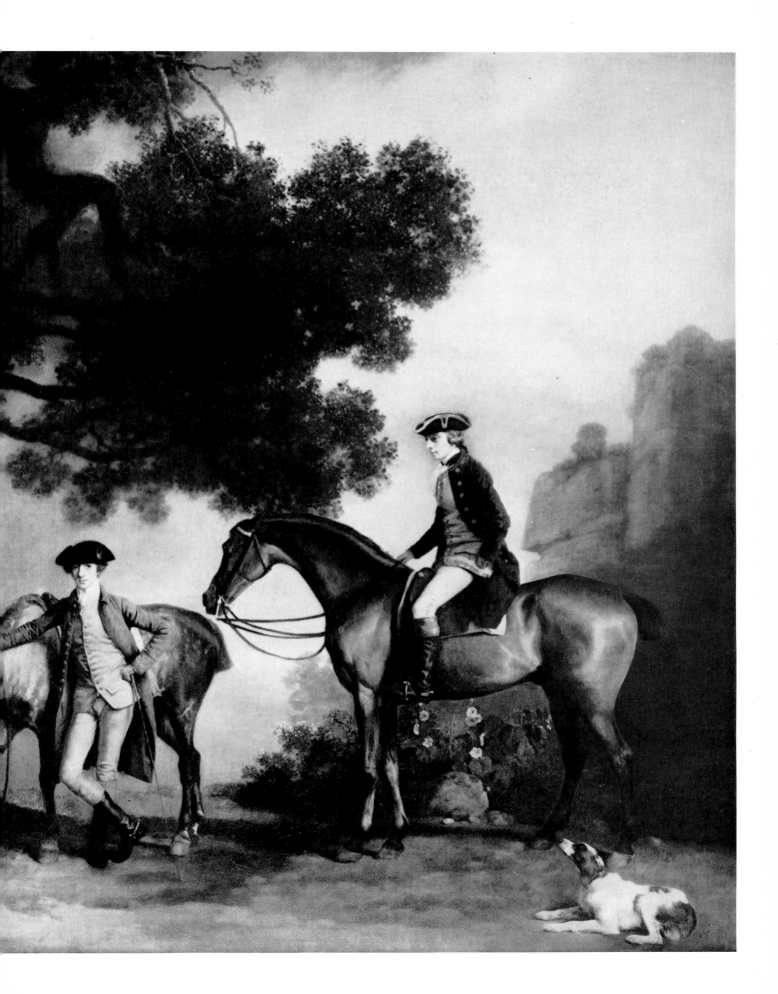

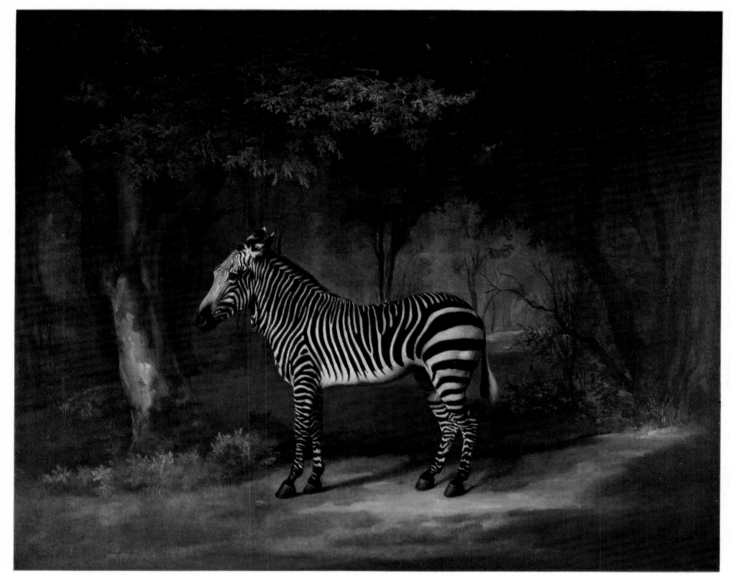

56. ZEBRA. 1762–3. 40 × 50 in. United States, Mr and Mrs Paul Mellon

This is probably the earliest of Stubbs's wild animal portraits.

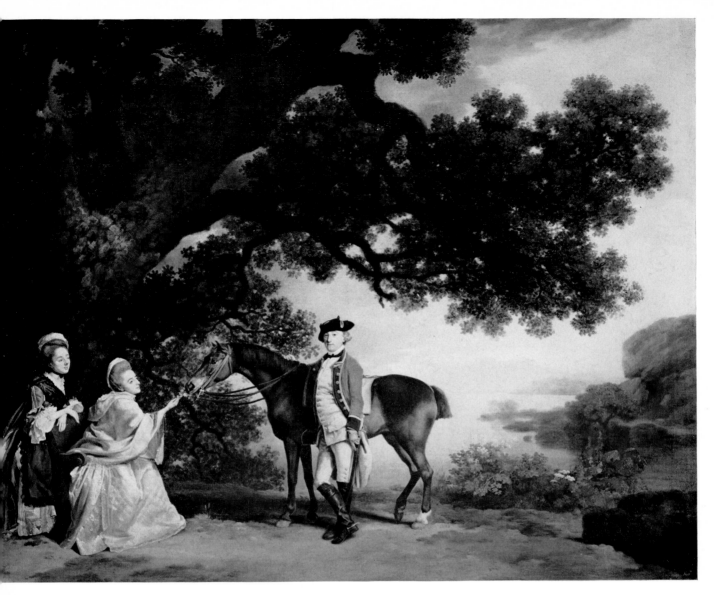

COLONEL POCKLINGTON WITH HIS SISTERS. Dated 1769. $38\frac{3}{4} \times 48\frac{3}{4}$ in. Washington, D.C.,
National Gallery of Art

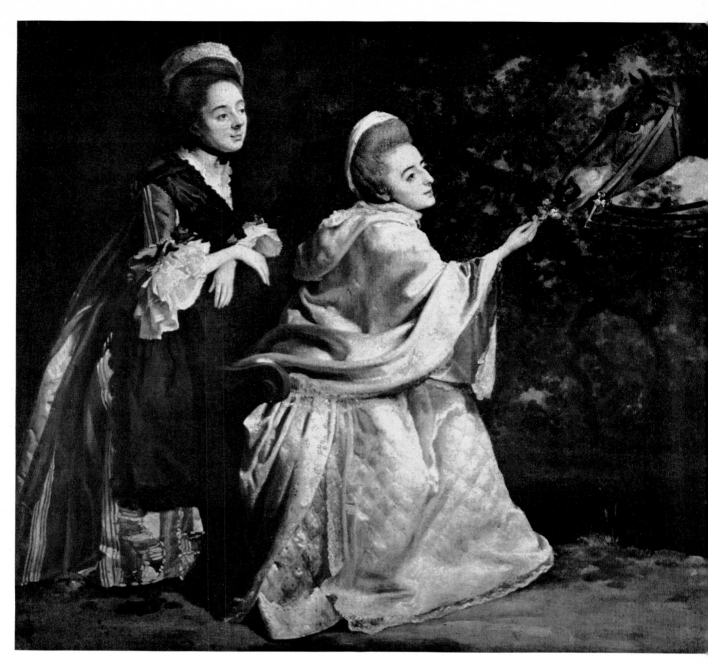

58. Colonel Pocklington's sisters. Detail from Plate 57

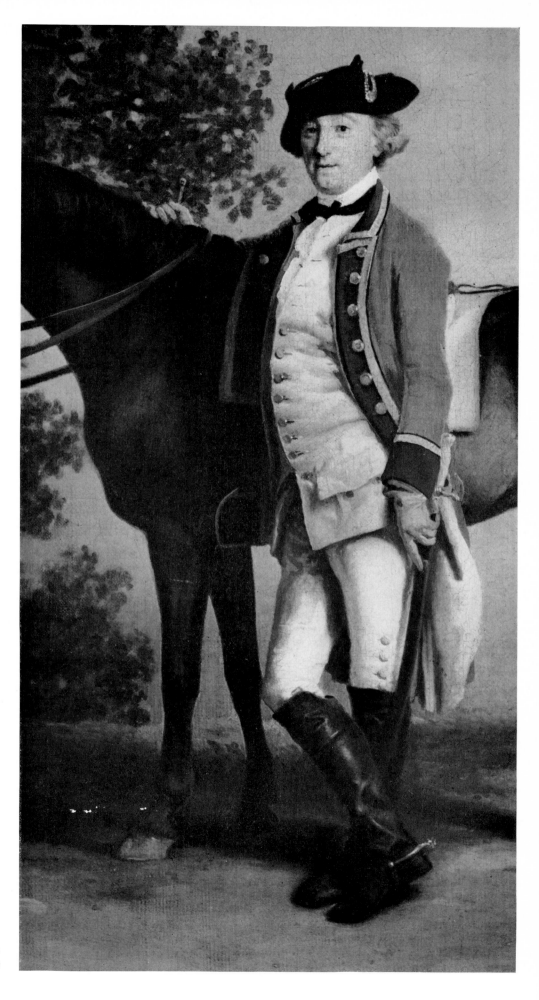

59. Colonel Pocklington.
Detail from Plate 57

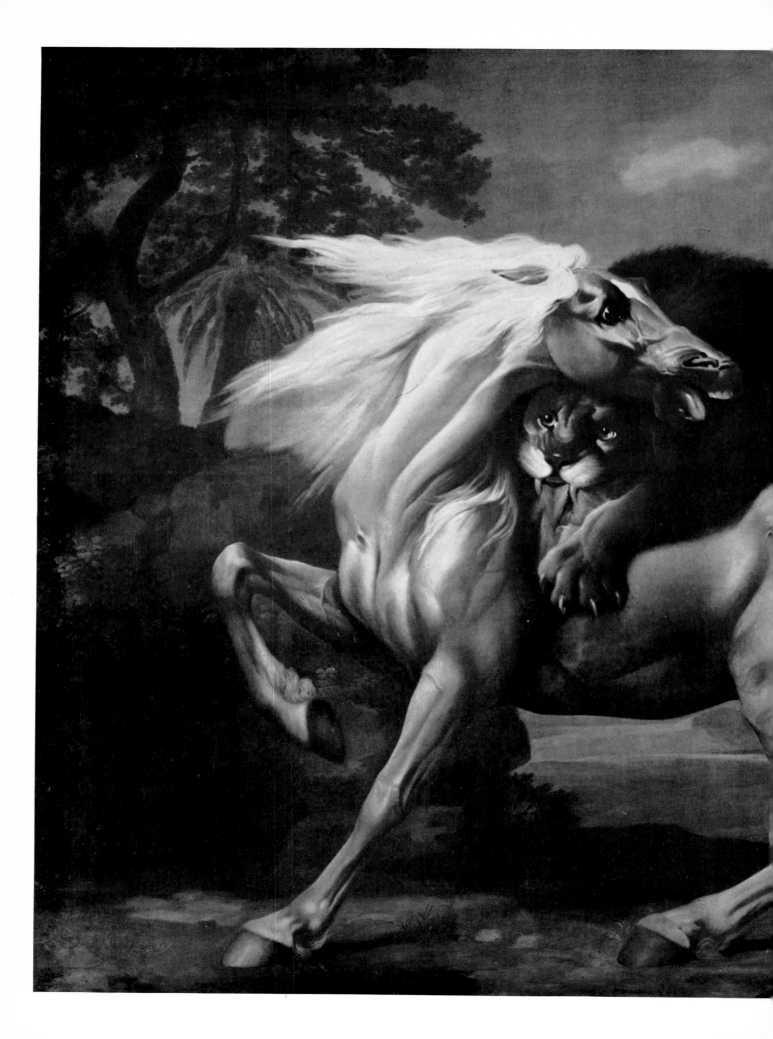

60. HORSE ATTACKED BY A LION.
1762? 96 × 131 in. United States,
Mr and Mrs Paul Mellon

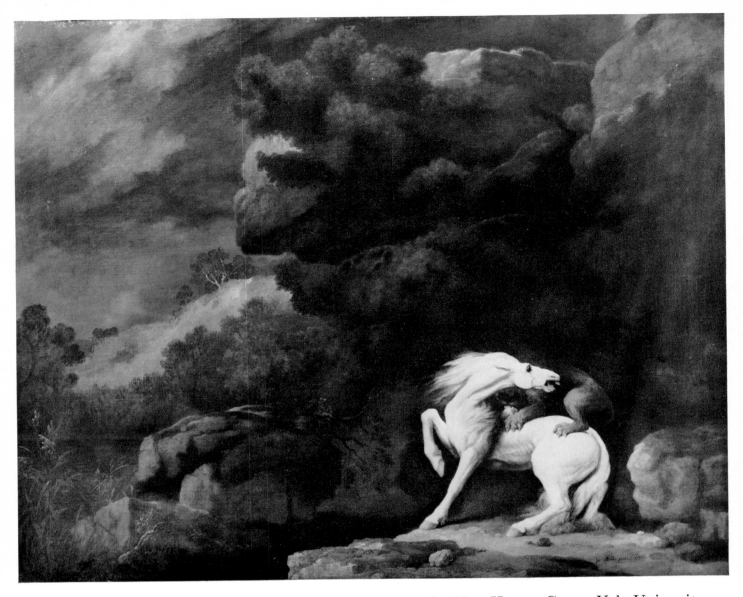

61. HORSE ATTACKED BY A LION. Dated 1770. 40 × 50 in. New Haven, Conn., Yale University Art Gallery

This work and that shown on the opposite page may have been executed as a pair.

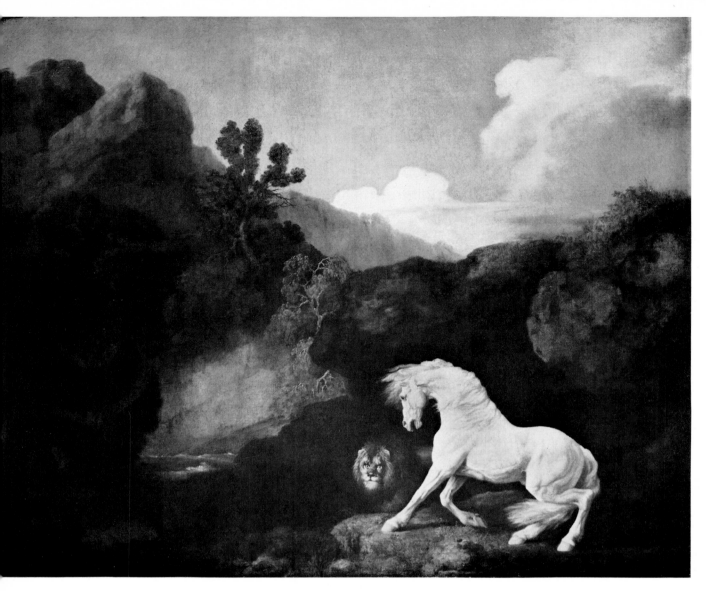

52. HORSE FRIGHTENED BY A LION. Dated 1770. 40 × 50 in. Liverpool, Walker Art Gallery

64. RECUMBENT LION. Date unknown. $8\frac{1}{4} \times 12$ Black and red chalk. Formerly Sir Bruce Ingra

65. Detail from HORSE FRIGHTENED BY A LION (Plate 6

63. LION AND LIONESS. Dated 1770. $9\frac{1}{2} \times 11$ in. Enamel on copper. Mr P. Jeannerat

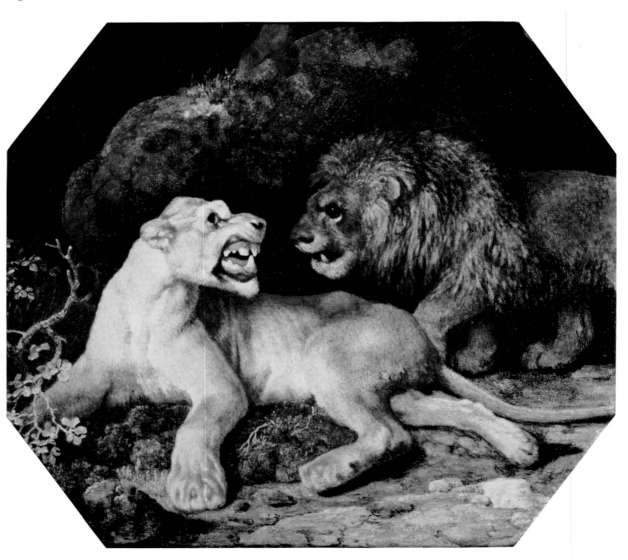

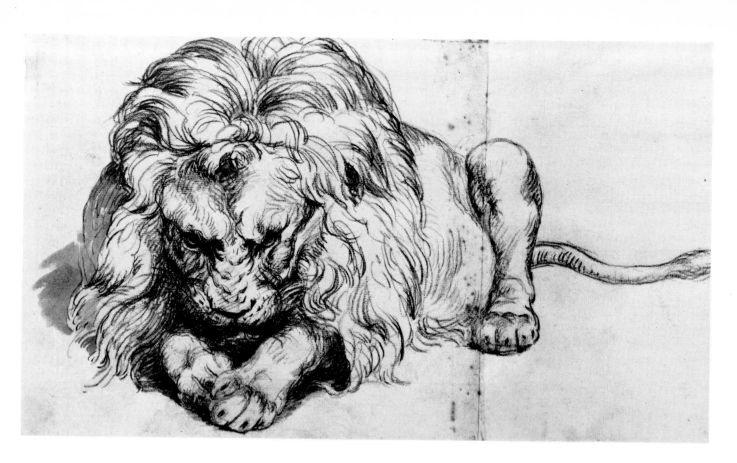

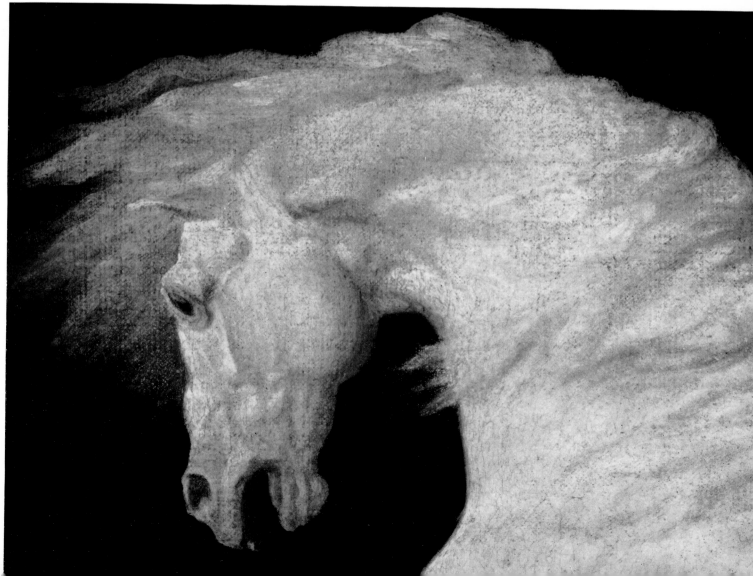

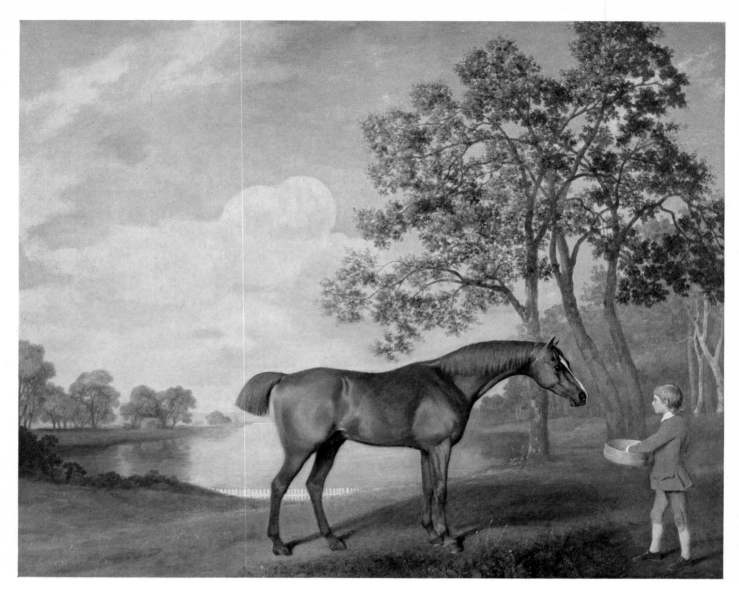

66. PUMPKIN WITH A STABLE-LAD. Dated 1774. $31\frac{1}{2} \times 39\frac{1}{4}$ in. Oil on panel. United States, Mr and Mrs Paul Mellon

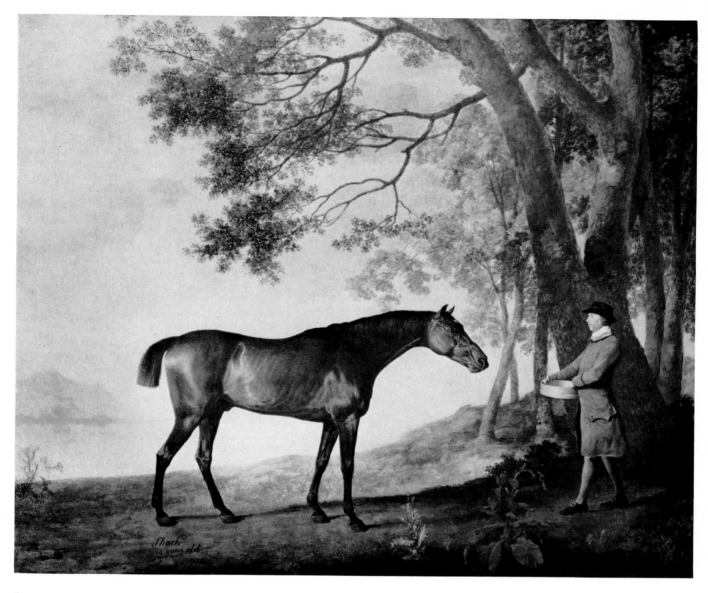

67. SHARK WITH HIS TRAINER, PRICE. Dated 1775. $31\frac{1}{2} \times 39\frac{1}{2}$ in. Oil on panel. Private Collection

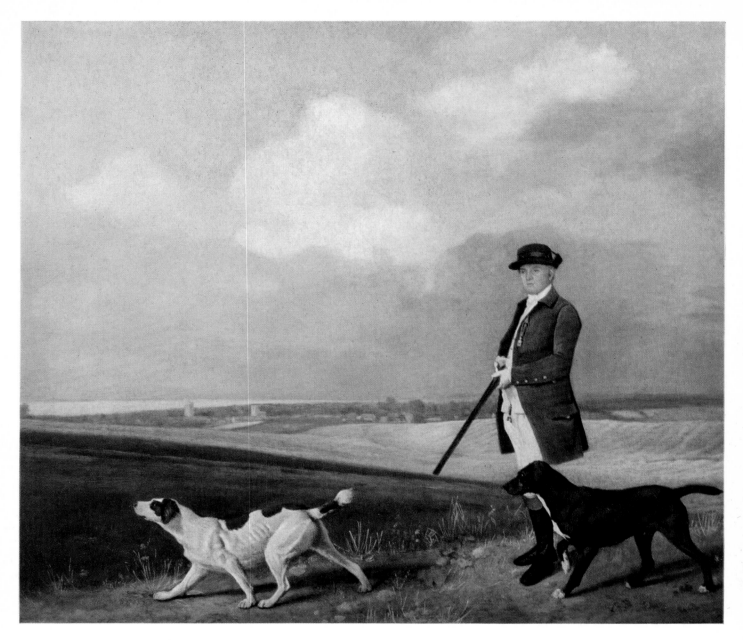

68. SIR JOHN NELTHORPE OUT SHOOTING WITH TWO POINTERS. Dated 1776. $23\frac{1}{4} \times 27\frac{3}{4}$ in. Oil on panel. Private Collection

For a portrait of John Nelthorpe as a child, see Plate 3.

69. LAURA WITH A JOCKEY AND A STABLE-LAD. Dated 1771. $24\frac{1}{2} \times 33$ in. Private Collection

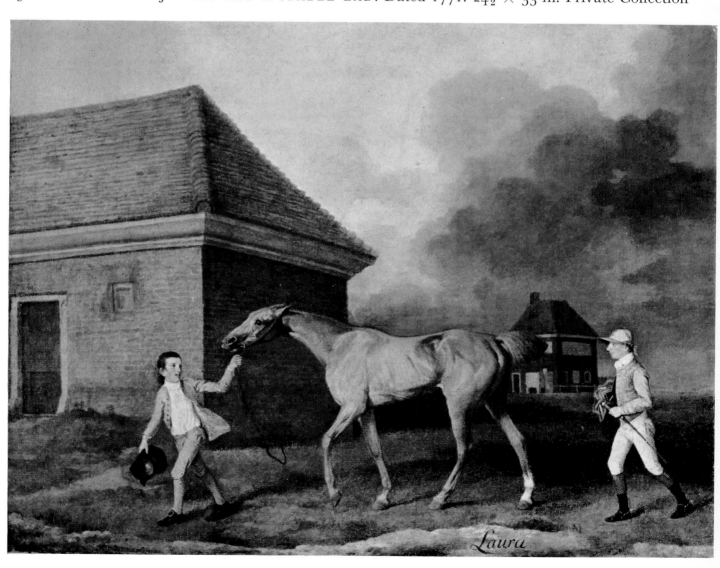

Laura

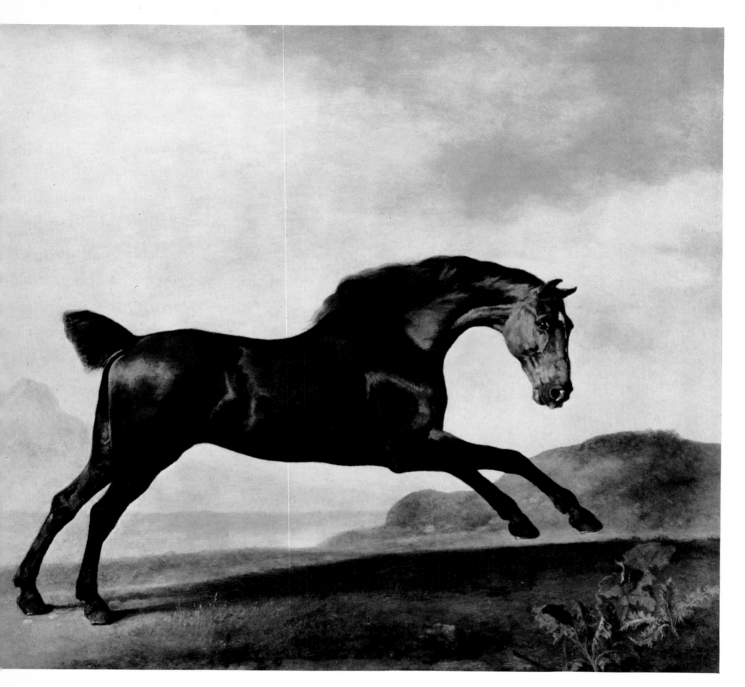

70. PRANCING HORSE BY A LAKE. Dated 1775. 23 × 27½ in. Mr H. J. Joel

71. INDIAN RHINOCEROS SLEEPING. 1772. 11⅛ × 17⅛ in.
Black and white chalk on grey paper. Private Collection

72. INDIAN RHINOCEROS. 1772. 27½ × 36½ in. London, Royal College of Surgeons

73. BABOON AND ALBINO MACAQUE MONKEY. 1770–5. 26 × 38 in. Oil on millboard. London, Royal College of Surgeons

This picture and the painting of a rhinoceros (Plate 72) were commissioned by the surgeon and anatomist, John Hunter, as exhibits for his scientific museum. It was his custom to obtain paintings or drawings of animals when he was unable to acquire specimens.

74. LEMUR. Date unknown. 7¾ × 12 in. Pencil on paper. London, British Museum

75. LEMURS. Date unknown. 7¾ × 12½ in. Pencil on paper. London, British Museum

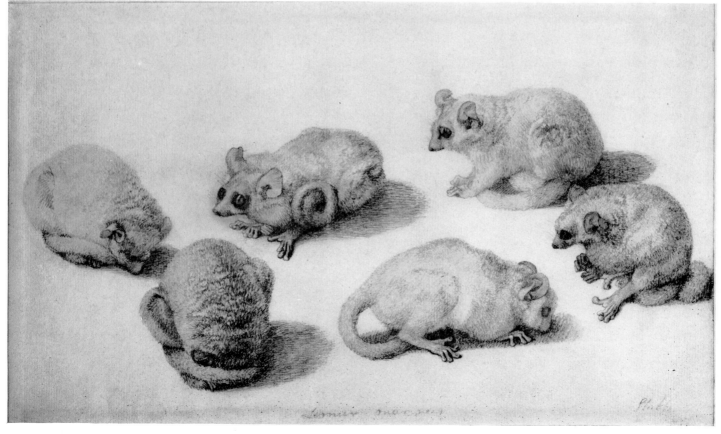

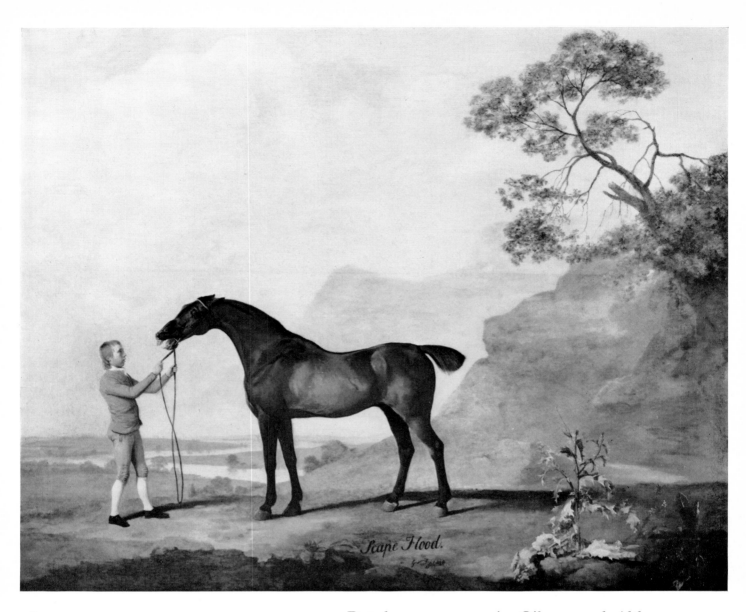

76, 77. SCAPEFLOOD WITH A STABLE-LAD. Dated 1777. 39 × 49 in. Oil on panel. Althorp, Earl Spencer

The artist evidently changed his first conception of the background, as a distant mountainous feature, painted over, appears to the left of the promontory in the foreground.

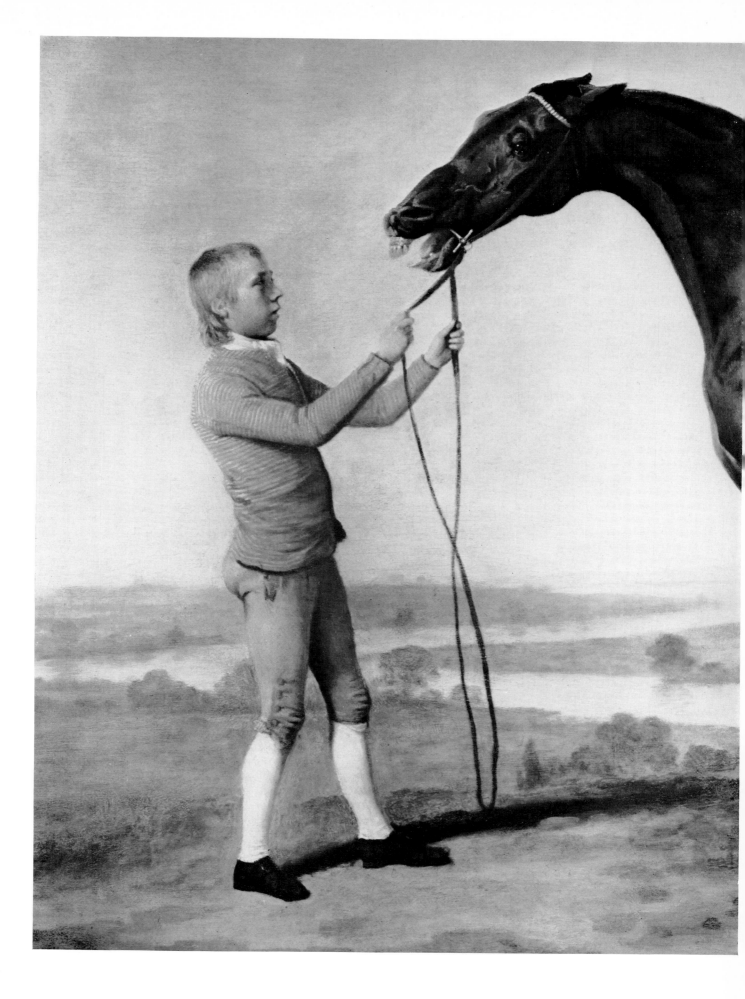

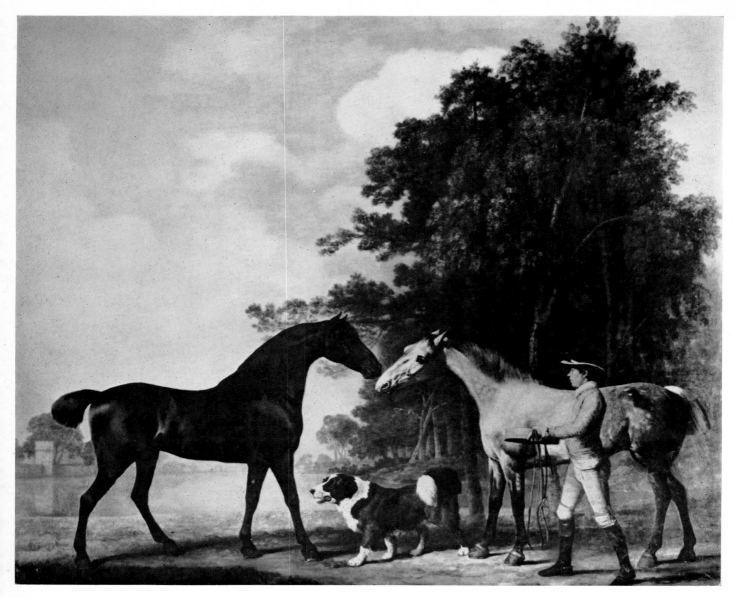

78, 79. TWO HUNTERS WITH A YOUNG GROOM AND A DOG. Dated 1778. $32 \times 39\frac{1}{2}$ in.
Oil on panel. Private Collection

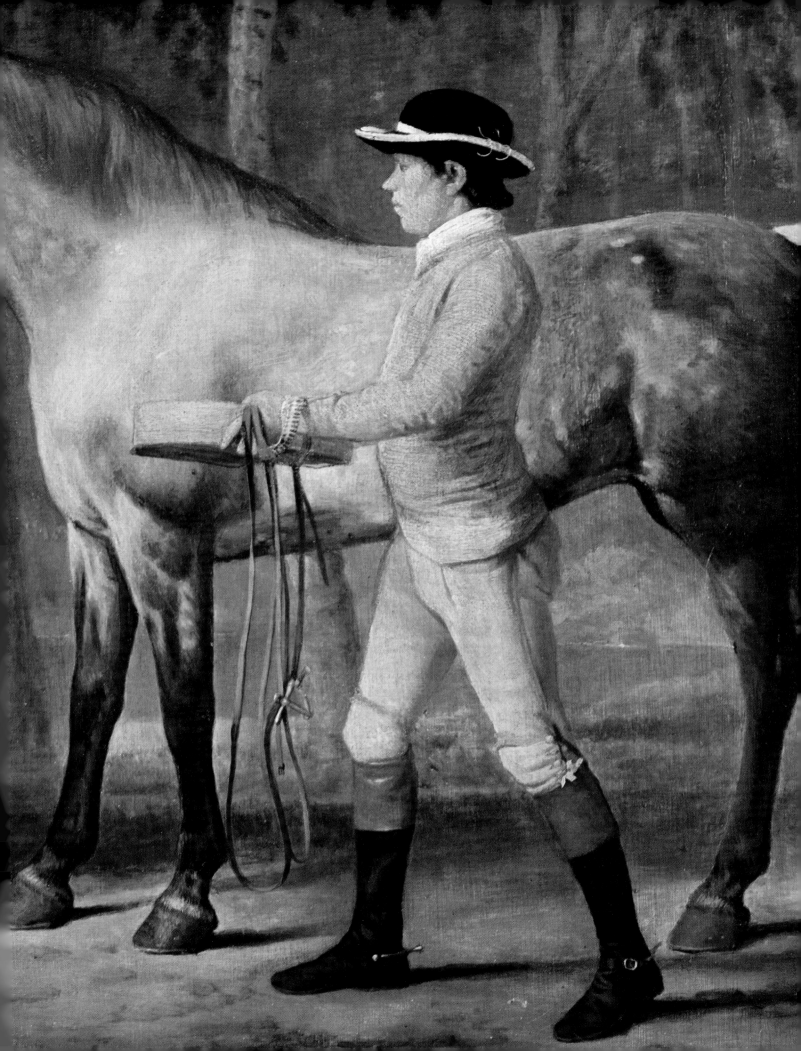

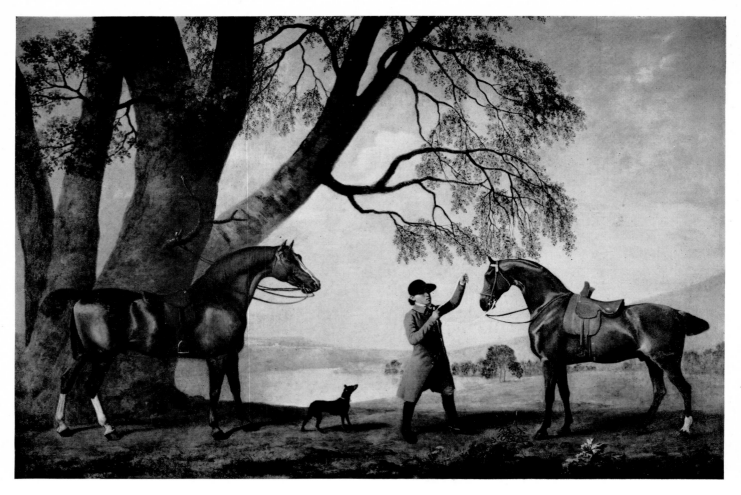

80. TWO HUNTERS WITH A GROOM AND A DOG. Dated 1779. $35\frac{1}{2} \times 53\frac{1}{2}$ in. Oil on panel.
Private Collection

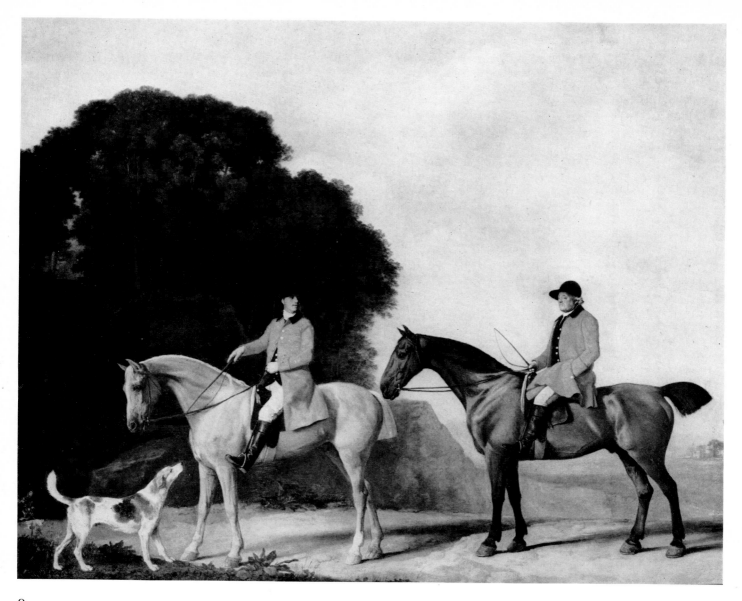

81. THOMAS SMITH, HUNTSMAN OF THE BROCKLESBY HOUNDS, AND HIS SON, TOM.
Dated 1776. $32\frac{1}{4} \times 39\frac{1}{2}$ in. Oil on panel. The Earl of Yarborough

It is an indication of Stubbs's contemporary artistic status that Charles Pelham, who had commissioned Reynolds two years earlier to make a large portrait of his wife, should have turned to Stubbs for a portrait of the huntsman of his famous pack of foxhounds.

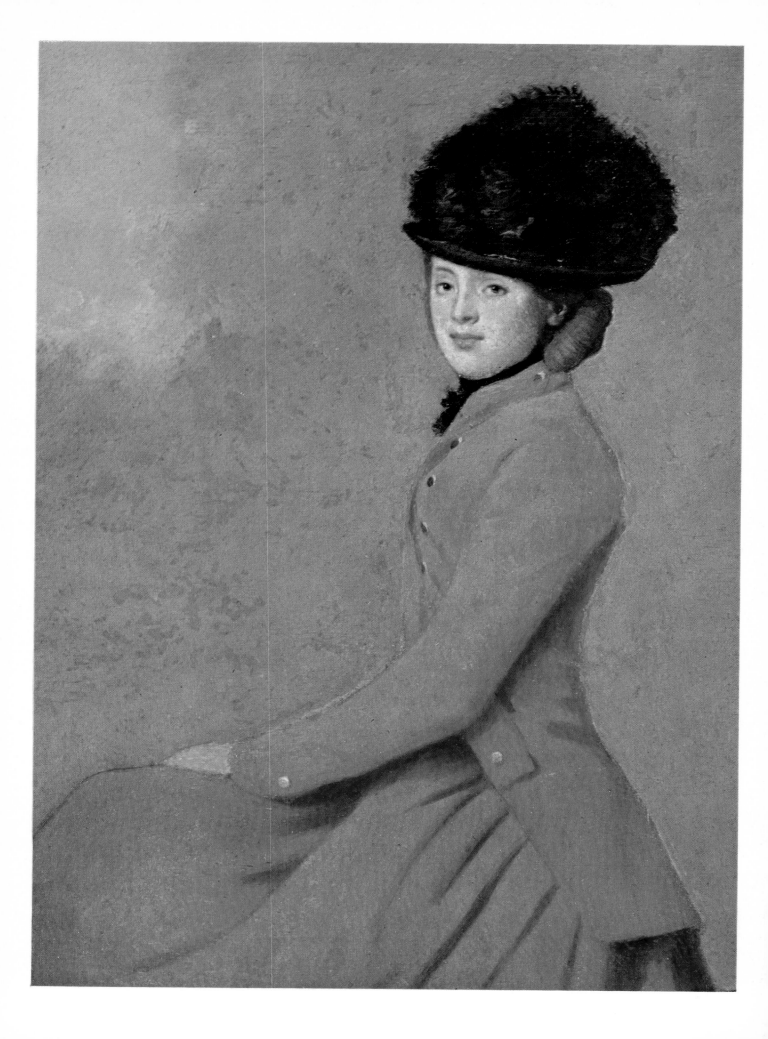

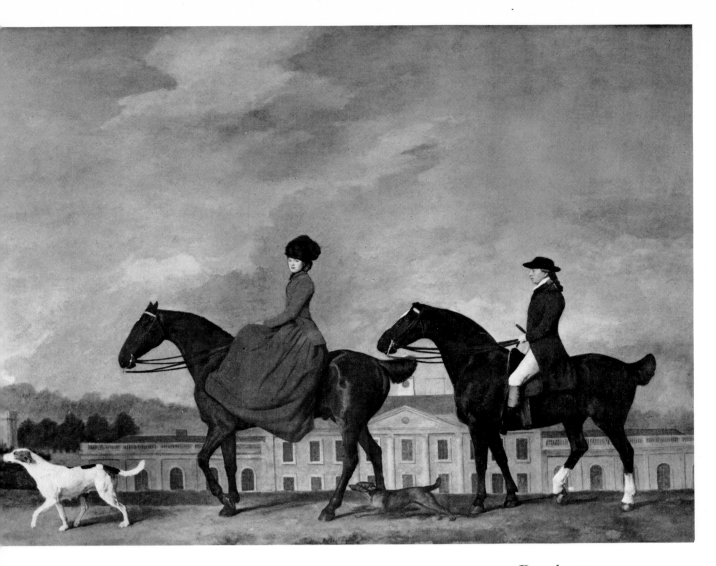

2, 83. JOHN AND SOPHIA MUSTERS OUT RIDING AT COLWICK HALL. Dated 1777.
8 × 50½ in. Oil on panel. Private Collection

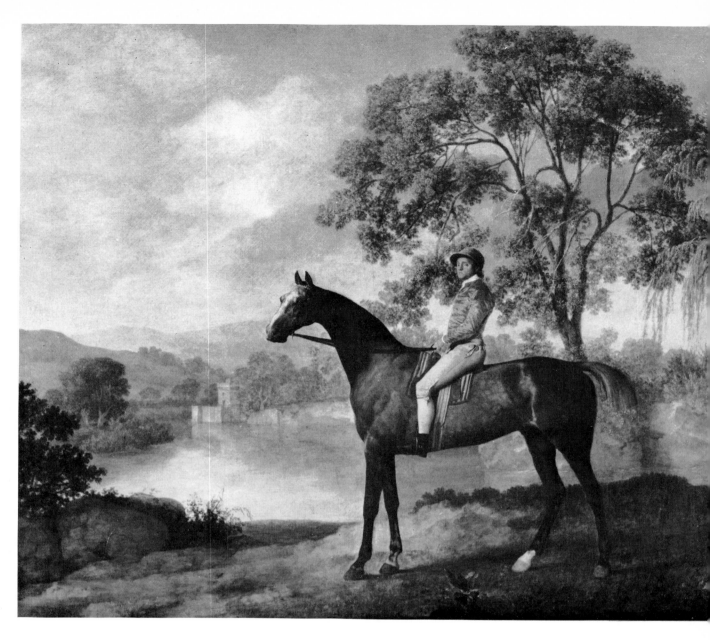

84. GREY HORSE WITH JOCKEY UP. Dated 1774. 34 × 39 in. Oil on panel. Private Collection

85. MAMBRINO. Dated 1779. 25 × 30 in. Oil on panel. Trustees of the Grosvenor Estate

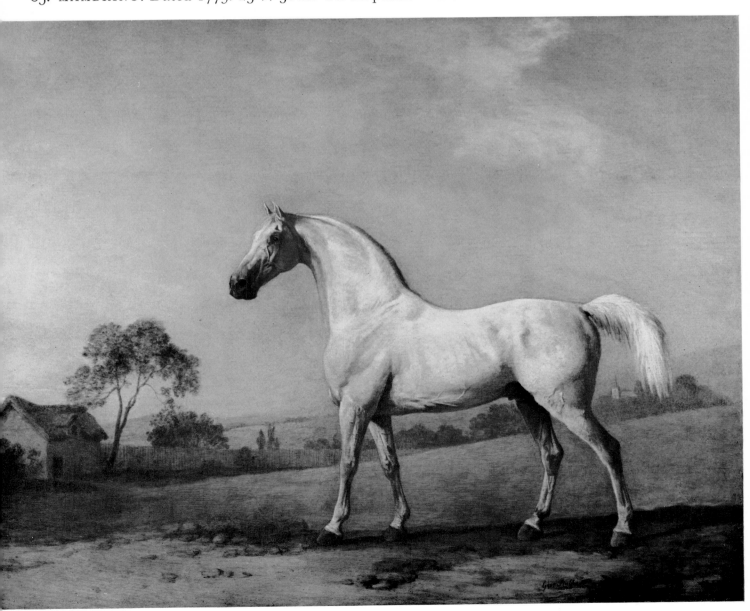

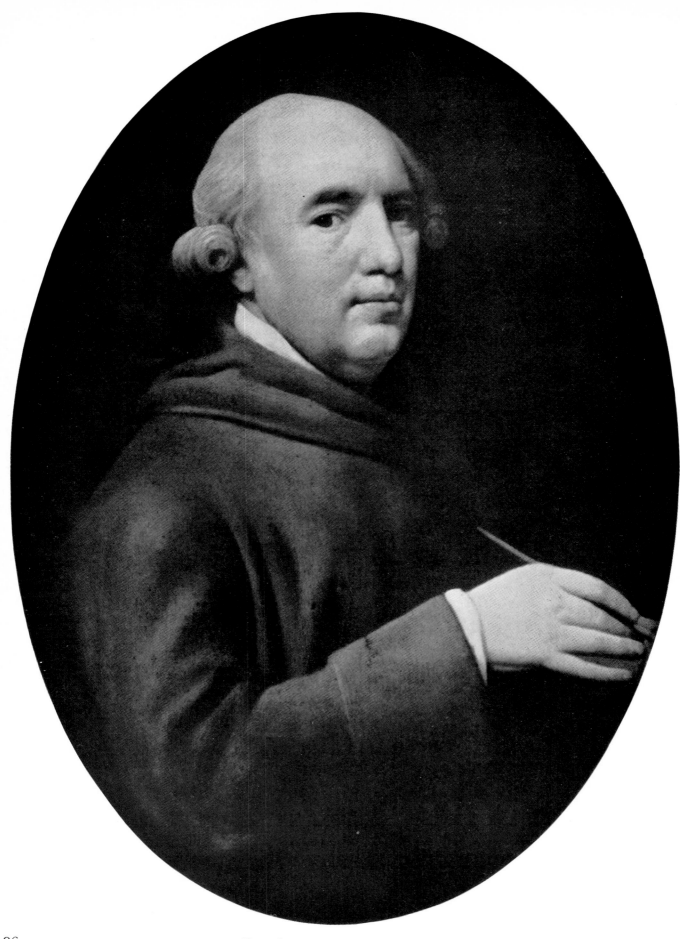

86. PORTRAIT OF THE ARTIST. Dated 1781. 27 × 20 in. Enamel on ceramic tablet. London,
National Portrait Gallery. The Frontispiece reproduces the study for this portrait.

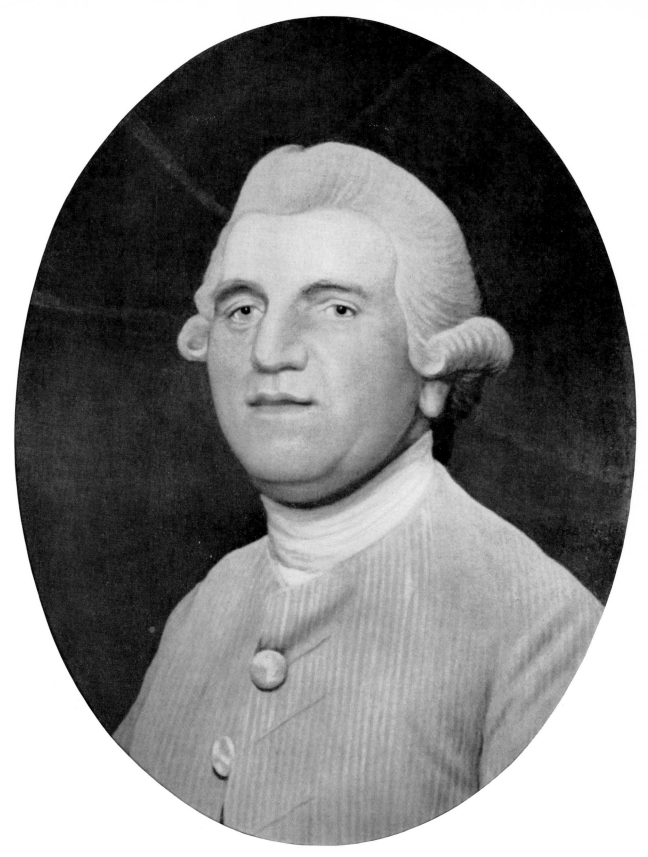

87. JOSIAH WEDGWOOD. Dated 1780. 20 × 16 in. Enamel on ceramic tablet. Barlaston, Wedgwood Museum

This was certainly not commissioned by the sitter but was probably made by the artist at a time when he was seeking to establish a reputation as a portrait painter in support of his claim to be considered as such.

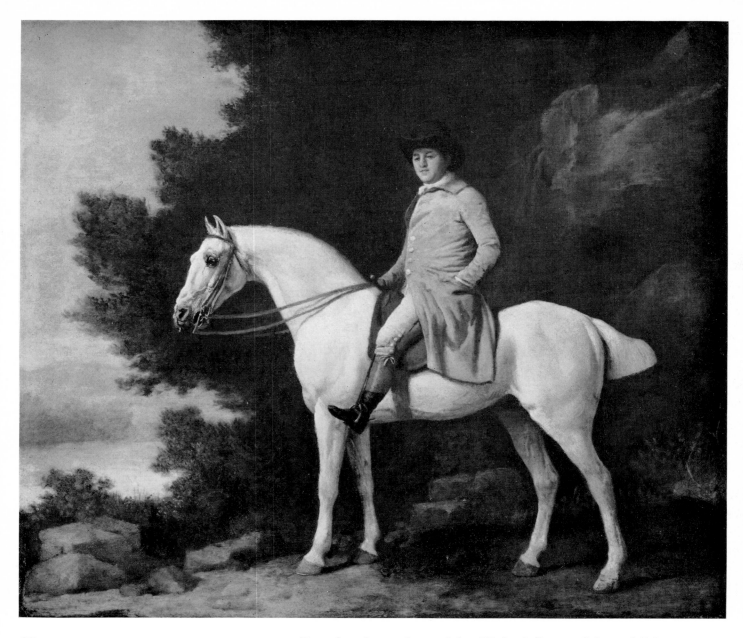

88. GENTLEMAN ON A GREY HORSE. Dated 1781. 23⅜ × 28 in. United States, Mr and Mrs Paul Mellon

89. PORTRAIT OF THE ARTIST ON A GREY HORSE. Dated 1782. 36½ × 27½ in. Enamel on ceramic tablet. Port Sunlight, Lady Lever Art Gallery

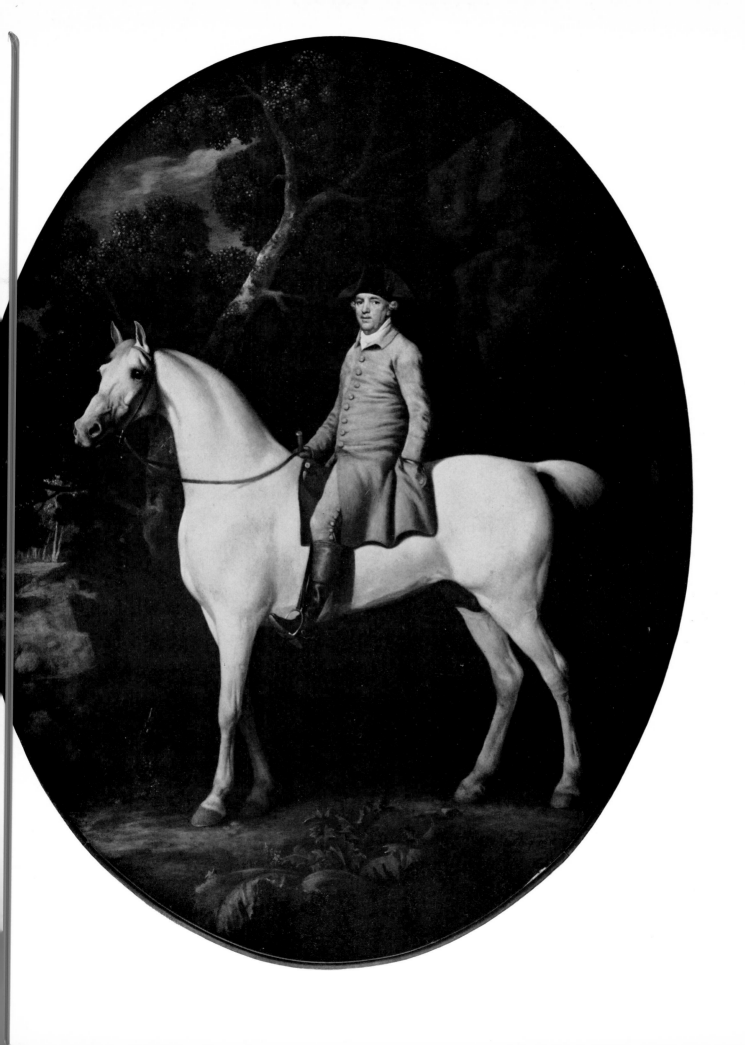

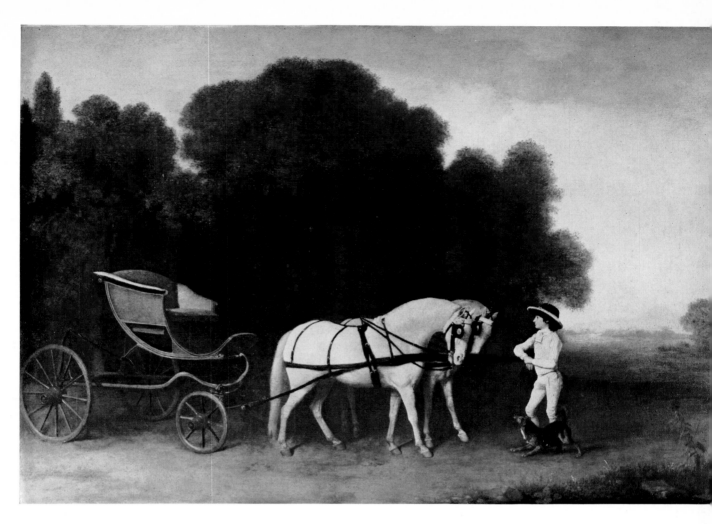

90, 91. PARK PHAETON WITH A PAIR OF CREAM PONIES IN CHARGE OF A STABLE-LAD WITH A DOG. 1780–5. $35\frac{1}{4} \times 53\frac{1}{2}$ in. United States, Mr and Mrs Paul Mellon

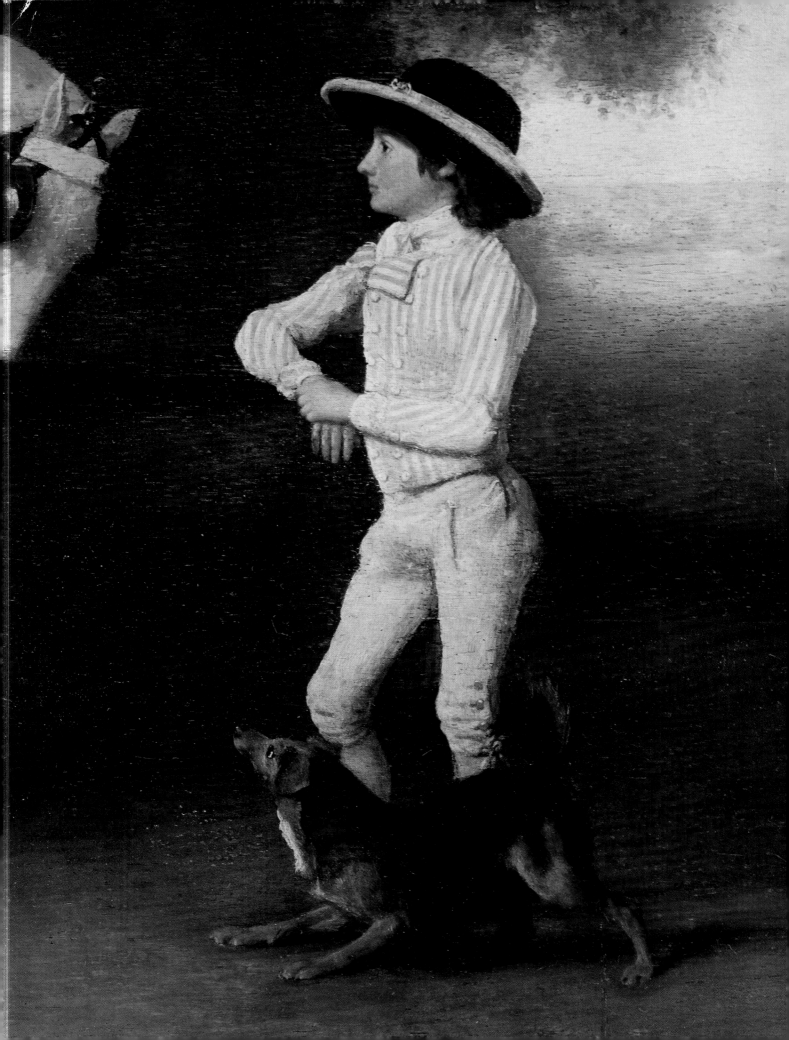

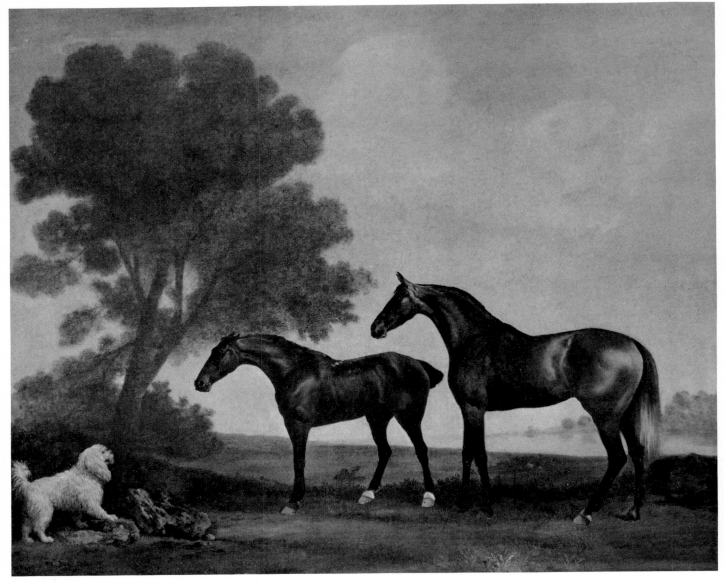

92. HUNTER, ARAB AND WATER SPANIEL. 1780–90. 39 × 49 in. Formerly Mrs J. V. Bank

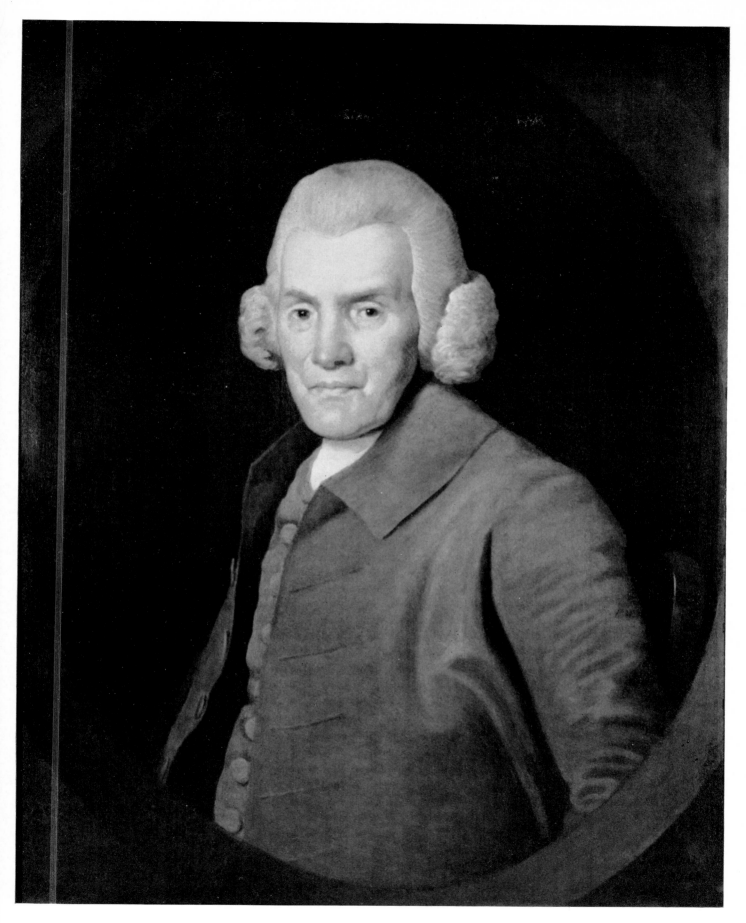

93. RICHARD WEDGWOOD. 1780. 28 × 23 in. Oil on panel. Barlaston, Wedgwood Museum

The sitter was the father-in-law of Josiah Wedgwood (see Plate 87).

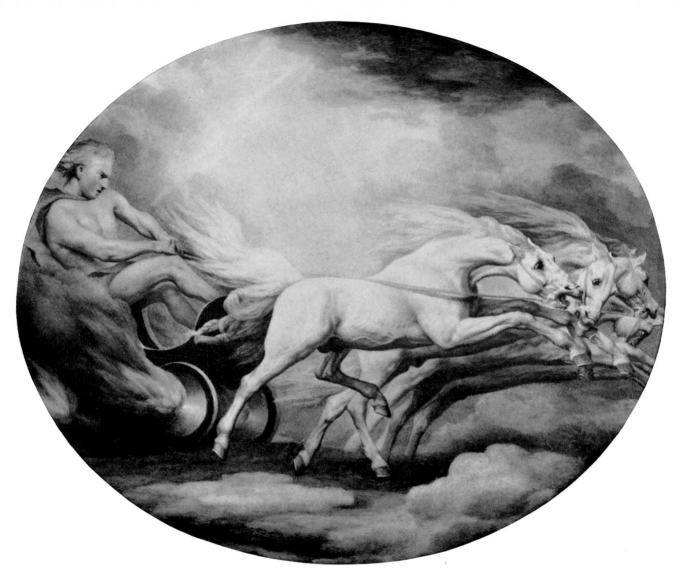

94. PHAETON. Dated 1775. 14¾ × 18 in. Enamel on copper. Private Collection

95. PHAETON. 1780. $10\frac{1}{2} \times 19\frac{3}{8}$ in. Wedgwood plaque, blue and white basalt relief. Port Sunlight, Lady Lever Art Gallery

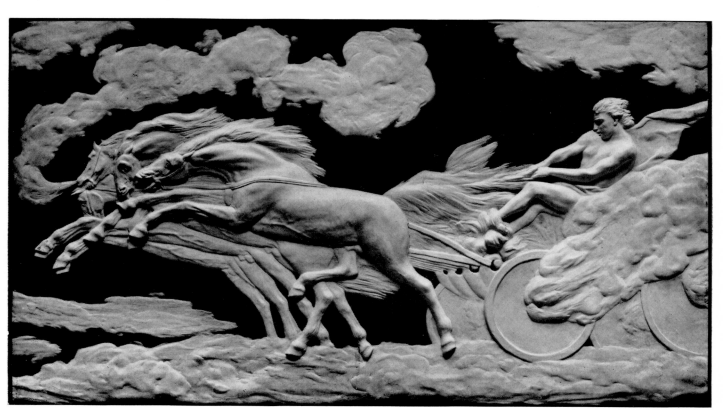

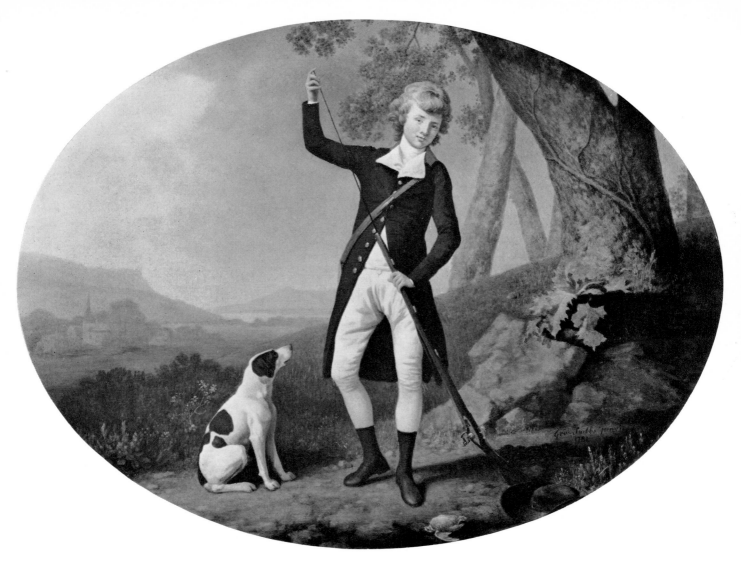

96. YOUNG GENTLEMAN [MR HUTH?] PREPARING TO SHOOT. Dated 1781. 18 × 24½ in.
Enamel on ceramic tablet. Private Collection

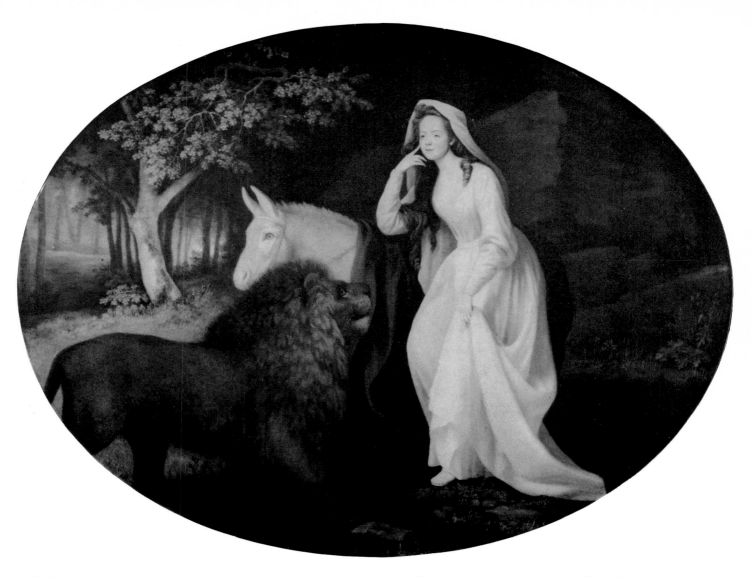

97. ISABELLA SALTONSTALL AS UNA FROM SPENSER'S 'FAERIE QUEENE'. Dated 1782.
$18\frac{1}{2}$ × 25 in. Enamel colours on Wedgwood tablet. Private Collection

Miss Saltonstall was to give Stubbs financial aid in the last impoverished years of his life.

98. AN OLD HUNTER, ORINOCO, WITH A DOG. Dated 1780. 22 × 28 in. Private Collection

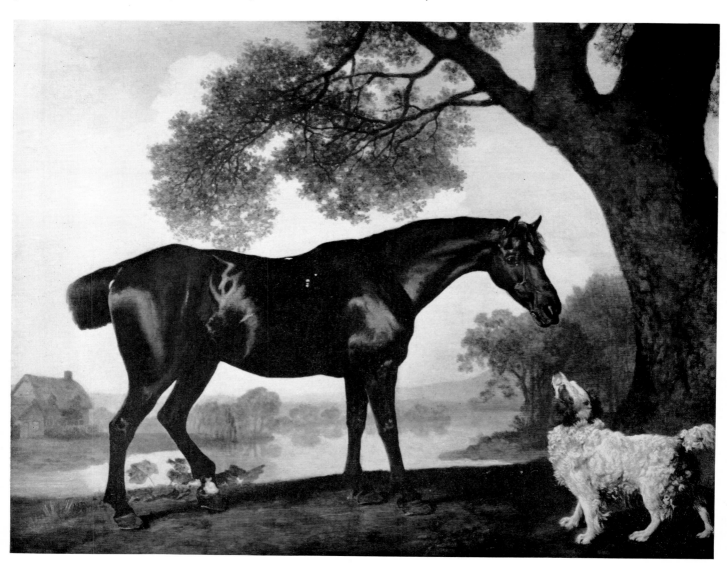

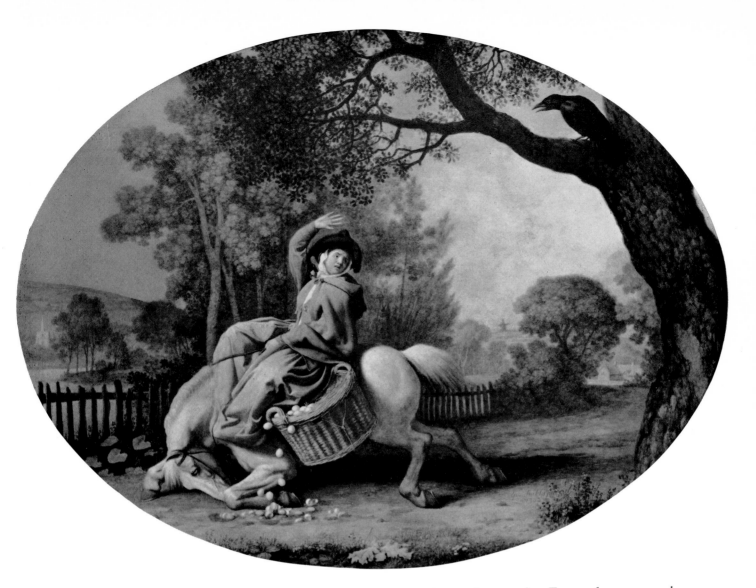

99. 'THE FARMER'S WIFE AND THE RAVEN.' Dated 1782. $27\frac{1}{2} \times 37$ in. Enamel on ceramic tablet. Port Sunlight, Lady Lever Art Gallery

The subject is taken directly from one of the fables by John Gay.

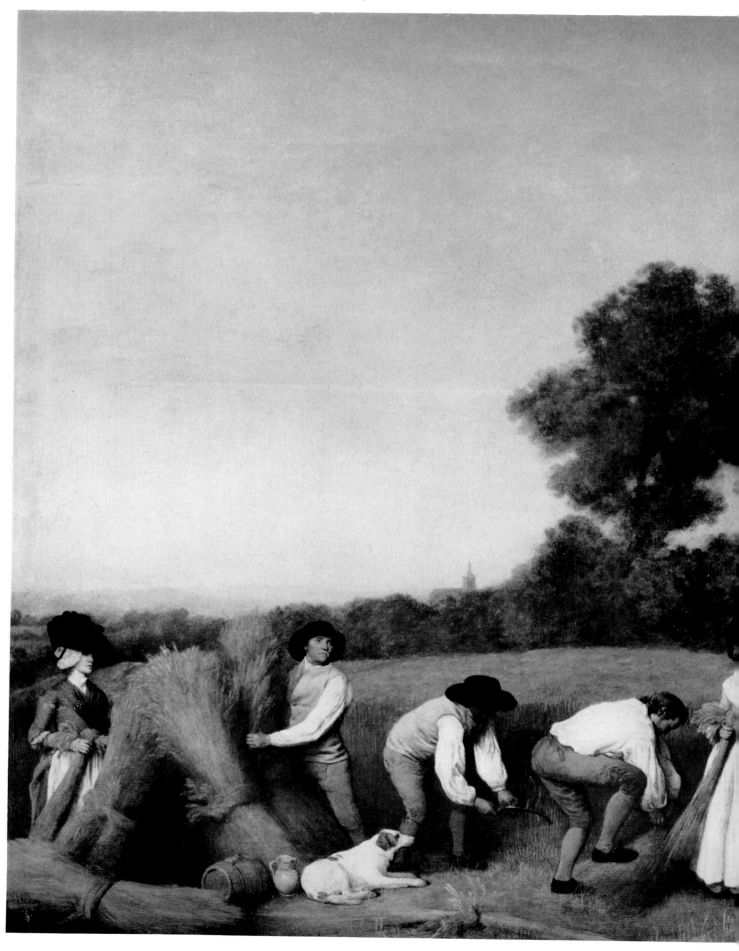

100. REAPERS. Dated 1784. 35½ × 54 in. Oil on panel. Private Collection

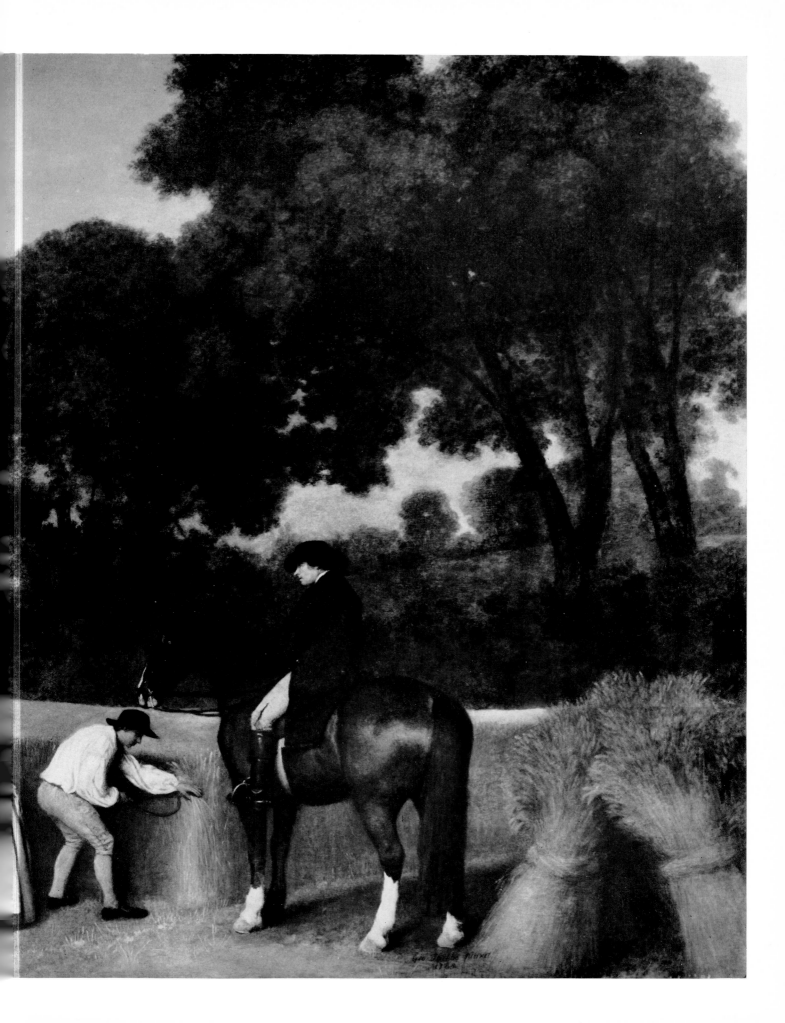

101. Detail from REAPERS (Plate 100)

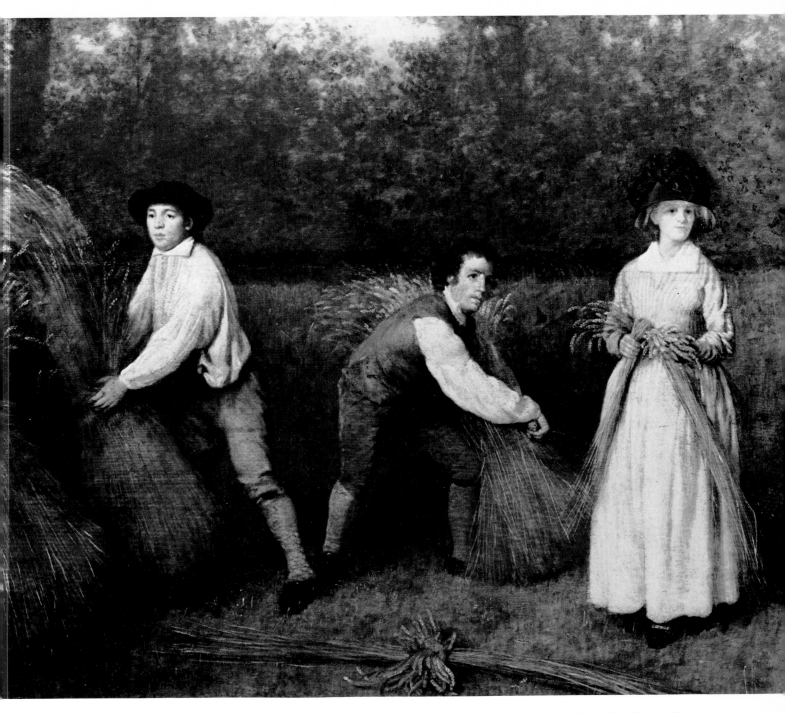

102. Detail from REAPERS. Dated 1783. Oil on panel. Upton House, Banbury, The National Trust (Bearsted Collection)

103. HAYMAKERS. Dated 1785. $35\frac{1}{2} \times 54$ in. Oil on panel. Private Collection

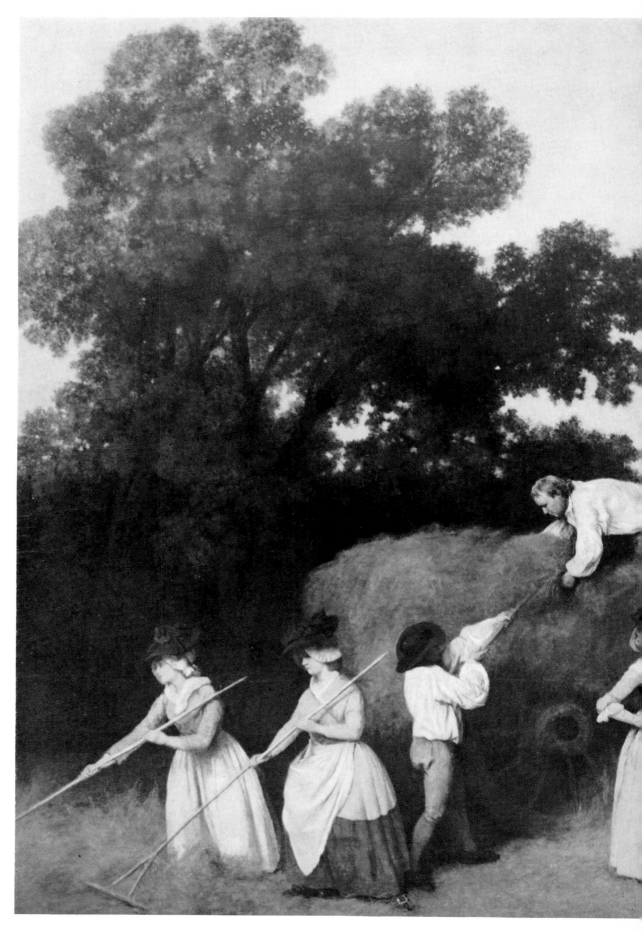

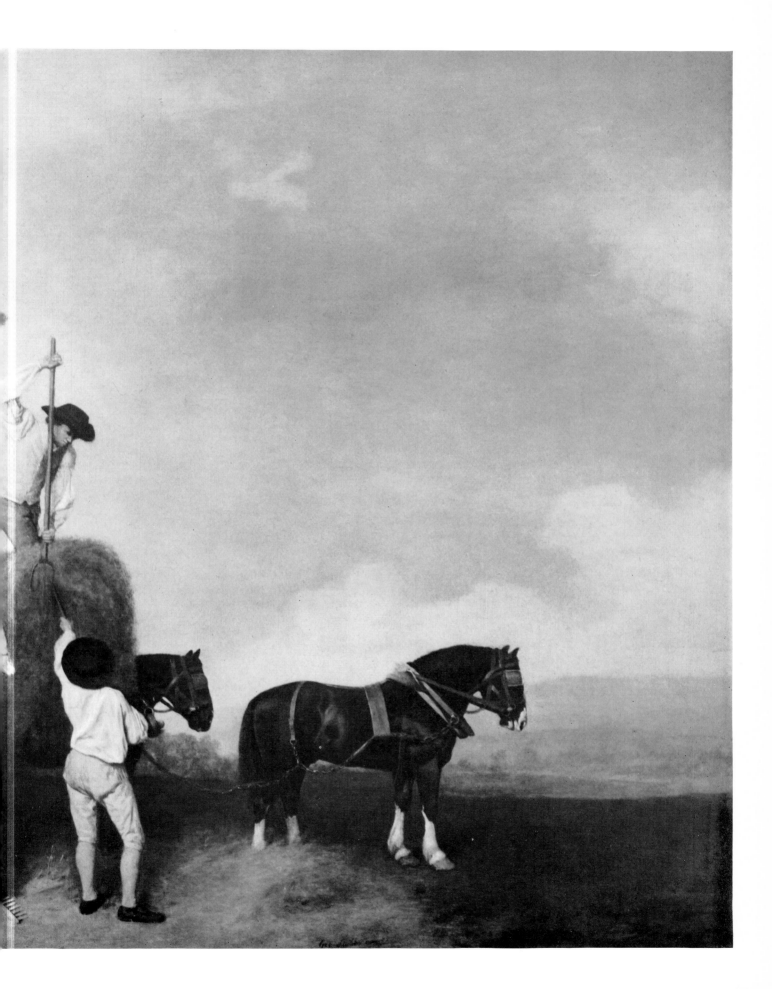

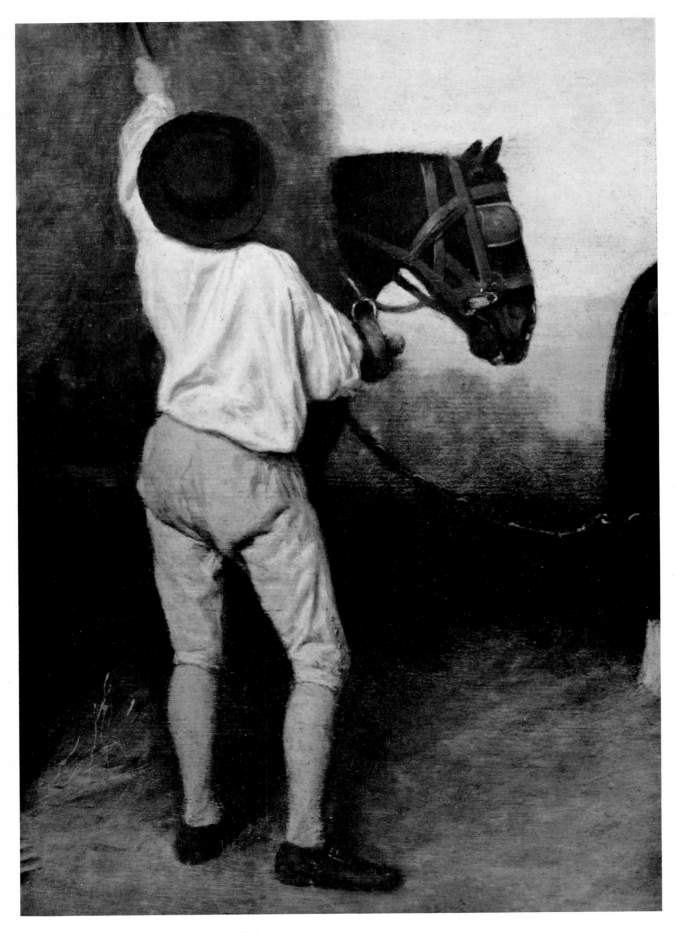

104. Detail from HAYMAKERS (Plate 103)

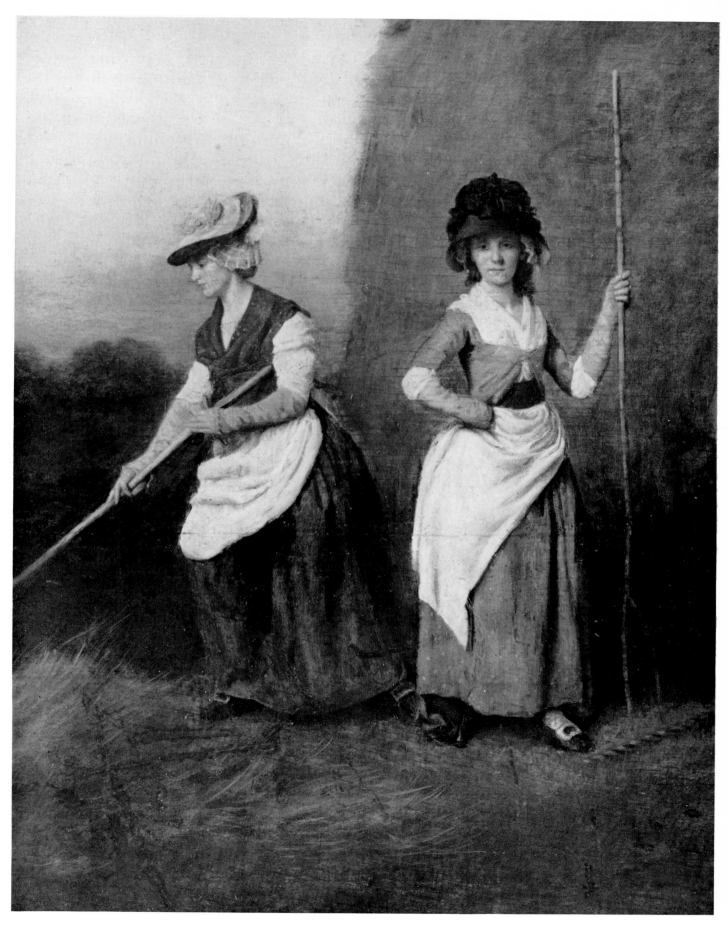

105. Detail from HAYMAKERS. Dated 1783. Oil on panel. Upton House, Banbury, The National Trust (Bearsted Collection)

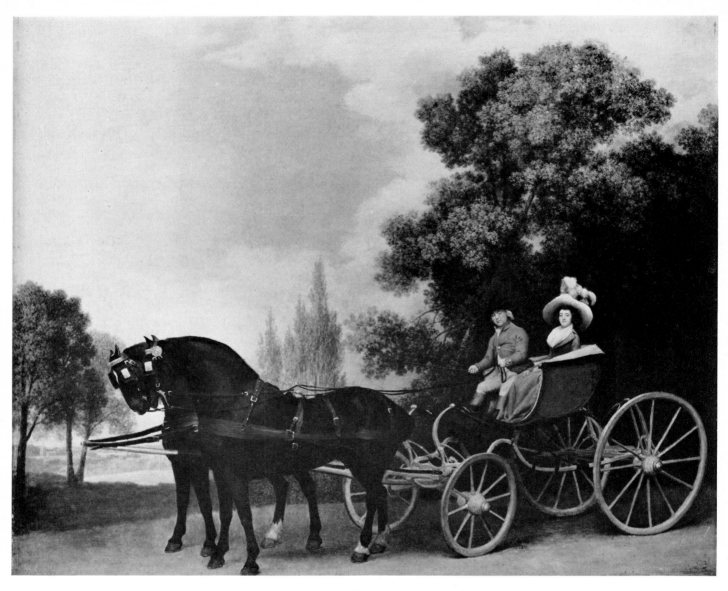

106. LADY AND GENTLEMAN IN A PHAETON. Dated 1787. 32½ × 40 in. Oil on panel. London, National Gallery

107. Detail from Plate 106

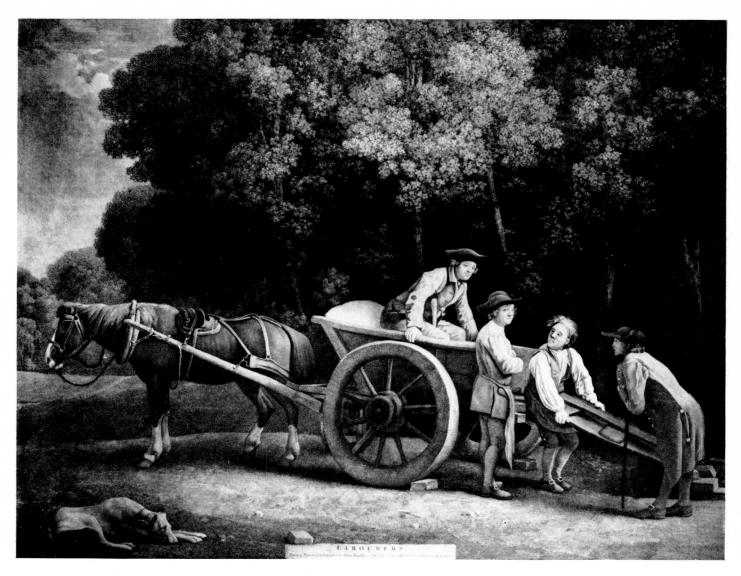

108. LABOURERS. Dated 1789. $20\frac{5}{8} \times 27\frac{5}{8}$ in. Mezzotint (mixed method)

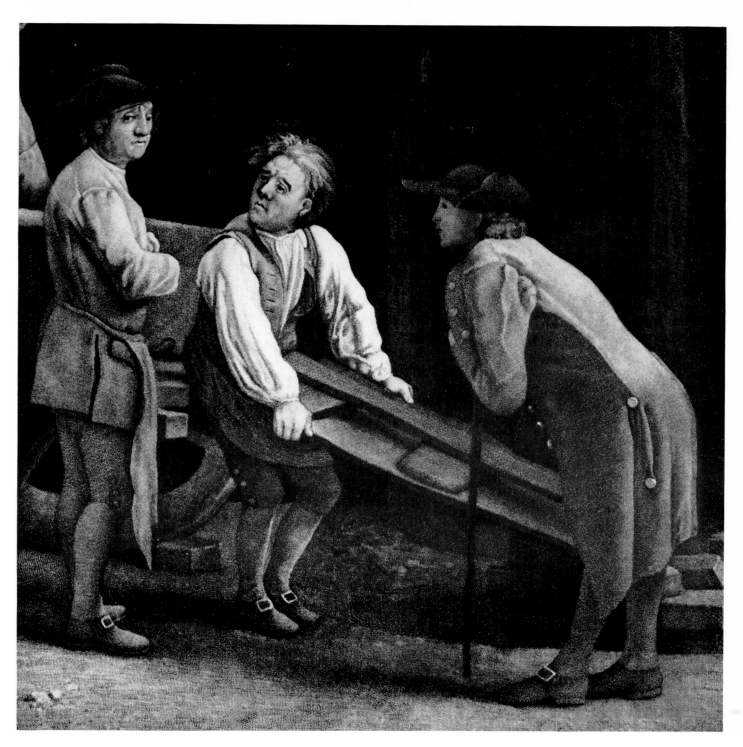

109. Detail from Plate 108

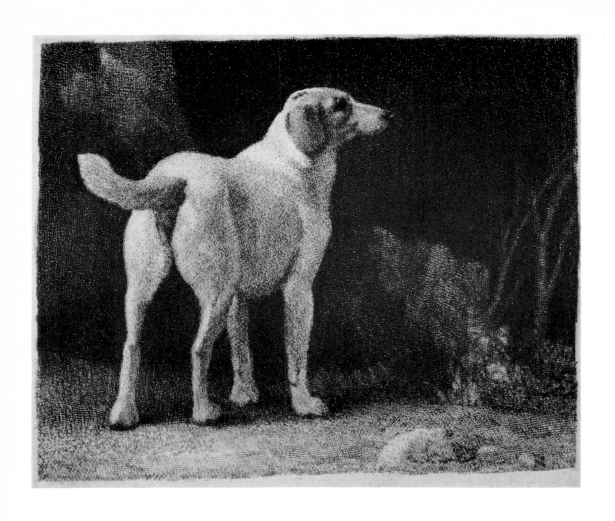

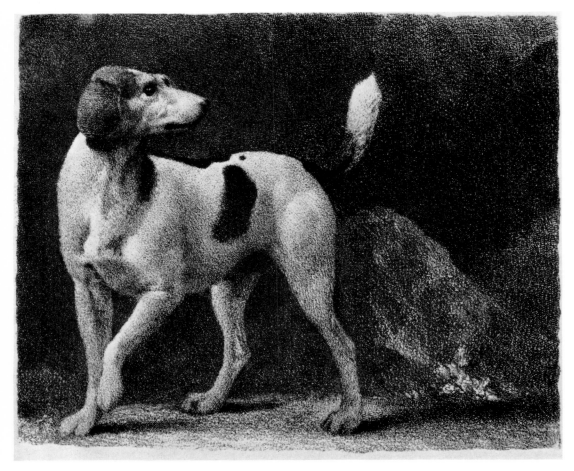

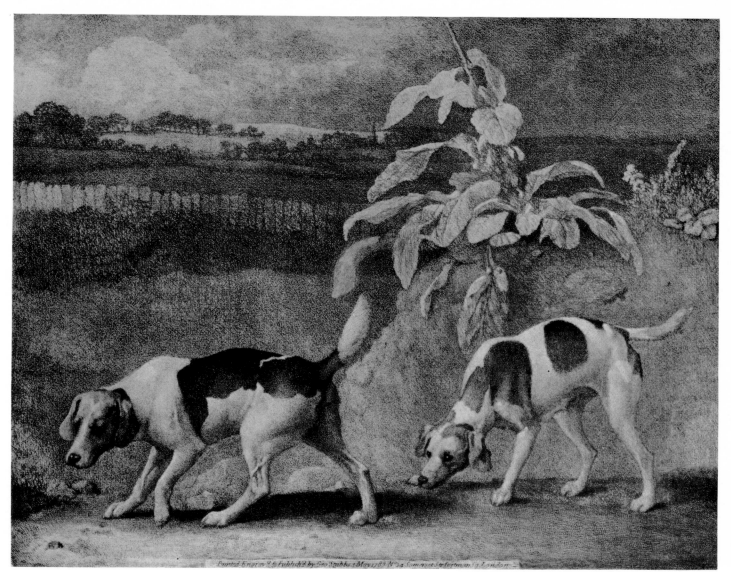

112. TWO FOXHOUNDS IN A LANDSCAPE. Dated 1788. $7\frac{1}{2} \times 9$ in. Mezzotint (mixed method)

110. FOXHOUND VIEWED FROM BEHIND. Dated 1788. $3\frac{3}{8} \times 4\frac{1}{8}$ in. Mezzotint (mixed method)

111. FOXHOUND. Dated 1788. $3\frac{5}{8} \times 4\frac{1}{2}$ in. Mezzotint (mixed method)

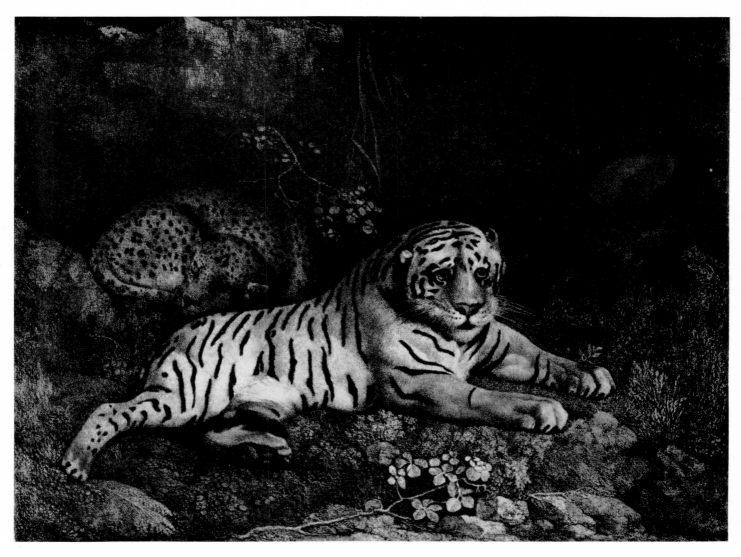

113. TIGER AND SLEEPING LEOPARD. Dated 1788. 9 × 12⅛ in. Mezzotint (mixed method)

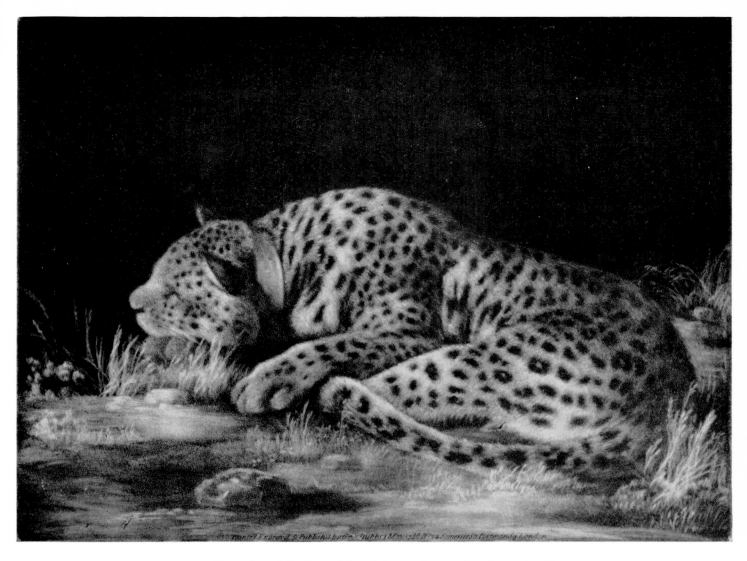

114. SLEEPING CHEETAH. Dated 1788. 6 × 8 in. Mezzotint (mixed method)

This must be the same animal as that represented in Plate 43.

115. TWO OLD HUNTERS BY A LAKE. Dated 1790. $26\frac{1}{2} \times 39$ in. Private Collection

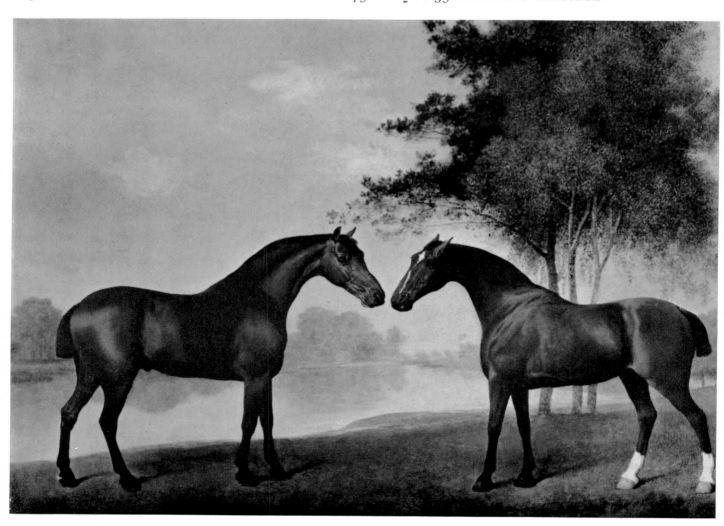

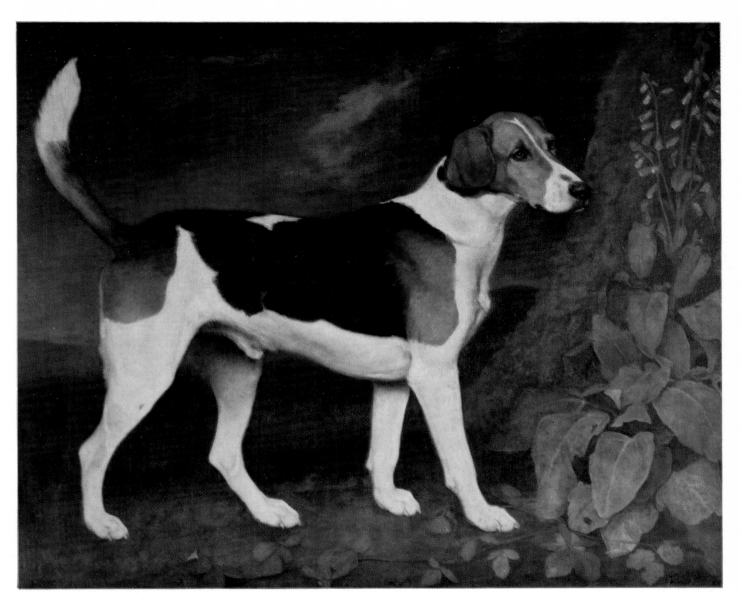

116. A FOXHOUND, RINGWOOD. Dated 1792. $39\frac{1}{2} \times 49\frac{1}{2}$ in. The Earl of Yarborough

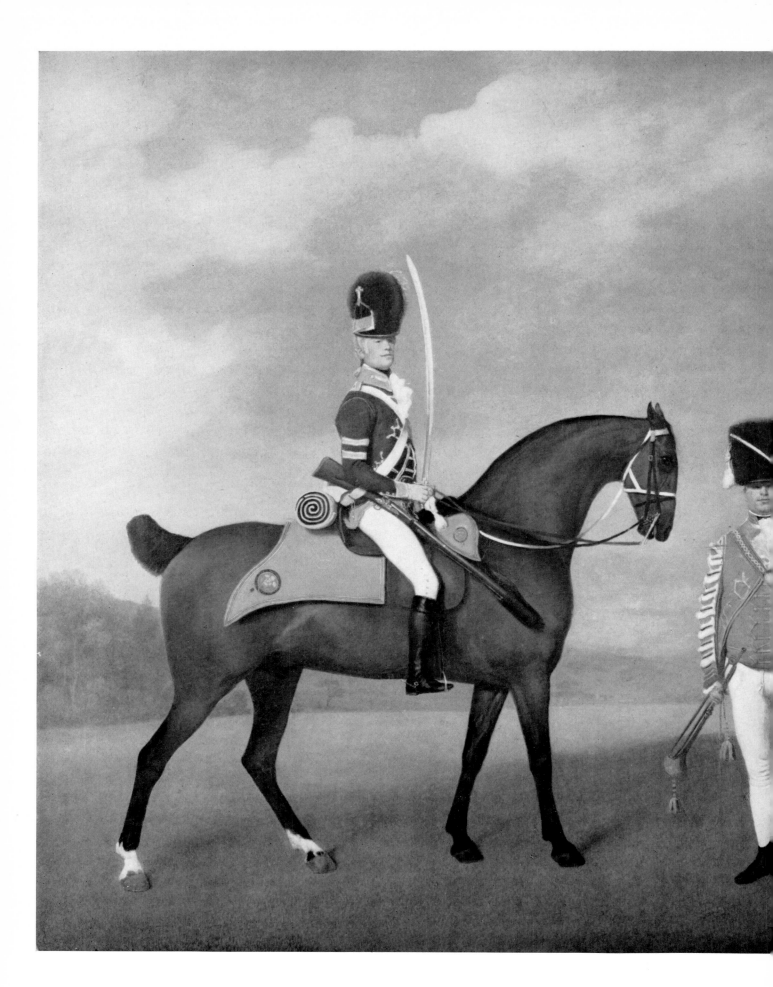

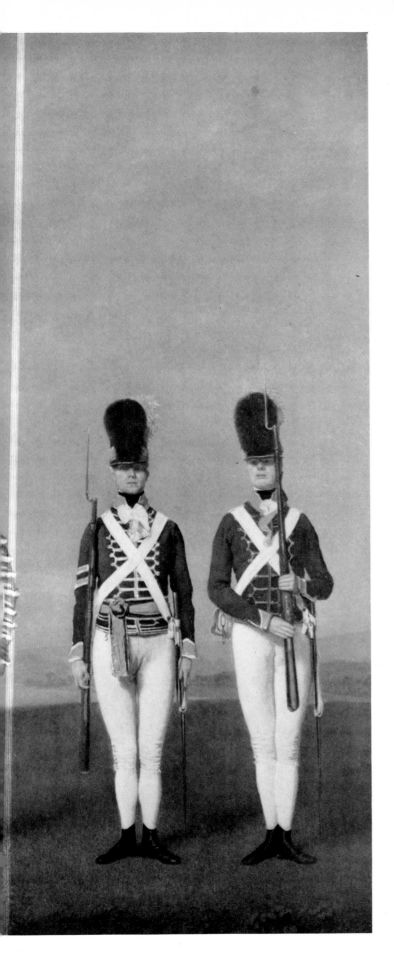

117. SOLDIERS OF THE 10TH LIGHT
DRAGOONS. Dated 1793. 40 × 50 in. Windsor
Castle, Royal Collection. *Reproduced by gracious
permission of Her Majesty The Queen*

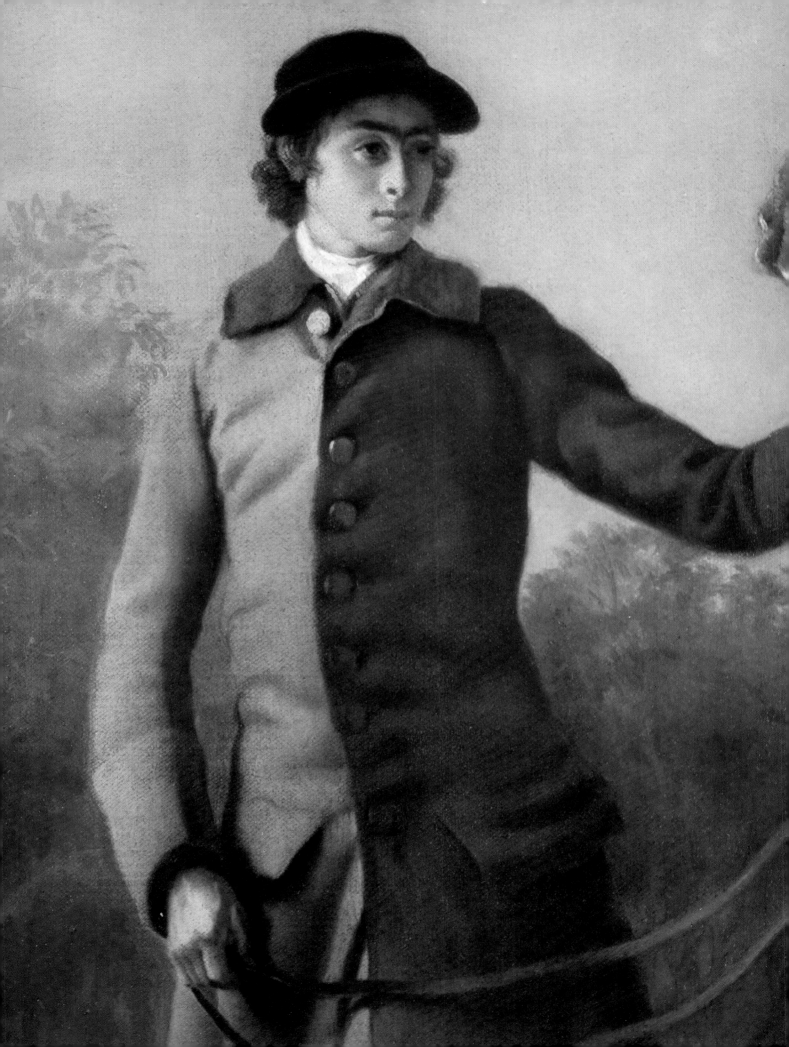

118. Groom.
Detail from a portrait
of the racehorse Lustre,
painted about 1760.
Approximately
actual size

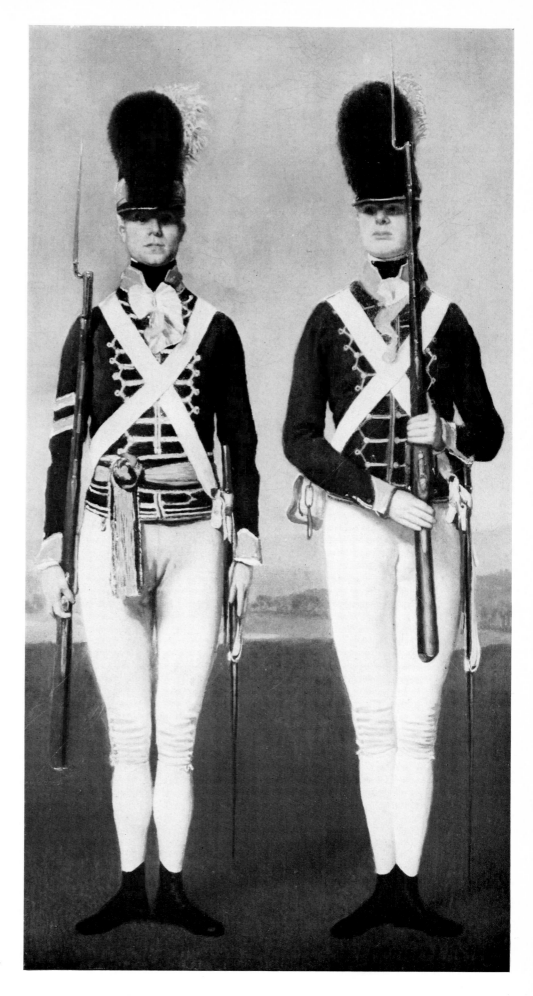

119. Sergeant and Private.
Detail from Plate 117

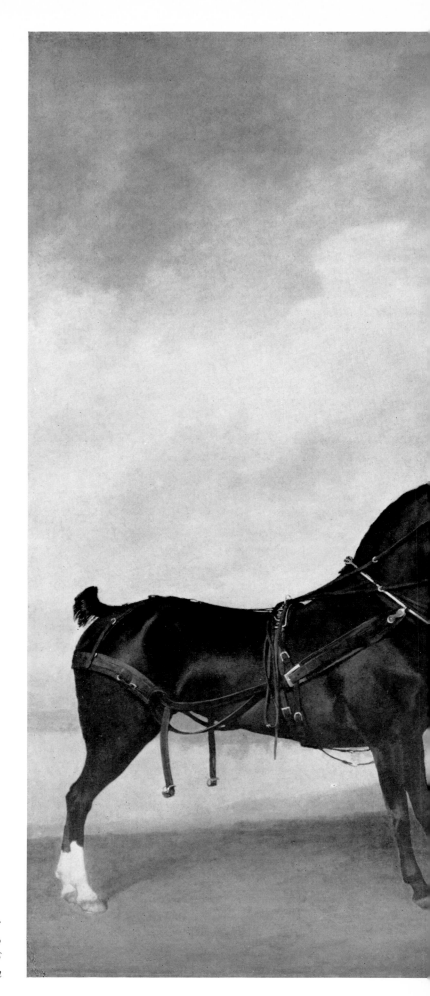

120. THE PRINCE OF WALES'S PHAETON.
Dated 1793. 40¼ × 50½ in. Windsor Castle,
Royal Collection. *Reproduced by gracious
permission of Her Majesty The Queen*

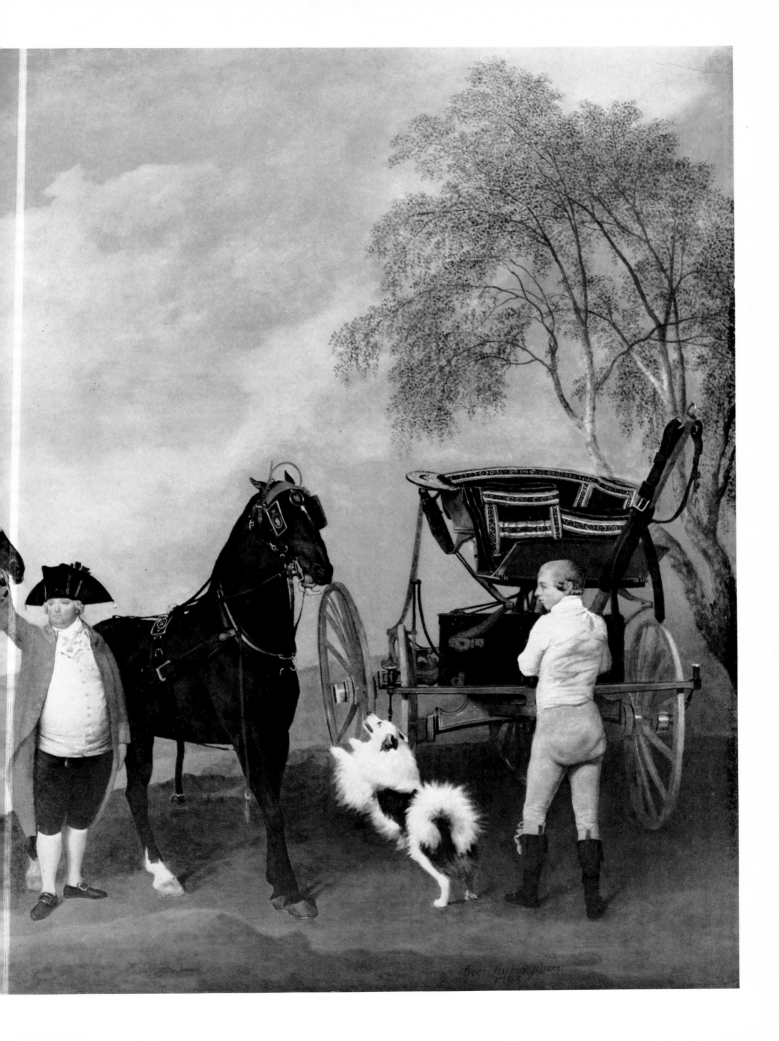

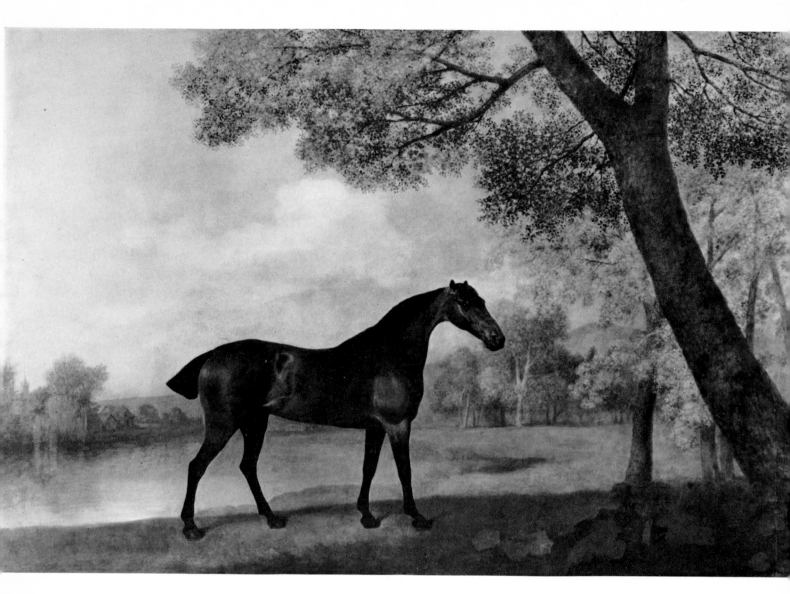

121. HUNTER BY A LAKE. Dated 1787. 36 × 54 in. United States, Mr and Mrs Paul Mellon

122. FINO AND TINY. Dated 179[?1]. 40 × 50 in. Buckingham Palace, Royal Collection.
Reproduced by gracious permission of Her Majesty The Queen

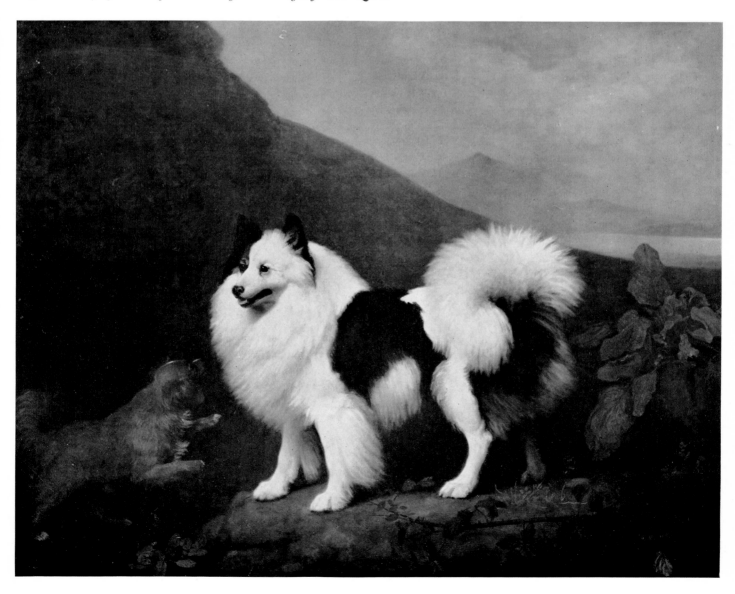

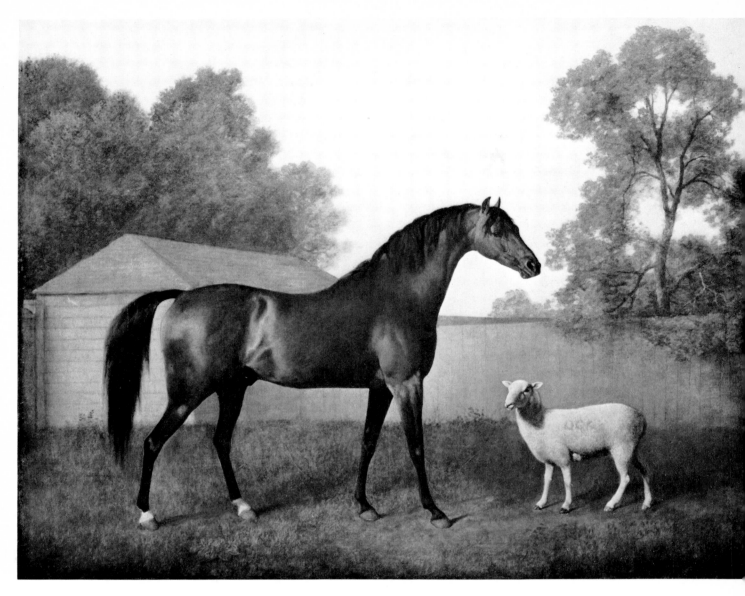

123. DUNGANNON. 1793. 40 × 50 in. Lord Irwin

The sheep represented here was Dungannon's constant companion.

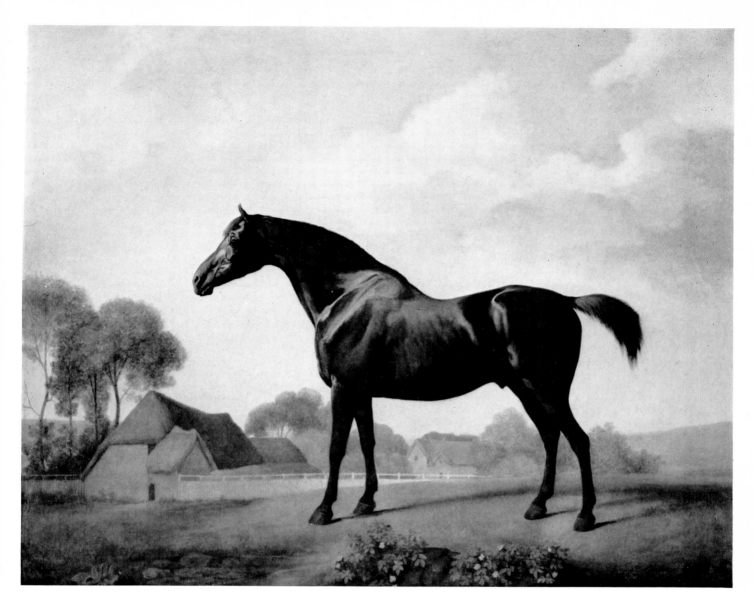

124. SWEETBRIAR. Dated 1779. 39 × 49 in. Lord Irwin

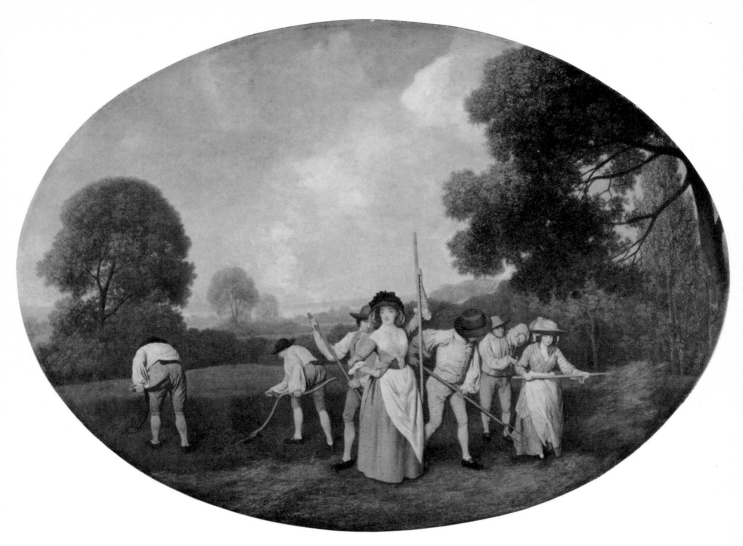

125. HAYMAKERS. Dated 1794. $28\frac{1}{2} \times 39\frac{1}{2}$ in. Enamel on ceramic tablet. Port Sunlight, Lady Lever Art Gallery

126. RED DEER STAG AND HIND. Dated 1792. 39¾ × 50¼ in. Windsor Castle, Royal Collection.
Reproduced by gracious permission of Her Majesty The Queen

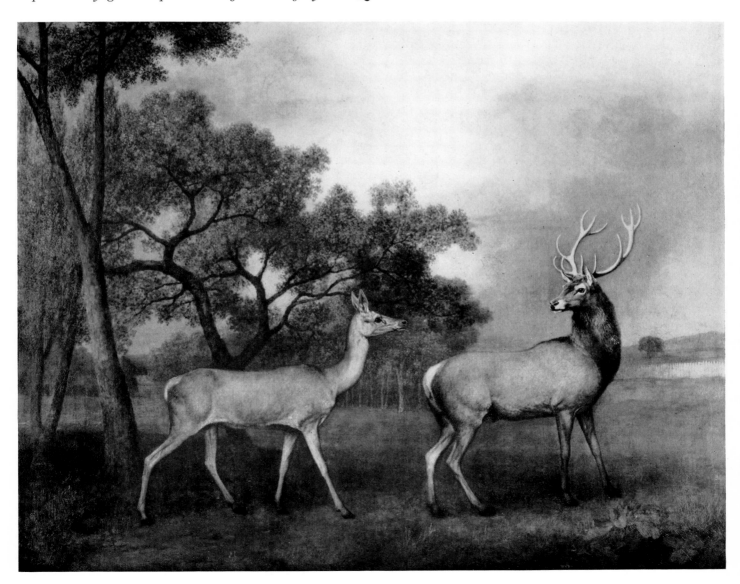

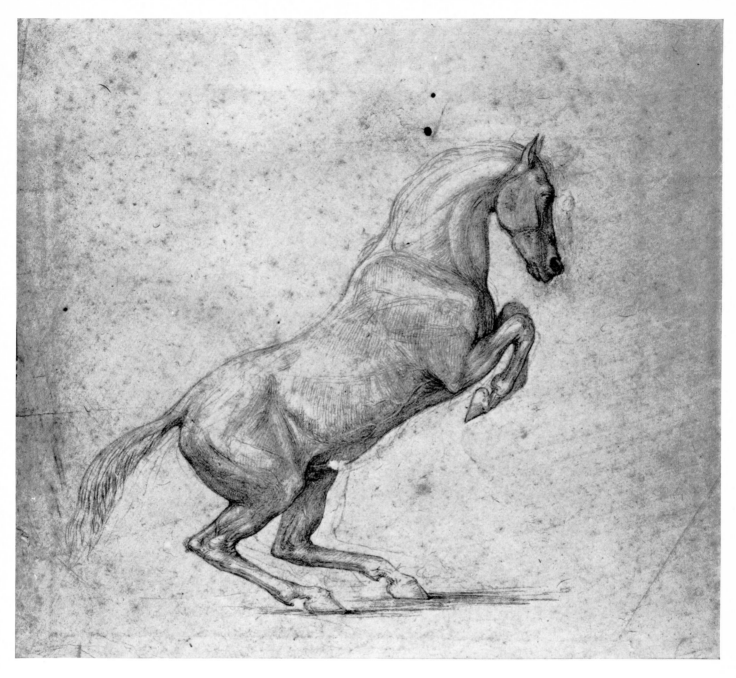

127. PRANCING HORSE. Date unknown. $8\frac{3}{4} \times 9\frac{1}{2}$ in. Red chalk on white paper. United States, Mr and Mrs Paul Mellon

128. WARREN HASTINGS ON HORSEBACK. Dated 1791. $34 \times 25\frac{1}{2}$ in. Enamel on ceramic tablet. Lord Rothermere

This is almost certainly not the version of the portrait originally commissioned by Hastings, for whom Stubbs also made a separate portrait of the horse depicted here.

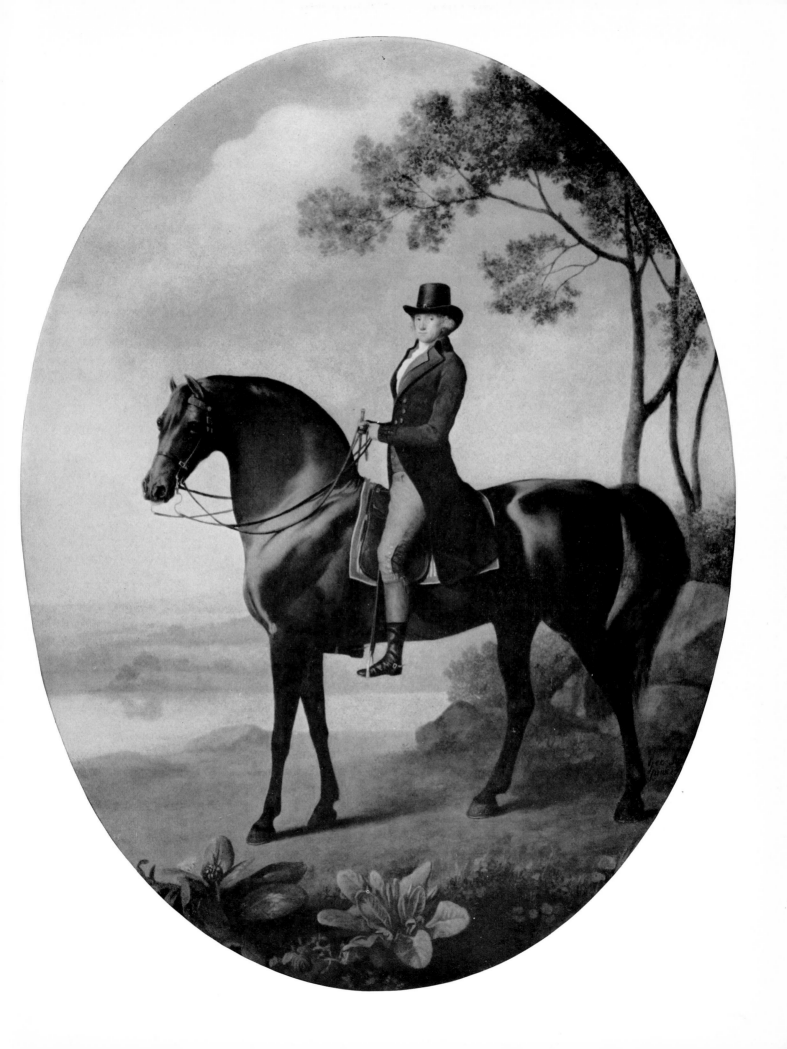

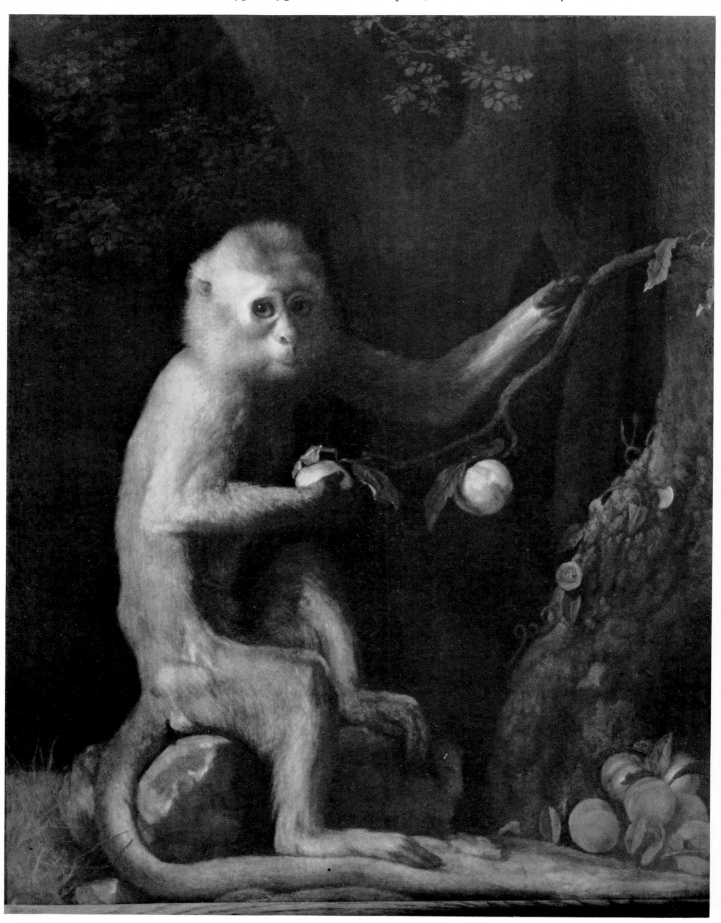

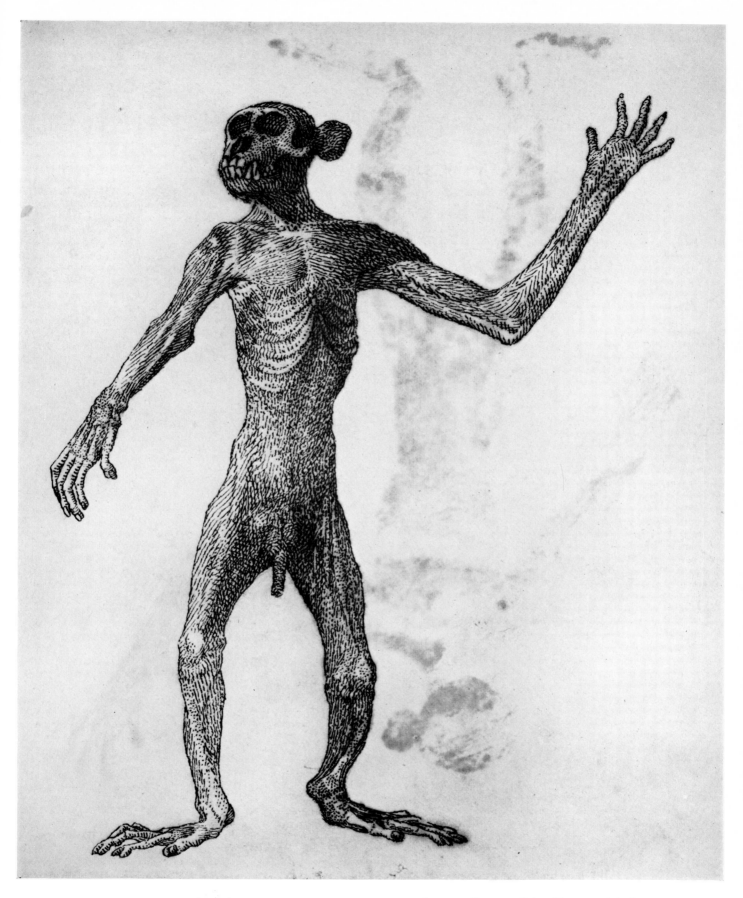

130. ANATOMICAL STUDY OF A BARBARY APE. 1795–1805. 11¾ × 13⅜ in. Pen and ink on paper. Worcester, Mass., Public Library

131. HAMBLETONIAN BEING RUBBED DOWN, WITH A TRAINER AND A STABLE-LAD. 1799. $82\frac{1}{2} \times 144\frac{1}{2}$ in. Private Collection

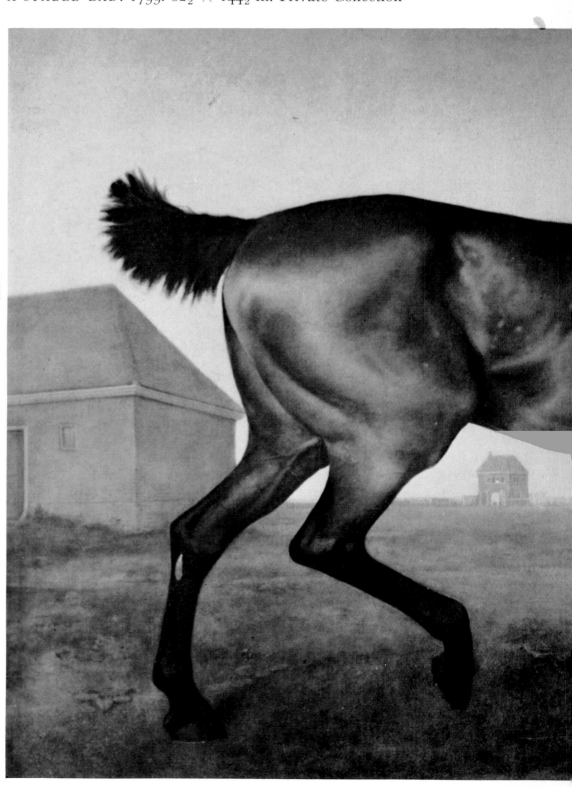

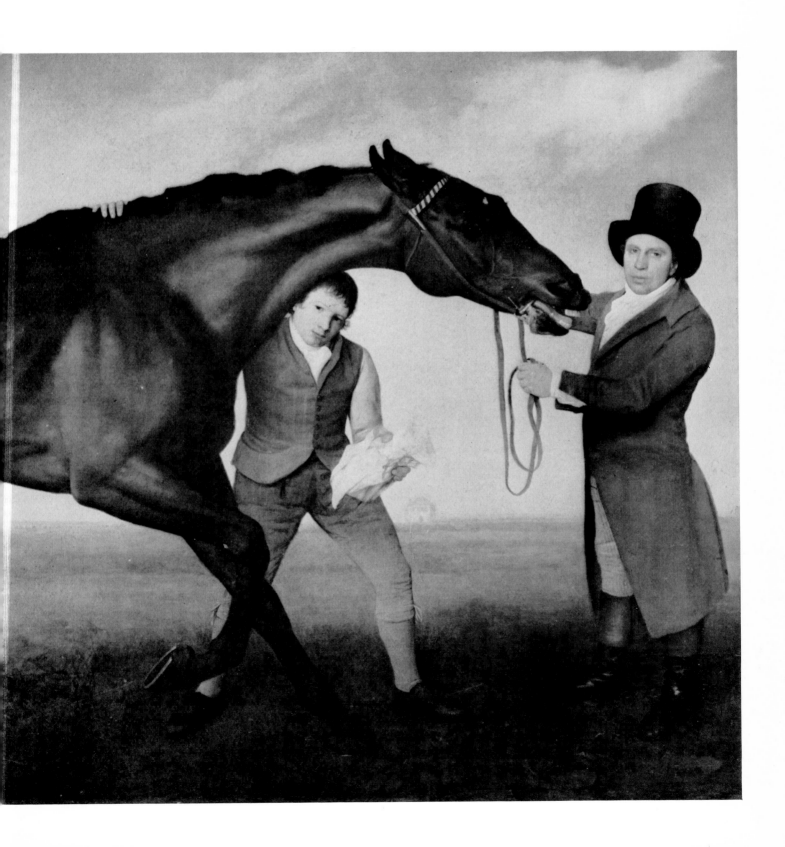

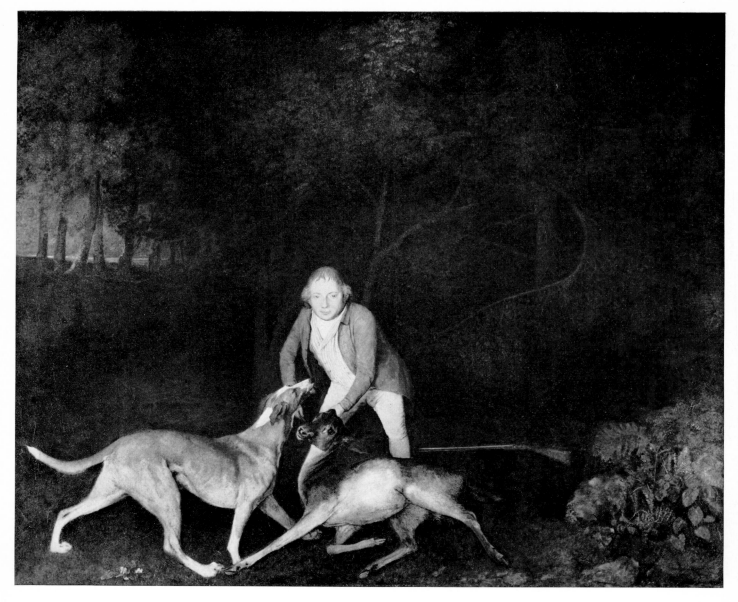

132. FREEMAN, THE EARL OF CLARENDON'S GAMEKEEPER, WITH A DYING DOE AND A HOUND.
Dated 1800. 40 × 50 in. United States, Mr and Mrs Paul Mellon

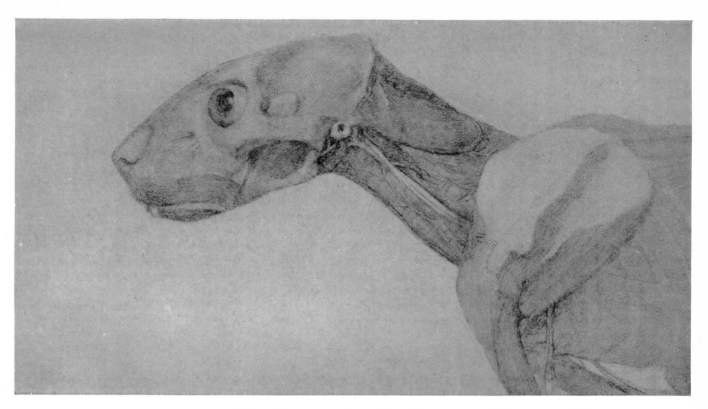

133. DISSECTION OF A TIGER (detail). 1795–1805. Pencil on paper. Worcester, Mass.,
Public Library

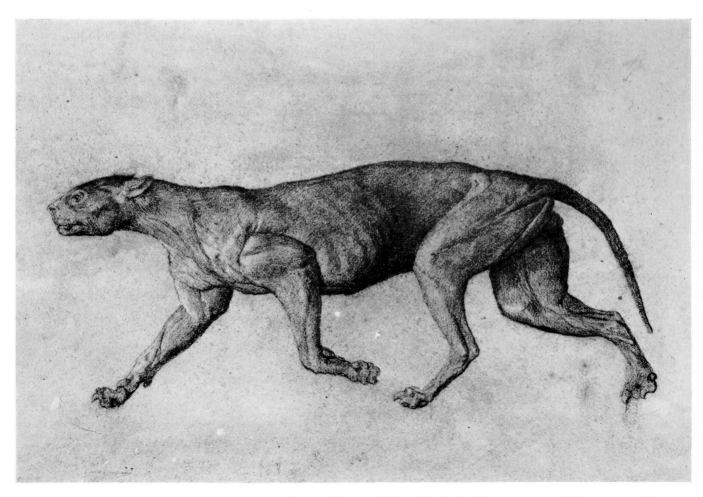

134. DISSECTION OF A TIGER. 1795–1805. $9\frac{7}{8} \times 13\frac{3}{4}$ in. Red chalk on paper. Worcester, Mass.,
Public Library

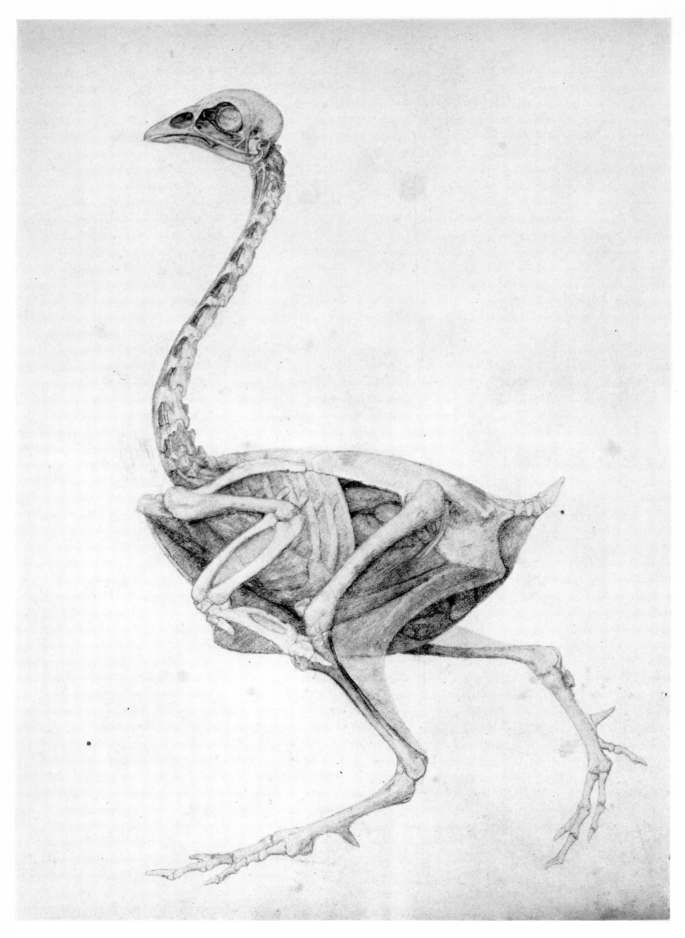

135. DISSECTION OF A FOWL. 1795–1805. 21¾ × 16 in. Pencil on paper. Worcester, Mass., Public Library

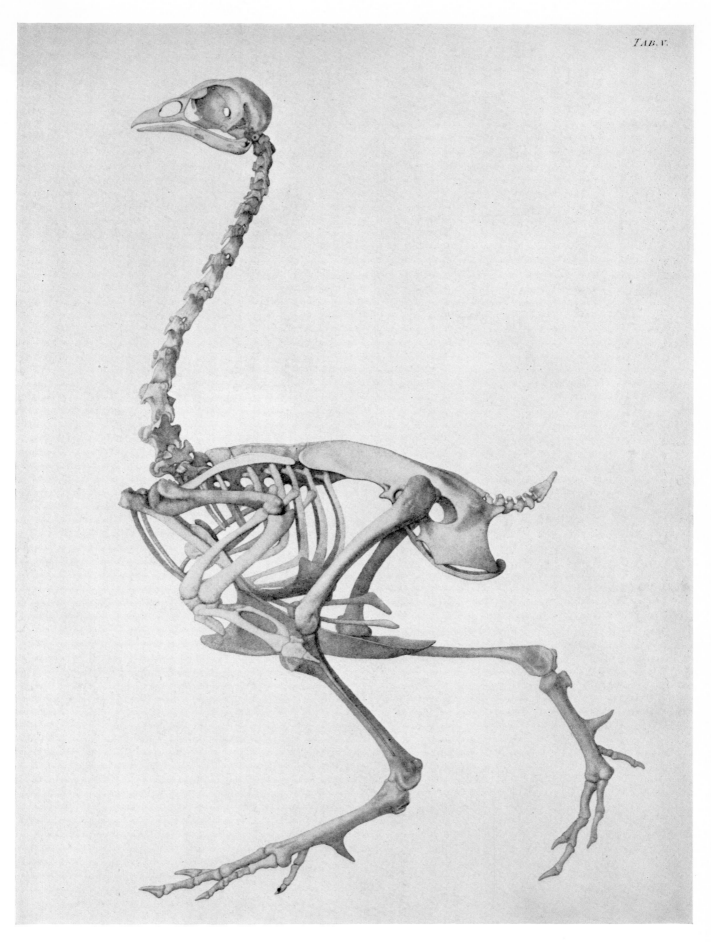

TAB. V.

136. SKELETON OF A FOWL. 1803–4. 20 × 15 in. (plate size). Engraving

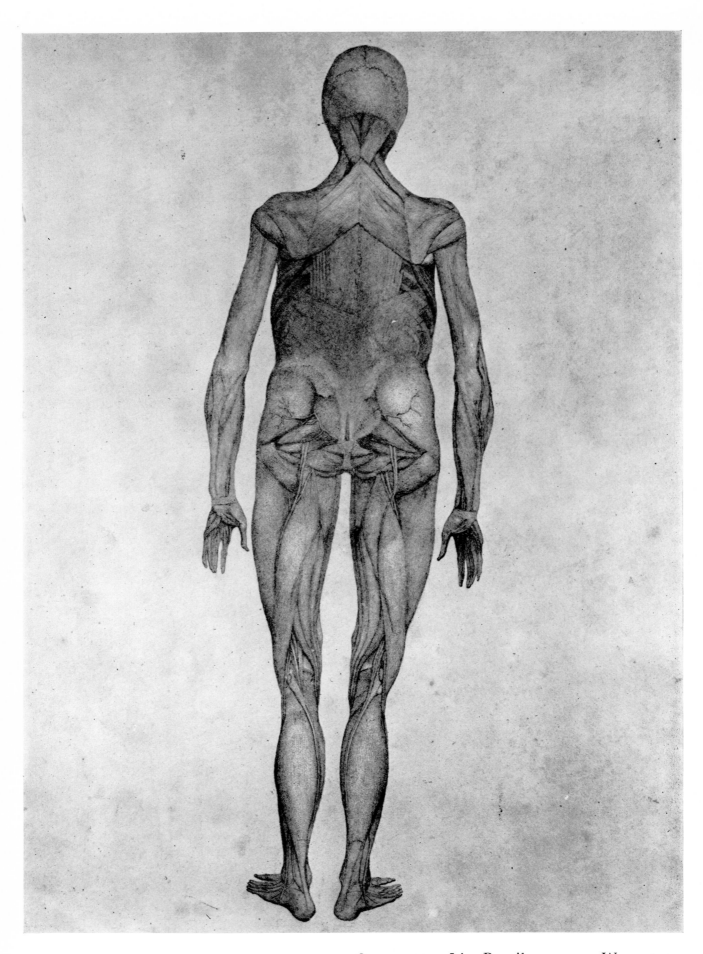

137. DISSECTION OF A HUMAN BODY. 1795–1805. 21 × 15⅞ in. Pencil on paper. Worcester, Mass., Public Library

THE FOLLOWING NOTES are intended primarily to supply further information than that provided in the introductory text about the subject or content of the works illustrated. Comments upon matters of attribution, dating and provenance are only included when these factors are significant for an understanding of the content of the pictures or in order to distinguish between versions. Signatures, dates and other inscriptions are given in full. Other information, such as the measurements and media, will be found in the captions to the plates.

1, 2. Two tables from Dr John Burton's 'An Essay towards a Complete New System of Midwifery . . .'

Burton was the model for Dr Slop, the man midwife in Sterne's *Tristram Shandy*; his book, published in 1751, has no very significant place in the history of obstetrics. Stubbs contributed to it, anonymously, eighteen tables, illustrating details of the female skeleton, dissections of the womb and other female parts, foetuses and obstetric instruments. According to Humphry, he was personally involved in the anatomical study which provided the foundation for his plates, and also had to learn the rudiments of etching from a York house-painter with some knowledge of the technique.

3. John Nelthorpe

Painted for Sir Henry Nelthorpe. John Nelthorpe, who was to succeed his father as the 8th Baronet, was born in 1745. The portrait must, therefore, have been made in the middle years of the following decade, probably just after Stubbs's visit to Italy in 1754, and at the same time that he painted the double portrait of the boy's parents. The Nelthorpes were the artist's earliest patrons of whom there is verifiable record; his attendance at their house probably led to the choice of the nearby village of Horkstow as the place in which to pursue his horse anatomy studies. For a later portrait of this subject, see Plate 68.

4–6. Three Drawings for 'The Anatomy of the Horse'

Forty-two drawings for *The Anatomy of the Horse* have survived, all of them in the possession of the Royal Academy, to whom they were bequeathed by Charles Landseer, who received them from his uncle, Edwin. It is impossible to say whether these are all that came into Mary Spencer's possession after Stubbs's death and whether they passed into the ownership of Edwin Landseer during her lifetime or after her death in 1817. Ten of the drawings present the horse in dramatically foreshortened views, which do not figure in the eventual publication of 1766. The rest are directly referable to the etched plates and diagrams.

7, 8. Racehorses belonging to the Duke of Richmond exercising at Goodwood

Painted for Charles, 3rd Duke of Richmond, about 1760/1. The chief figures, apart from the Duke, are his wife, Mary, and his sister-in-law, Lady Louisa Lennox; the setting is Goodwood Park, with Chichester and the Channel in the distance. This is one of a group of three large canvases, the others representing hunting and shooting themes, and including various members of the family. Stubbs worked for Richmond immediately after he came south.

9. Huntsman with a grey hunter and two foxhounds

This unusual and problematic work is placed here because of its connection with the Richmond hunting scene (mentioned in the note to Plate 8), in which the same main elements appear, with the hounds in a different place. The picture consists of several pieces of paper with which the composition seems to have been put together. It is impossible to say whether Stubbs has applied oil pigment to some drawn studies, and then added a landscape, or combined some existing oil studies. Moreover, it is difficult to date the resultant collage with any certainty; it could have been made as late as the 1780s.

10. Whistlejacket

Painted for Charles, 2nd Marquis of Rockingham, about 1762. Whistlejacket was acquired by Rockingham from Sir William Middleton. According to Humphry, the Marquis intended that a figure of George III and a landscape background should be added by other artists, so as to make the work a companion to Morier's equestrian portrait of George II at

Wentworth; the placing of the horse on the canvas seems to support this tradition. Rockingham was apparently so delighted with the painting as Stubbs left it, that he decided the additions should not be made. An American visitor to the house in 1835, George Ticknor, was told that Rockingham's decision was due to 'his being offended at the King'. Certainly, during the period of Stubbs's employment, Rockingham, as a Whig, had cause to be aggrieved by the new King's political policy, which was designed to break up his party's monopoly of power.

11–15. The Grosvenor Hunt
SIGNED: *Geo. Stubbs p. 1762*
Painted for Richard, 1st Earl Grosvenor, who appears immediately to the right of the tree. In addition to five hunt servants, the painting includes portraits of his brother, the Hon. Thomas Grosvenor, Sir Roger Mostyn and Mr Bell Lloyd. The setting is the Cheshire landscape visible from the front of Eaton Hall. A copy of the Society of Artists exhibition catalogue of 1764 originally belonging to Horace Walpole contains a note, added later by John Sheepshanks, stating that a hunting piece exhibited by Stubbs in that year was 'bought by Lord Grosvenor for 300 guineas'.

16. Five foxhounds in a landscape
Painted for Charles, 2nd Marquis of Rockingham, in 1761/2, being mentioned in the Wentworth accounts for 15 August 1762. Stubbs does not seem to have used this form of composition again, although the work is obviously comparable with the mares and foals pictures of the 1760s.

17. Molly Long Legs
SIGNED: *George Stubbs pinxit*
INSCRIBED: *Molly Long Legs*
This filly was bred in 1753 by a Mr Greville, who was the grandfather of the diarist, Charles Greville. The picture was exhibited at the Society of Artists in 1762 (112).

18–28. The 'Mares and foals' series
These compositions of brood mares, or mares with foals, form such an important part of the artist's work and present so many historical problems that only a brief, summary account of them can be given here. The series of nine extant paintings, which can be taken together, belong with one exception to the 1760s. One or two similar but less elaborate compositions appeared during the following decade. It is unlikely that the series included any other works than those presently known. All but one—the picture at Ascott (Plate 22)—show mares and foals. Five were painted on canvases measuring 40 by 75 inches, three of the rest being smaller, one larger. One was painted on a panel. The original purchasers of six examples can be identified with certainty. Grosvenor acquired two, Rockingham, Grafton, Bolingbroke and Colonel George Parker one each. Only in the Grafton and earlier Grosvenor pictures (Plates 18 and 23) can any of the animals be identified. The locations depicted can only be stated with certainty in the Grafton example (Plate 18), although we must suppose that some at least of the other landscapes were topographical, representing settings on the patrons' estates. Five of the compositions were exhibited at the Society of Artists: in 1762, '64, '65, '66, and '68.

18, 19. Mares and foals by a stream
SIGNED: *Geo. Stubbs pinxit*
INSCRIBED: *Antinous's Dam* and *Cassandra*
Painted for Augustus, 3rd Duke of Grafton. Until recently it has been suggested on a number of occasions that the foal being suckled was Antinous, a famous racehorse of the 1760s. Mr Peter Willett (*Horse and Hound*, 4 December 1970, p. 9) has recently established that the mare in the centre is the dam of Antinous and that on the right Cassandra, but that Antinous itself is not represented.

20, 27. Mares and foals without a background
Painted for Charles, 2nd Marquis of Rockingham. There is no verifiable explanation for the absence of a background, but Rockingham's decision to omit the background from the portrait of Whistlejacket (see note to Plate 10) may have led him to suggest a similar treatment for this composition.

21. Mares and foals disturbed by an approaching storm
Painted for Frederick, 2nd Viscount Bolingbroke. The

landscape here is almost certainly the park of Lydiard Tregoze, where Bolingbroke had his estate, as a similar stretch of water appears in a horse portrait by Stubbs which includes a view of the house.

22, 28. Mares by an oak-tree

This is the only one of these compositions in which mares alone are represented. It is probably the picture exhibited at the Society of Artists in 1765, which, according to notes in a catalogue once owned and annotated by Horace Walpole, showed animals in the Duke of Cumberland's stud. If that is so, the setting may be Windsor Great Park.

23. Mares and foals in a wooded landscape

Painted for Richard, 1st Earl Grosvenor. The present stretcher bears the following typed label: 'Robert 2nd Earl Grosvenor left the following memorandum in 1806. English Grey, Arabian and Barb. The Barb was given to Lord Grosvenor by the late Earl of Chatham and had no produce. The Arabian was a gift from Lord Pigot [*sic*] to Lord Grosvenor and had no produce. The English mare was Eloisa with bay Malkin at near foot.'

Young (*A Catalogue of the Pictures at Grosvenor House*, 1821, no. 9) describes the horses as 'presents from Lord Clive and others . . .'

If the first of the records quoted is accurate, the Pigott referred to may have been George Pigot (created Baron Pigot of Patshull in 1766), twice Governor of Fort St George, Madras (see note to Plate 43). There may, however, have been a confusion of names and the individual mentioned may have been Mr Charles Pigott, a well known racing enthusiast and breeder of the period. There may, alternatively, have been a confusion between Lord Pigot and Lord Clive, as both were in India at the same time. The picture was probably painted between 1760 and 1762, but a dating in the following two years is not impossible. The landscape may represent a part of the Eaton Hall estate, or Grosvenor's stud farm at Oxcroft, near Newmarket.

24. Mares and foals in a river landscape

This picture was until recently in the collection of the Earl of Midleton and may have always been in the ownership of the family.

25. Mares and foals in a mountainous landscape

The history of this picture cannot be fully traced. The animals are the same as those in the picture in the Macclesfield collection, which can be illustrated here only through the engraving, after Stubbs, by Benjamin Green (see Fig. 4). There is no verifiable explanation of this repetition, but there is at least the possibility that in neither case were the horses represented portraits of animals belonging to whichever patron may have been concerned.

26. Mares and foals under an oak-tree

SIGNED: *Geo. Stubbs pinxit 1773*

Painted for Richard, 1st Earl Grosvenor. The landscape may represent a part of the Eaton Hall estate, or Grosvenor's stud farm at Oxcroft, near Newmarket. A watercolour copy by George Townley Stubbs, inscribed by him and dated 1797, was reproduced by Walter Shaw Sparrow in his *British Sporting Artists* (p. 136). The date of this painting has in the past been wrongly recorded as 1770, this being the year inscribed on the present frame.

29. Chestnut hunter and grey Arab with a groom

30–32, 35, 36. Gimcrack on Newmarket Heath, with a trainer, jockey and stable-lad

INSCRIBED: *Gimcrack*

Painted for Frederick, 2nd Viscount Bolingbroke. Gimcrack, by Cripple out of Blossom, was bred by Gideon Elliott in 1760 and first raced, at Epsom, in 1764. He won 27 out of 35 races, being owned in turn by Mr Wildman, Viscount Bolingbroke, Count Lauraguais, Sir Charles Bunbury and Lord Grosvenor. In the present picture the jockey wears Bolingbroke's colours. An identical version is in the collection of the Jockey Club, to which it was bequeathed by Admiral Rous.

An unusually small horse, originally dark grey, Gimcrack's coat changed colour as he aged. In another portrait which Stubbs made for Grosvenor in 1770, he appears almost white. A second version of this, now in the Halifax collection, was included in the *Turf Review* series and engraved by George Townley Stubbs. There is also a portrait of the horse, with a jockey up, in the Adeane collection.

33. The Rubbing-down House, Newmarket Heath

34. Newmarket Heath, with the Rubbing-down House

These were obviously studies intended for continuing use in the artist's studio, where they remained until his death, appearing in the posthumous sale of 1807 (second day, lot 59). The view represented in Plate 34 appears in the portrait of Gimcrack (Plate 32) and shows, in the foreground, the Rubbing-down House, which stood by the start of the Beacon Course and was one of the most famous features of the Heath. The Rubbing-down House is also the subject of the other work and was to appear in many of the artist's race-horse portraits. These are the only studies of their kind which are known to have survived, but numerous landscape drawings and a few paintings are recorded in the catalogue of the sale mentioned.

37. William, Third Duke of Portland, and Lord Edward Bentinck, with a groom and horses

Painted for William, 3rd Duke of Portland, about 1766/7. The companion piece, which shows the Duke on horseback by the entrance to Welbeck Abbey, was exhibited at the Society of Artists in 1767. The commission provides evidence of the close association which existed at this time between several of Stubbs's major patrons, for Portland, like Grafton, was a member of Rockingham's political group.

38. Hunter with a groom

39. Leopards playing in a rocky landscape

The central group of animals appears in three other works of later date, in the Fitzwilliam, Villiers and Yarborough collections, the last being inscribed 1776. These later works show the animals in a dark, rocky setting; the landscape in this example, as well as the picture's style, is characteristic of the 1760s. Stubbs published an etching, probably based upon the Yarborough version, in 1780.

40. Tiger

Probably the picture included in the artist's posthumous sale of 1807 (second day, lot 92). It is difficult to discover how many paintings of tigers Stubbs made, for, as was the custom in his day, he gave the same name to the animals we now call leopards. There is a work of similar size at Blenheim and a small version of the subject in the Mellon collection. He published a mezzotint of a tiger (with a sleeping leopard in the background) in 1788 (see Plate 113).

41, 42. Huntsmen setting out from Southill, Bedfordshire

SIGNED: *George Stubbs pinxit*

Painted for George, 4th Viscount Torrington. It is the hunting piece mentioned by Humphry as having been made for this patron, with a view of Southill village. On stylistic grounds it can be assigned to the middle years of the 1760s, the landscape being one of the finest examples of Stubbs's most realistic manner.

43-45. Cheetah with two Indian attendants and a stag

Painted for Sir George Pigot, Bt., about 1764/5. This is the largest and most ambitious of Stubbs's wild animal portraits. Pigot, created a baronet in 1764 and subsequently awarded an Irish peerage as Baron Pigot of Patshull, was at two periods (1755–63 and 1775–7), as a servant of the East India Company, Governor of Fort St George, Madras, and made a fortune in India. According to family tradition, the cheetah was presented by him to George III. The picture was exhibited at the Society of Artists in 1765 (126, *Portrait of a hunting tyger*; Stubbs, like others at the time, always gave this name to leopards, and cheetahs were so called, even in India). It was almost certainly painted in the period between Pigot's return from Madras in May 1764 and the following spring. Although the picture is not conceived as a descriptive record of such an event, the animal may have been the one with which the Duke of Cumberland attempted to hunt a stag at Windsor in July 1764. A later member of the Pigot family had the stag painted out in the 1880s and the picture was exhibited in that modified condition at the Whitechapel Gallery Stubbs exhibition in 1957 (catalogue, plate IX).

46. Hound hunting a stag

SIGNED: *Geo. Stubbs 1769*

47. Two gentlemen going shooting

48, 49. Two gentlemen out shooting at Cresswell Crags, Derbyshire

50. Two gentlemen resting in a wood after shooting

51, 52. Details from **Two gentlemen shooting**

Painted between 1767 and 1770. These four pictures constitute a set of four shooting subjects, exhibited individually at the Society of Artists between 1767 and 1770, and subsequently engraved by William Woollett. The order of exhibition was different from the numbered sequence of the prints, each of which include clumsy verses indicating the time of day represented. In this sequence, the painting reproduced as Plate 48 was numbered 3, but it was the first to be shown. Plate 50 was numbered 4 and exhibited in 1770. Plate 47 was numbered 1 and exhibited in 1768. In these circumstances it is difficult to decide whether Stubbs himself intended the works to have a temporal sequence, completing them together as a group, or executed them at intervals over four years. Certainly the landscape in Plate 50 is more characteristic of his style at the end of the decade.

53, 54. Lady reading in a wooded park

The figure has previously been named Princess Charlotte, but for historical and stylistic reasons this identification cannot be accepted. The portrait must have been made at an important moment in the lady's life, such as her coming-of-age, betrothal, or marriage, for the painter has wreathed and ornamented her figure with flowers.

55. Lord and Lady Melbourne, Sir Ralph Milbanke and John Milbanke

Painted for Peniston Lamb, 1st Lord Melbourne, and exhibited at the Society of Artists in 1770 (133). The sitters are, from right to left: Lord Melbourne; his brother-in-law, John Milbanke; his father-in-law, Sir Ralph Milbanke; Lady Melbourne.

56. Zebra

Exhibited at the Society of Artists in 1763 (121). The animal is a female of the species known as the moun-

tain, or common, zebra. It had been brought, with a male, from the Cape of Good Hope and presented, according to different accounts, either to George III, when Prince of Wales, or to his wife, when Princess Charlotte. The picture remained in the artist's possession until his death and was sold in the posthumous sale of 1807 (second day, lot 88).

57–59. Colonel Pocklington with his sisters

SIGNED: *Geo: Stubbs pinxit 1769*

60. Horse attacked by a lion

Painted for Charles, 2nd Marquis of Rockingham, perhaps as early as 1762. An account of the origin of this subject, in an antique sculpture, is given on p. 33. This is by far the largest version and has a companion, made for the same patron, depicting a lion attacking a stag. Stubbs treated the theme in oils and enamel colours, and in mezzotint. The variations are found in the colour of the horse (grey or light brown as here), the landscape, and the conception of the main group; one example (Fig. 17) shows the horse struggling to rise from a prone position, and in others its tail curves back towards the body. Seven versions in oils and one in enamel are currently known, as well as the artist's own mezzotint of 1788. Three versions are known to have been exhibited, only one of which is identifiable, and the fact that only two occurred in the artist's posthumous sale is some evidence of the subject's contemporary success.

61. Horse attacked by a lion

SIGNED: *Geo: Stubbs pinxit 1770*

See note to Plate 60.

62, 65. Horse frightened by a lion

SIGNED: *Geo: Stubbs pinxit 1770*

This subject formed a pendant to the *Horse attacked by a lion*; it appears in other forms, one showing the lion at a greater distance from its prey, another with a different landscape. There is also a variant in which the horse is threatened by a lioness, now known only in the engraving by Benjamin Green published in 1774. The present picture was probably painted as a companion to Plate 61. Of the three paintings known, one is in enamel colours.

63. Lion and lioness

SIGNED: *Geo: Stubbs pinxit 1770*

This general theme of lions and lionesses, treated by Stubbs with varying backgrounds and in different compositions, seems to have been one of the artist's particular interests between 1770 and 1775. There are other examples, all of them in oils, at the Victoria and Albert Museum, at the Boston Museum of Fine Arts, at Goodwood House and in the Nelthorpe collection.

64. Recumbent lion

If the anatomical studies (see Plates 130, 133–137) are excluded, Stubbs's drawings are uncommonly rare. The posthumous sale of 1807 included forty lots devoted to drawings of all kinds, including what are described in the catalogue as 'finished coloured drawings'. Taking the contents of sketchbooks into consideration, Stubbs must have produced at least four hundred studies. Only thirty-six are known to exist.

66. Pumpkin with a stable-lad

SIGNED: *Geo: Stubbs pinxit 1774*

Pumpkin, by Matchem out of Old Squirt Mare, was bred by John Pratt, being foaled in 1769; the horse was jointly owned by Charles James Fox and the Hon. Thomas Foley. Stubbs painted several versions of the horse being ridden at Newmarket by the jockey South, one of which was in the *Turf Review* series. Examples are in the Royal collection and at Ascott, Wing (The National Trust, Rothschild Collection).

67. Shark with his trainer, Price

SIGNED: *Geo: Stubbs pinxit 1775*

Shark, foaled in 1771 and bred by Mr Pigot, was, like Eclipse, sired by Marske. After a successful racing career, he was later exported to America. Another version of the same date is in the Mellon collection and may have been the work included in the *Turf Review* exhibition of 1793, when an engraving of the subject by George Townley Stubbs was published.

68. Sir John Nelthorpe out shooting with two pointers

SIGNED: *Geo: Stubbs pinxit 1776*

Painted for Sir John Nelthorpe, 8th Baronet. The portrait was made during Stubbs's second period of association with the family, when Nelthorpe was 32. The setting is Barton Fields, with the Lincolnshire village of Barton-upon-Humber and the river estuary in the distance.

69. Laura with a jockey and a stable-lad

SIGNED: *Geo: Stubbs pinxit 1771*

The horse was bred by William Bethell. The jockey represented is John Pratt and the groom John Allen.

70. Prancing horse by a lake

SIGNED: *Geo: Stubbs p: 1775*

There are several other examples known of pictures showing horses in this free posture, which is different from the more formal, 'managed' position to be seen in the portraits of Whistlejacket (Plate 10) or Scrub (Irwin collection), and which had had a long history in both painting and sculpture. Stubbs seems to have been particularly fond of this type of landscape background showing a river or lake and distant mountains, for it occurs frequently in works of the 1770s and 1780s especially. Unfortunately the delicate and vaporous atmospheric effects which he managed in representing these perspectives across water have only too often been marred by insensitive cleaning.

71. Indian rhinoceros sleeping

This drawing was probably one of the 'Nine studies of the Rhinoceros in different attitudes' included in the posthumous sale of 1807 (first day, lot 15), and as such one of the studies made in connection with Plate 72.

72. Indian rhinoceros

Painted for John Hunter, about 1772. The animal was exhibited at Pidcock's Menagerie, Exeter 'Change, Strand, in 1772. The picture was one of those, by various artists, which Hunter obtained for his famous scientific museum, ultimately located in his Leicester Square house.

73. Baboon and albino macaque monkey

Painted for John Hunter. Like the portrait of a rhinoceros (see note to Plate 72) and another of a yak, this was made for Hunter's museum. It is comparable in style with Stubbs's other wild animal paintings bearing dates between 1770 and 1775.

74. Lemur

INSCRIBED (probably in Joseph Banks's hand, certainly not Stubbs's): *Lemur murinus* and *Stubbs*

75. Lemurs

One of three drawings commissioned or obtained from the artist by Joseph Banks.

76, 77. Scapeflood with a stable-lad

SIGNED: *Geo: Stubbs 1777*

Painted for John, 1st Earl Spencer.

78, 79. Two hunters with a young groom and a dog

SIGNED: *Geo: Stubbs pinxit 1778*

80. Two hunters with a groom and a dog

SIGNED: *Geo: Stubbs pinxit 1779*

81. Thomas Smith, huntsman of the Brocklesby Hounds, and his son, Tom

SIGNED: *Geo: Stubbs pinxit 1776*

Painted for Charles Pelham, later 1st Baron Yarborough. Thomas Smith was the huntsman of the Brocklesby pack and was succeeded by his son, who, at this date, was first whipper-in.

82, 83. John and Sophia Musters out riding at Colwick Hall

SIGNED: *Geo: Stubbs pinxit 1777*

Painted for John Musters. The house is Colwick Hall, Nottinghamshire. John and Sophia Musters were the parents of John Musters, the husband of Byron's distant relative, Mary Chaworth, to whom at the age of 16 the poet unsuccessfully proposed when she was already engaged. Some years after the portrait was painted, the elder Musters, probably on account of his wife's infidelity, had both figures painted out and two walking grooms added by another hand. The painting was restored to its original appearance in 1938.

On the evidence of surviving work (see also Plates 68 and 81) Stubbs was seeking at this period to consolidate his practice as a painter of this type of informal portrait.

84. Grey horse with jockey up

SIGNED: *Geo: Stubbs pinxit 1774*

85. Mambrino

SIGNED: *Geo: Stubbs pinxit 1779*

Painted for Richard, 1st Earl Grosvenor. The horse, by

Engineer out of Blaze, was bred by John Atkinson of Scoles, near Leeds, and later acquired by Lord Grosvenor. After a successful racing career it was put to stud and was to have an important influence upon the breeding of trotting horses. Stubbs made a second portrait, with a different landscape, for the *Turf Review* series (Irwin collection).

86. Portrait of the artist

SIGNED: *George Stubbs pinxit 1781*

This work is almost certainly one referred to by Humphry as having been commissioned by a Mrs Thorold and an inscription on the reverse refers to a Richard Thorold. It may also have been the 'Portrait of an artist' exhibited at the Royal Academy in 1782 (No. 173). The drawing reproduced here as the frontispiece is obviously the finished study for this painting.

87. Josiah Wedgwood

SIGNED: *Geo: Stubbs pinxit 1780*

This painting, with a companion portrait of Mrs Wedgwood, was evidently not commissioned by the sitter, as neither work is mentioned in the letters Wedgwood wrote to his partner during Stubbs's stay at Etruria in 1780, which describe his activities there in such detail. As the posthumous sale of 1807 included pictures that must have been this and its pendant (first day, lot 63), it can be assumed that Stubbs made the portraits on his own account, after leaving Etruria, probably from drawings similar to the one reproduced here as the frontispiece.

88. Gentleman on a grey horse

SIGNED: *George Stubbs pinxit 1781*

The landscape in this portrait, with its generalized formality and free handling, is typical of the backgrounds which Stubbs was using in the 1780s. The man's features show such a strong resemblance to the artist's, while being considerably younger, that one is bound to consider the possibility that the picture may represent his natural son, George Townley Stubbs.

89. Portrait of the artist on a grey horse

SIGNED: *Geo: Stubbs pinxit 1782*

This work was for many years considered to be a portrait of Josiah Wedgwood and as such was included

in Reginald Grundy's catalogue of the picture collection at the Lady Lever Art Gallery. The true identity of the sitter was finally established in 1957. The picture remained in the artist's possession until his death, when it passed to Mary Spencer. It appeared in the sale of 1807 (second day, lot 97), but was not then sold.

90, 91. Park phaeton with a pair of cream ponies in charge of a stable-lad with a dog

This picture can confidently be placed in the 1780s, probably before 1785, on the evidence of the landscape which is of a type confined to this decade. Several dated works embody a similar background, notably the portrait of Mr Santhague in the Royal collection which is inscribed 1782. The rarity of cream ponies was a good reason in itself for a work of this distinctive character to have been commissioned.

92. Hunter, Arab and water spaniel

In terms of subject and composition the motif of confrontation or meeting seems to have been for Stubbs of obsessional interest, for it determines the nature of so many pictures. The present work, with its minutely calculated and finely poised balance, is a most elegant example of the theme.

93. Richard Wedgwood

SIGNED: *Geo: Stubbs pinx.*

The sitter was father of Josiah Wedgwood's cousin, Sarah Wedgwood, who became his wife in 1764. The portrait was painted during Stubbs's stay at Etruria, and in a letter written to his partner Bentley while the work was in progress, the potter noted that 'it will be a very strong likeness'.

94. Phaeton

SIGNED: *Geo: Stubbs pinxit 1775*

Phaeton, son of Phoebus the sun god, drove his father's chariot too close to the earth and was destroyed by a thunderbolt cast at him by Jupiter, seeking to save the world from destruction. The most familiar source of the legend was Ovid's *Metamorphoses*. It was an obvious subject for an animal painter seeking material for history painting. Stubbs also painted it in oil colours at least once and there is a version in this medium in the

Saltram collection, which may be the same as that which, according to Humphry, Reynolds acquired as early as 1762.

This is almost certainly the largest of the enamel paintings he made on a metal support, before working on a greater scale with the Wedgwood tablets. Having been invited by Wedgwood to model two reliefs for translation into ceramic he chose Phaeton as one subject (Plate 95) and based his treatment upon the engraving by Benjamin Green (1770) after one of his earlier versions in oils.

95. Phaeton

See note to Plate 94.

96. Young gentleman [Mr Huth?] preparing to shoot

SIGNED: *Geo: Stubbs pinxit 1781*

This is probably the portrait of Mr Huth referred to by Humphry.

97. Isabella Saltonstall as Una from Spenser's 'Faerie Queene'

SIGNED: *Geo. Stubbs pinxit 1782*

Probably painted for the sitter's parents. Una, who appears in the first book of Spenser's poem, typifies the true religion. Her encounter with the lion (representing England) may be found in the first ten stanzas o Canto III. The picture was exhibited at the Royal Academy in 1782, where two years earlier Reynolds had shown a portrait of Miss Beauclerk in the character of Una.

Stubbs had previously painted Miss Saltonstall with her father and mother in a portrait group of 1769 (Waddesdon Manor collection). In the last years of the artist's life she was to lend him, according to Farington (*Diary*, 3 June 1807), 'a considerable sum of money', and after his death she took possession of numerous pictures which had been security for the loan.

98. An old hunter, Orinoco, with a dog

SIGNED: *Geo: Stubbs 1780*

99. 'The Farmer's Wife and the Raven'

SIGNED: *Geo. Stubbs pinxit 1782*

The subject was taken from Fable XXXVII in the

Fables of John Gay (1738) and was based upon the lines:

> That Raven on yon left-hand Oak
> (Curse on his ill-betiding croak!)
> Bodes me no good' No more she said
> When poor Blind Ball with stumbling tread
> Fell prone.

The original text was illustrated with an engraving by Van der Gucht after Wootton, and Stubbs's interpretation of the subject is very similar but less baroque in form. Apart from his own mezzotint of 1788, two versions in oil colours also exist.

100, 101. Reapers
SIGNED: *Geo: Stubbs pinxit 1784*

102. Reapers
Detail of the picture at Upton House. See note to Plate 103.

103, 104. Haymakers
SIGNED: *Geo: Stubbs pinxit 1785*
These pictures (Plates 100 and 103) were probably those exhibited at the Academy in 1786 and were the source of the two large mezzotints Stubbs published in January 1791. There are also oval versions of the subjects in enamel, the Reapers dated 1794 (Mellon collection) and the Haymakers, 1795 (Lady Lever Art Gallery). In 1783 Stubbs had treated both subjects in a different form of composition These works, also very distinct in character, are now at Upton House (details reproduced in Plates 102 and 105).

105. Haymakers
Detail of the picture at Upton House. See note to Plate 103.

106, 107. Lady and gentleman in a phaeton
SIGNED: *Geo: Stubbs pinxit 1787*
The sitters cannot be identified, but it is reasonable to assume that the picture was intended to be as much a portrait of their fine carriage and pair as of themselves.

108, 109. Labourers
INSCRIBED: LABOURERS. *Painted, Engraved & Published*
by Geo. Stubbs 1 Jan 1789. No 24 Somerset Street, Portman Square, London.
The first version of this subject, exhibited at the Royal Academy in 1779 (now in the Bearsted collection), was made as the result of a commission from Lord Torrington (see p. 40). Another version seems to have encouraged Wedgwood to commission from Stubbs the family group painted at Etruria in 1780, when he also acquired the present picture.

This mezzotint is different from the extant painted versions of the subject and may well have been based upon the study originally made on Torrington's estate.

110. Foxhound viewed from behind
INSCRIBED: *Publish'd by Geo Stubbs 1 May 1788*

111. Foxhound
INSCRIBED: *Publish'd by Geo Stubbs 1 May 1788*
Identical foxhounds in these positions appear in the large hunting piece in the Richmond collection (see also Plate 9) and were probably derived from drawings made in connection with that work. A third print, of a foxhound on the scent, was published in the same year.

112. Two foxhounds in a landscape
INSCRIBED: *Painted, Engrav'd & Publish'd by Geo Stubbs 1 May 1788 No 24 Somerset Str Portman Sq London*
In an advertisement of his prints, Stubbs described this as 'two Dogs'. In the catalogue of the posthumous sale (first day, lot 27) occurs a drawing of '2 pointers in a landscape'. In view of the unreliable descriptions in the catalogue the drawing may be related to the present engraving.

113. Tiger and sleeping leopard
INSCRIBED: *Painted, Engrav'd & Publish'd by Geo Stubbs 1 May 1788 No 24 Somerset Str Portman Sq London*
The inscription implies that this mezzotint was based upon a painting of the subject. It is likely that both engraving and painting had their origin in the work reproduced here as Plate 40.

114. Sleeping cheetah
INSCRIBED: *Painted Engrav'd & Publish'd by Geo Stubbs 1 May 1788 No 24 Somerset Str Portman Sq London*
This must be the same animal which Stubbs had

painted for Sir George Pigot in 1764–5, the print being based upon a drawing made at that time.

115. Two old hunters by a lake
SIGNED: *Geo: Stubbs pinxit 1790*

This pictorial motif, the face to face encounter of two horses, seems to have interested the painter in the years around 1790 as much as the mares and foals theme had done twenty-five years before, five other examples being known.

116. A foxhound, Ringwood
SIGNED: *Geo: Stubbs pinx 1792*

Painted for Charles Pelham, later 1st Baron Yarborough. Pelham was particularly famous as a breeder of foxhounds and for his Brocklesby pack. The picture, perhaps Stubbs's greatest dog portrait and a work comparable in its formal nobility with the *Hambletonian* (see Plate 131), shows that ultimate economy and strength of form which appears so impressively in some of his late works.

117, 119. Soldiers of the 10th Light Dragoons
SIGNED: *Geo: Stubbs p: 1793*

Painted for George, Prince of Wales (afterwards George IV). The soldiers were members of the Prince's regiment, the 10th Light Dragoons. From left to right they are a mounted sergeant a trumpeter, a sergeant and a private. It is the only known example of a military subject by the artist.

118. Groom. Detail from a portrait of Lustre.

120. The Prince of Wales's Phaeton
SIGNED: *Geo: Stubbs pinxit 1793*

Painted for George, Prince of Wales (afterwards George IV). Apart from Thomas the coachman, the composition includes a tiger-boy and a dog called Fino, which appears in another work commissioned from Stubbs by the same patron (see Plate 122). The strong, clear colour, firm contours and extremely direct economic handling are all characteristic of the work of the early 1790s and especially the group of pictures painted in that period for the Prince.

121. Hunter by a lake
SIGNED: *Geo: Stubbs pinxit 1787*

The background in this work is characteristic of Stubbs's landscape during the following ten years.

122. Fino and Tiny
SIGNED: *Geo: Stubbs Pinxit 179[?1]*

Presumably painted for George IV when Prince of Wales, as the black and white spitz dog, Fino, also appears in the painting of the royal phaeton (see Plate 120). The other animal, Tiny, is a brown spaniel.

123. Dungannon

Painted as one of the portraits for inclusion in the *Turf Review* series and engraved by George Townley Stubbs (1793), it is characteristic in style and conception of the works made for that unsuccessful enterprise. Dungannon, a son of Eclipse, was bred and owned by Dennis O'Kelly. The horse became attached to a sheep, which, according to contemporary accounts, had been left in one of O'Kelly's paddocks by a drover because it was lame.

124. Sweetbriar
SIGNED: *Geo: Stubbs p. 1779*

This racehorse was one of those sixteen which Stubbs included in the series presented by the *Turf Review* in 1794. In the catalogue of the exhibition it is referred to as 'a horse of considerable note both as a racer and stallion'. The rose-bush in the foreground provides an allusion to its name. The date inscribed on the work raises a question which applies to other pictures in the *Turf Review* group and which can only be touched on here. The inscribed date is, in fact, incompatible with the picture's style, which is characteristic of the work belonging to the 1790s.

125. Haymakers
SIGNED: *Geo: Stubbs pinxit 1794*

A version of this subject in oil colours also exists. The present work was sold in the posthumous sale of 1807 (second day, lot 94).

126. Red deer stag and hind
SIGNED: *Geo: Stubbs pinx . . . 1792*

Painted for George, Prince of Wales (afterwards George IV). Presumably commissioned as a record of deer belonging to a small herd he had acquired not

long before and was keeping at Windsor. The landscape style is typical of the period and is also in evidence in the horse portraits painted for the *Turf Review* series.

127. Prancing horse
The position of the drawing in this book should not be taken as a suggestion, to any degree, of its date. Stubbs's drawings, apart from his anatomical studies, are so scarce that it is impossible to assess the date of the few which seem to have survived apart from those to which external or circumstantial evidence can confidently be applied. Although the pose of the animal here is almost the same as that of *Whistle-jacket* (see Plate 10) it does not appear to be a study for that picture.

128. Warren Hastings on horseback
SIGNED: *Geo: Stubbs pinx: 1791*
Being in enamel colours this is probably the second version of the portrait in oil colours on panel and of similar size (also dated 1791) formerly in the collection of the Earl of Rosebery. These works were therefore painted half-way through Hastings's trial before the House of Lords for 'high crimes and misdemeanours', of which, in 1795, he was, after seven years, to be wholly acquitted. He had commissioned from Stubbs a portrait of the Arab horse (he is probably riding the same animal in the portraits) which he had used in India and brought with him from there, as well as a picture of a yak which he had also imported; both these works are today in the Rothermere collection at Daylesford, Gloucestershire, the house which Hastings built for his retirement. There is reason to believe that one of the portraits was commissioned by the sitter; in making a repetition Stubbs was perhaps hoping to profit by the fame, indeed notoriety, of his subject.

129. Green monkey
SIGNED: *Geo. Stubbs 1798*

130. Anatomical study of a Barbary ape
See note to Plates 133–137.

131. Hambletonian being rubbed down, with a trainer and a stable-lad
Painted for Sir Henry Vane-Tempest in 1799. Vane-Tempest commissioned two pictures to commemorate the race between his horse and Mr Joseph Cookson's Diamond for a wager of 3000 guineas at the Newmarket Craven meeting of 1799. The other painting, like the present work exhibited at the Royal Academy in 1800, showed the finish and is lost. The bay horse, by King Fergus out of Highflyer, was a descendant of Eclipse and Herod and an ancestor of St Simon. Foaled in 1792, it won the St Leger in 1795. The race against Diamond was won by Hambletonian only in the last strides, both animals, according to contemporary reports, having been ruthlessly spurred and whipped by their jockeys. Hambletonian was never raced again.

Vane-Tempest advertised in *The Sporting Magazine* for June of 1799 that engravings were to be published after the two pictures, but these evidently did not materialize. In order to obtain his fee of 300 guineas for the portrait, Stubbs had to take his patron to court, where Lawrence, Humphry and Garrard appeared on his behalf, with Hoppner and Opie on the other side (Farington, *Diary*, 9 April 1801).

132. Freeman, the Earl of Clarendon's gamekeeper, with a dying doe and a hound
SIGNED: *Geo: Stubbs pinx 1800*
There are two identical versions of this subject, the other being in a private collection in Ireland; both are dated 1800. Their recent history is, however, so obscure that it is impossible to establish which example was the one formerly in the Clarendon collection and which was exhibited at the Royal Academy in 1801 (175. *A park scene at the Grove, near Watford, Herts. . .*). In 1804 Stubbs published a mezzotint of the subject, but only one impression is presently known in its original monochrome state. Two inferior impressions printed in colours also exist, but it seems unlikely that these were pulled during the artist's lifetime.

133–137. Drawings for 'A Comparative Anatomical Exposition of the Human Body with that of a Tiger and a Common Fowl'
The artist began to prepare this work, for which he made the dissections as well as producing the text and illustrations, in the mid-1790s. There is reason to suppose that the preparatory drawings had been made by 1802, for in the middle of that year subscriptions

were being sought. By December 1804 the first ten tables had been completed and by December 1805 five more were available. One may assume that these were issued unbound in wrappers, as there is no uniformity in the binding of the extant copies. As in *The Anatomy of the Horse* the illustrations are accompanied by numbered and lettered diagrams to connect them with the text. The technique employed was stipple, both engraving and etching processes being used in the achievement of the effect. The dimensions of the plates are various, being on average 20 × 15 in.

According to a note, probably composed by his common-law wife Mary Spencer, the artist was working on the project on the day of his death and just before the end regretted that he had not completed his Comparative Anatomy 'ere he went'. He left at least 120 drawings, which together with the text of the work found their way into the possession of Thomas Bell, F.R.S., an anatomist and dental surgeon, and later passed to a Dr John Green, a medical practitioner and a leading citizen of Worcester, Massachusetts. After Dr Green's death they became the property of the Worcester Free Public Library, which Green had founded in 1859. The drawings and manuscripts were rediscovered there in 1957.

The works reproduced here which relate to this publication are of four different kinds: Plate 136 is an example of the final, engraved illustrations; Plates 135 and 137 are examples of the finished drawings from which the published plates were to be engraved; Plate 134 is a preparatory study derived from Stubbs's dissections; Plate 130 is one of the drawings in the portfolio discovered at Worcester, Massachusetts, which are plainly of an anatomical nature but which may have only the most incidental relationship to the publication Stubbs had planned.

Index of works illustrated